Sascha Steinhoff

The VueScan Bible

Everything You Need to Know for Perfect Scanning

rockynook

Sascha Steinhoff (www.sascha-steinhoff.de)

Editor: Gerhard Rossbach
Copyeditor: Cynthia Anderson
Layout and Type: Steffen Kulpe
Cover Design: Helmut Kraus, www.exclam.de

Printer: Golden Cup
Printed in China

ISBN: 978-1-933952-69-7

1st Edition 2011
© 2011 by Sascha Steinhoff

Rocky Nook, Inc.
26 West Mission Street Ste 3
Santa Barbara, CA 93101-2432
www.rockynook.com

Library of Congress Cataloging-in-Publication Data

Steinhoff, Sascha, 1975-

 The VueScan bible : everything you need to know for perfect scanning / Sascha Steinhoff. -- 1st ed.

 p. cm.

 ISBN 978-1-933952-69-7 (soft cover : alk. paper)

 1. VueScan. 2. Photography--Digital techniques. 3. Scanning systems. I. Title.

 TR267.5.V84S74 2011

 621.36'7--dc22

 2010051180

Distributed by O'Reilly Media
1005 Gravenstein Highway North
Sebastopol, CA 95472

Contents

Preface

Dear Reader,

First, I would like to say thank you for giving me your trust by purchasing this book! I owe and dedicate *The VueScan Bible* to my readers. It was your feedback that convinced me to write another book about scanning. After publishing my successful book, *Scanning Negatives and Slides*, that describes all scanning processes in detail, I received loads of letters via my website, www.scanguru.info. Along with giving me useful feedback, readers frequently demanded even more software-specific guidance—and VueScan was at the forefront of those readers' interests.

So, here we go! *The VueScan Bible* is designed to help both beginners and experienced users get the most out of their VueScan-powered scanners. While it includes all the basic scanning know-how you need, VueScan-specific workflows are the center of attention. Scanning is not rocket science, but you simply have to know certain things; otherwise, you will waste a lot of time and effort. This is especially true when you use software as powerful as VueScan. Despite its rich features, VueScan is a remarkably lean scanning program that has been continually improved by its inventor, Ed Hamrick, for more than a decade. I want to express my gratitude to Ed Hamrick, who has been supporting this book project from the very beginning.

VueScan was the first scanning software ever to provide sophisticated features, like RAW data scanning functionality, that live up to their promise. And it runs on Mac, Windows and Linux computers alike. Whether you are a techie-loving pixel peeper or just an average user who wants to work quickly and efficiently with the software—you must get used to VueScan's tricks and traps for the best scanning results. This book provides you with everything you need to know to convert your analog negatives, slides, documents, and photo prints into high-quality digital files.

Best Regards

Sascha Steinhoff
Bangkok, April 2011

Using this book

VueScan has an astonishing variety of options. This book uses different styles for intuitive navigation through all these tabs, options, and buttons. Below is an explanation of how it works.

A. The entries of the menu bar

a) Adressing of first level entries like File (Edit, Scanner, etc.):
 File
b) Adressing of subentry:
 File ▶ Save image
or when written separately:
 go to File menu and pick Save image or Page setup.

B. The tabs of VueScan

a) Adressing of tab, like Input (Crop, Filter, etc.):
 Input
b) Adressing of subentry in tab:
 Input ▶ Task
c) Adressing of configuration option in subentry:
 Input ▶ Task ▶ Scan to file
or when written seperately:
 go to Input ▶ Task and configure Scan to file.
This format is used for the tabs Preview and Scan as well.

C. Keys and Buttons

Pushbuttons either on the keyboard or in VueScan look like this:
 Scan for Scan Button in the GUI
 F1 for F1 key on the keyboard
This format is used for the pushbuttons Scan and Preview in the VueScan GUI as well. Don't mix it up with the tabs Preview and Scan.

A note on VueScan updates

This book refers to VueScan Professional 9.0.22, which was the newest version of VueScan at the time of writing. Ed Hamrick continually releases updates; a new version every two weeks or so is quite common. Please consider that the updates mainly contain bug fixes; new functionality is implemented much less frequently. That means the information in this book will stay up to date even though you might be using a newer version of VueScan. If you have any questions contact the author at his website www.scanguru.info.

 In general the images for this book have been taken by the author, the exceptions are marked clearly.

VueScan – Look and Feel

VueScan is possibly the most feature-rich application available on the market today. It allows you to control nearly all current scanner models plus a good portion of vintage models. When you compare the program to the scanner drivers shipped with scanning hardware, you will find that VueScan is much more powerful. Of course, this power comes at a price. Though it has a beginners' mode, the sheer number of options in VueScan can make it cumbersome if you are not familiar with its operation. But as this chapter will show, you can easily handle VueScan once you are familiar with the concepts.

Contents

1.1 Field of application

VueScan is a third-party scan application developed by Ed Hamrick. Although every scanner comes with a scanner driver provided by the manufacturer, you can noticeably expand your scanner's abilities by using VueScan. VueScan is a commercial yet economically priced application. It supports 1,600 different scanners at the time of writing this book and new scanners are added frequently, therefore the numbers are still rising. The application supports almost all flatbed and film scanners available on the market today, and a good portion of vintage scanners as well. So if you are using any common desktop scanner, the chances are high that VueScan will work with it.

CMOS scanners

Of course, there are a few exceptions to the rule. At present, VueScan does not support CMOS scanners. CMOS scanners are small, box-shaped devices that have a CMOS chip inside to convert analog slides into digital pictures. Despite their comparably poor quality, they sell quite well—mostly because of their low price. For quality-conscious users, they are not a reasonable choice; though they have been around for some years, they still lag far behind traditional flatbed and film scanners. Basically these are just cheap digital cameras in a box.

Drum scanners and Hasselblad scanners

The other scanners not supported by VueScan are vintage drum scanners and their modern successors manufactured by Hasselblad. Drum scanners are the dinosaurs of scanning. During their heyday in the 1990s, they were incredibly heavy, incredibly expensive, and very difficult to operate. A specially trained scan operator had to run these monster scanners, which could easily cost as much as a house. Drum scanners still exist in small numbers, but they are slowly dying out. If you still want to use one, either talk to the manufacturer regarding scanning software or try your luck with SilverFast. SilverFast provides support for some of these high-end scanners, but the software is quite pricey.

The modern alternative to a drum scanner is manufactured by a company originally called Imacon. Imacon was bought out by Hasselblad, so the scanners are now sold as Hasselblad devices. Hasselblad scanners operate with a kind of virtual drum, so they look quite different from average film and flatbed scanners. Neither VueScan nor SilverFast provide scanning software for Hasselblad scanners. For the average user, these scanners are not an option. Although Hasselblad scanners are cheaper than the old drum scanners, they still can cost as much as a car. For average desktop scanning, film and flatbed scanners are the first choice—and the chance that VueScan supports your desktop scanner is almost 100%. The manufacturer's website, www.hamrick.com, hosts a compatibility list where you can see all supported scanner models.

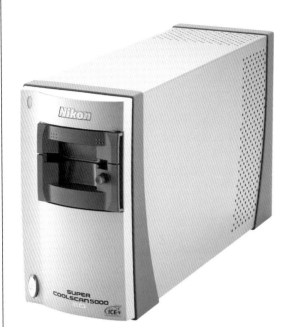

Image: Nikon

Classic film scanners like this Nikon Coolscan 5000 deliver brillant scans of 35mm film. VueScan supports almost every film scanner on the market.

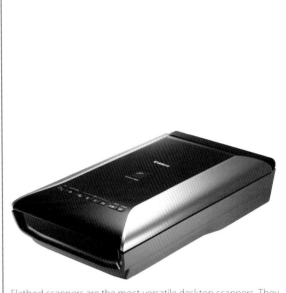

Image: Canon

Flatbed scanners are the most versatile desktop scanners. They can process transparencies and reflectives of various sizes. VueScan supports almost every flatbed scanner on the market.

Image: Reflecta

CMOS scanners are relatively new on the market. Most of these devices are quite cheap and not capable of scanning analog originals in good quality. Not supported by VueScan, yet.

Image: Hasselblad

Hasselblad scanners are the Ferraris of the scanning world. They cost as much as a car and, despite the high price, functionality like infrared channel is missing. Not supported by VueScan, yet.

1.2 Compatibility and license issues

There is no other scanning software available on the market that support a similar range of operating systems as VueScan. The support of Windows systems is more or less standard. VueScan supports all current versions of Windows, as well as all versions of Windows since Windows 2000. Mac OS X is supported by VueScan, too - from version 10.3.9 to the latest version. Mac OS 9 is not supported any more. At this point all other scanning software manufacturers usually stop. You can be happy if they provide compatibility with Windows and Mac OS X, and that's it. VueScan, goes one step further, as you can use it with Linux, too! This is a very nice feature and can be quite convenient, especially if you want to reuse an existing computer as a scan machine and you have no Windows license for it. All in all the support of different operating systems by VueScan is quite unique in the world of scanning. The user can freely decide what platform he wants for his scanning computer and that is a very nice feature, indeed.*

** Unlike other software, VueScan provides the same functionality on every platform! Infrared clean will always work the same, no matter if you are using VueScan with Linux, Windows, or a Mac. With SilverFast, it can be different due to license restrictions of proprietary correction filters like Digital ICE. While Windows versions of SilverFast may support Digital ICE, it may not be the case when you are using SilverFast on a Mac. You have to check this carefully for your individual scanner and your operating system.*

Unlike older scanning programs, VueScan is also available in 32-bit and 64-bit versions (the x32 and x64 versions). These are available for Windows, Mac OS X and Linux operating systems. In addition, the Mac OS X versions of VueScan are universal binaries. The Mac OS X x32 version is a universal binary with 32-bit Intel and PowerPC binaries, and the Mac OS X x64 version is a universal binary with 32-bit Intel and 64-bit Intel binaries. The x32 version of VueScan will run on both 32-bit and 64-bit Windows, Mac OS X, and Linux. The x64 version will only run on x64 Windows, Mac OS X 10.5 and later, and 64-bit Linux of course.

Flexible licensing regulations

The licensing scheme of VueScan is as flexible as its operating system support. When you buy one license, you can use it on any kind of computer—Windows, Mac OS X, or Linux. You can even switch among operating systems while running the software, if you like. Also, in contrast to SilverFast, the license is not dedicated to a specific scanner type. If you buy any VueScan license, you can use it with any scanner supported by the software. If you buy a new scanner, you would have to buy a new SilverFast license; with VueScan, this is not necessary, since you can use VueScan with as many scanners as you like.

In most cases, you would buy a single-user license from VueScan. You can use this in two ways with your VueScan license. For one user or family, you can install VueScan on four different computers in the same home. This is extremely convenient, especially if you are using different scanners at the same time at different workstations. But if you have multiple users outside your family configuration, you should only install VueScan on one computer at the same time. For workgroups or corporate use, Hamrick Software offers multi-user licenses that are much cheaper than buying several single-user licenses.

Standard vs. Professional Edition

Due to the flexibility of VueScan's licensing regulations, there is only one major decision that you have to make before purchasing: do you want the Standard or Professional Edition? The Standard Edition costs $39.95, and the Professional Edition costs $79.95—about twice as much. The Professional Edition offers some nice features that you will not find in the Standard Edition. None of them is a must—you can do proper scanning with the Standard version, too—but the extra features can be quite useful.

The first of these Professional Edition exclusive features is the ability to create raw scan files, which can be extremely helpful during batch scanning. When you use this feature, you can concentrate on the scan itself and do all your configurations later when processing the raw file. With the Standard Edition of VueScan, you have to decide before scanning whether you want to use Infrared Clean or not. If you change your mind and decide you want to fine tune an image further, you would have to rescan it. But if you have a raw scan file, all you have to do is simply change the settings—there's no need to do a time-consuming rescan.

The second feature exclusive to the Professional Edition is the embedding of ICC profiles. With IT8 color calibration, the third Professional feature, you can even create your own profiles. These features are quite convenient, as they help you produce true colors throughout the workflow. Whether you really need them or not depends on what you are scanning—e.g., for slides, IT8 color calibration is useful, while for negatives it is not. In addition, the ability to embed color profiles and do color calibration will help improve picture quality only if you have a good scanner; if you have a cheap scanner, these options are more or less a waste of time. A poor quality scanner will produce mismatched colors whether you calibrate it or not.

The fourth and potentially most important feature of the Professional Edition is an unlimited upgrade period. Ed Hamrick actively improves VueScan. Every two weeks or so, a new version is available for download. Most modifications are improved hardware support and bug fixes, but from time to time new features and GUI improvements are available. Thus, it makes sense to update your VueScan installation from time to time. With VueScan Professional, you can upgrade as many times as you like. With the Standard Edition, you can upgrade for only one year, and then you have to buy a new license. Thus, it doesn't take long for the higher price of the Professional Edition to pay off.

Try before you buy

Before you purchase VueScan, you should check out the free trial version. It offers the full functionality of VueScan with only one restriction: the scanned pictures will bear a watermark. If you buy a license, you can unlock the installation at any time—there's no need to reinstall the program.*

This book refers to the Professional Edition of VueScan as this is the only edition that offers the full functionality. If you use the Standard Edition of VueScan, just skip the parts that deal with color management and raw scanning.

Especially if you are going to use exotic filmholders with your scanner, you should try out VueScan and make sure that it fully supports them. At the very least, run the software before you buy it to make sure it matches your expectations.

Program Version - Shows the current program version of Vuescan

Preview/Scan Panel - Here you switch between Preview and Scan forecast

Menu Bar - The menu bar offers some exclusive options that are not available via tab section

Option Tabs - This is the main control center of VueScan; here you can handle all data input, datan output and processing options

Graph display - Here you can check the graph, curves, and image histogram of the current scan

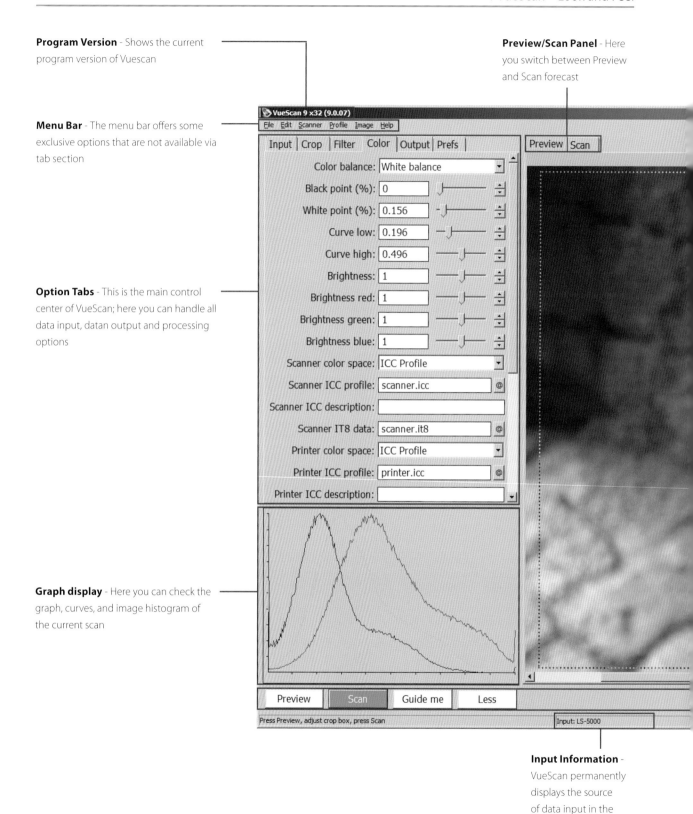

Input Information - VueScan permanently displays the source of data input in the bottom line of the GUI

Output: 2419x1949 pixels 472 dpi 130x105 mm 0 MB

Buttons - The buttons speed up frequent tasks

Output Information - Absolute pixels, relative pixels, image dimensions and output file size are displayed here

1.3 VueScan GUI

The user interface of VueScan can be perceived either as very user friendly or as extremely confusing. This depends not only on the settings you make, but also on your degree of familiarity with the software. The main concept behind VueScan is simple and easy to understand. VueScan is pure scanning software: it helps you convert analog images into digital image files. VueScan focuses mainly on scanning; for image post-processing, you need image editing software like Photoshop. Some basic image editing options, e.g., unsharp masking, are available in the GUI of VueScan as well.*

The sheer number of configuration options in VueScan can drive beginners to desperation, which is probably why different user modes were introduced some years ago. You can switch between them with the buttons at the lower left of the VueScan window.

Guide me – Beginner's mode

The easiest option for beginners is the `Guide me` mode. Here the program will lead you step-by-step through the different scanning options. For example, if you want to scan a slide, the software will propose the following settings that you can change if you want: **Input** ▶ **Task** ▶ *Scan to file*, **Input** ▶ **Media** ▶ *Slide film*, **Input** ▶ **Quality** ▶ *Archive*, and **Crop** ▶ **Crop size** ▶ *Manual*. For every setting, there is short explanatory text that provides the necessary information. You cannot choose a file type; the scan will be saved as a JPEG. All in all, `Guide me` mode is a nice door opener for your first steps in scanning. Sooner or later, when you need more control over the configuration settings, you will want to switch over to `Advanced` mode. There are actually two advanced modes to choose from, `More` and `Less`.

Advanced/Less – Extended mode

The `Advanced` mode can be overwhelming when you first switch into it, as there are so many different options. You can reduce the display to the most common options by pressing the `Less` button. This mode is convenient if you want to combine good configuration control with an easily manageable interface. To display all of the options, you must switch over to `More`.

Advanced/More – Full display of all options

You can display VueScan's full range of options in `Advanced` mode only when you select the option `More`. And this can be quite a lot, as you will see if you take a quick look at the **Prefs** tab! Even a 24-inch screen is too small to display all of the options without scrolling. But once you are familiar with the software, you can work easily with it. When you're scanning negatives and slides, this mode is recommended as it is the only mode where all filter options are displayed. For example, the **Filter** ▶ **Grain reduction** is found only in this mode. `Advanced` mode with `More` is simply the best choice for experienced users. Once you are familiar with VueScan, you should use it.

The variety of options in advanced mode can be confusing for the beginner. Start with `Guide me` first, and after you are familiar with that, switch over to `Advanced` mode. `Advanced` has the options `Less` and `More`.

1.4 Dependencies – Automatic GUI changes

The concept behind VueScan is built upon pure logic. In contrast to other programs, VueScan is not a patchwork that grew over time; instead, it was created as a whole. It has a very lean design. There are no popups, just a single window that includes the whole functionality. The price you have to pay for this is an interface that changes dynamically according to your settings. For beginners who are not familiar with the software, this can be quite confusing. You can waste a lot of time searching for an option that magically seems to have disappeared—and when you give up searching, it may pop up again in the same mysterious manner.

But this happens for a good reason: The key principle behind the user interface is that options are only displayed when they do something useful. For instance, if you're scanning film, you won't see any options about descreening, and if you're scanning documents, you won't see any options about color balance.

Dependencies are the key factor

In fact, the VueScan concept is an extremely smart way to design a software interface. You just need to know how it works. The secret behind it is dependencies! This has nothing to do with the previously discussed user modes— `Guide me` and `Advanced`. The options you can choose from the graphical user interface (GUI) depend on your settings, and in most cases the GUI changes according to the different tasks you select. For example, go to `Input` tab and change `Task` ▸ *Scan to file* to `Task` ▸ *Make IT8 target*. You will see that the GUI flips and a lot of options disappear. This GUI change is a smart feature, as it keeps the GUI lean. It displays only the options that are useful for a certain task.

Frequent GUI changes

Even if you stay within a task, GUI changes may occur. For example, go to `Input tab` and set `Task` ▸ *Scan to file*. By default, there will be a `Quality` option (between `Media` and `Bits per pixel`). If you go below to `Scan resolution`, you will see that it is set to `Scan resolution` ▸ *Auto*. Change `Scan resolution` ▸ *Auto* to any scan resolution in the dropdown list, e.g., *2000 dpi*. You can see that the `Quality` button disappears immediately. As a matter of fact, there are GUI changes every time you switch back and forth in `Scan resolution` between *Custom*, *Auto*, and specific resolution settings (e.g., *2000 dpi*, but the numbers in the list depend on the scanner model).

To sum up: if you are searching for a specific option that seems to be missing in the software GUI, first check what `Task` you have set in `Input` tab. If that does not help, check the other chosen options as well. After doing a couple of scans in VueScan, you will soon be familiar with the concept. *

** If you want to get familiar with the interface of VueScan there is only way way to success: Use the software frequently and scan as many analog originals as you can. Once you understood the concept, the program is actually quite easy to handle. Despite its rich variety of options.*

The graphical user interface of VueScan can vary a lot depending on your individual settings. Per default the option Input ▶ Quality is visible and Input ▶ Scan resolution is set to *Auto* as you can see in the screenshot above.

If you change Input ▶ Scan resolution manually, the option Input ▶ Quality will disappear as if by magic. It will reappear only if you reset the Input ▶ Scan resolution to *Auto*.

1.5 Saving and restoring options

As previously described, it can be cumbersome to configure VueScan for your personal needs. It takes a lot of time to readjust the software, especially when you are scanning different templates. But VueScan provides a solution: you can save and load options quite conveniently. For example, if you scan negatives, slides, and paper documents, you can save each setting and simply load the correct option as needed. Configure VueScan according to your settings and save the settings separately for each template as an *.ini-file via File ▶ Save options. Be sure to name the files in a comprehensible way, e.g., *negative.ini*, *slide.ini*, and *paper-document.ini*. You can save the files anywhere on your computer, but the best choice is the VueScan folder. For Windows computers, this is usually *C:\VueScan*. Then you can load the settings by pressing F10 . In addition, all your *.ini files can be quickly loaded with one of the function keys—just save your options in the same folder as the *vuescan.ini* and the next time you start VueScan you'll see them in the File menu.

Reset to default values

If you get lost during customization, you might want to restore the original setup. By pressing File ▶ Default options, you can reset the program completely and start from scratch. But be aware that this will reset all your color management options as well.

You can load, save and reset all options in VueScan easily. It is recommendable to save *.ini files for the most common scantasks; this will speed up you workflow remarkably.

Initial Setup

The initial setup of scanning programs does not always get the attention it deserves. Many users just start scanning, and in many cases, less than optimal procedures produce less than optimal results. There is a better way: a proper one-time initial setup of VueScan and its parameters. It only takes a couple of minutes, and this small investment will definitely pay off in better scans. This chapter tells you what to do and what to avoid.

Contents

2.1 Download and setup

The first step in installing VueScan is to download it. You can download the trial version at any time from www.hamrick.com. You'll be presented with a [Download] button. Click it and follow the instructions next to this button. VueScan has both x32 (32-bit) and x64 (64-bit) versions on Windows, Mac OS X, and Linux. In most cases, you only need to click on the [Download] button and this will download the most appropriate version for your system. The web page detects the type of operating system you're using and whether it's a 32-bit or 64-bit operating system. The advantage of the x64 version is that it's faster, because the x64 programming model gives more processor registers and can process data in 64-bit chunks. However, some manufacturers don't provide 64-bit plugins—that's why you need to consult the *Supported Scanners* list on www.hamrick.com.

On Mac OS X, some older scanners need to use Rosetta with the x32 version because they only have PowerPC plugins—the *Supported Scanner* list will mention this if it's necessary. These include most scanners from Reflecta, PIE, Plustek, some older Canon scanners.

After the installation is finished, the first action is to start the program and to check if all scanners attached to you computer are available. If everything is up and running, this usually is given. Minor problems can occur if you started VueScan first and switched on the scanner after. In this case just restart VueScan, this will solve the problem.

In general it is wise to start VueScan after (!) switching the scanners on. Please keep in mind that the computer may need a few seconds to recognize the scanner. If this does not help, check the *Device Manager*. The scanners are listed in *Imaging Devices* on Windows. In case they are missing, install the original manufacturer's driver and/or software again, this will fix the problem. There is usually detailed scanner driver installation information in the VueScan *Supported Scanners* list. Once the scanners appear in the dropdown menu of **Input** ▸ **Source**, you are ready to start. By default, **Input** ▸ **Task** is set to *Scan to file*, the basic scanning operation.

Input tab dependencies

The chosen **Input** *option controls the subsequent tabs. The profiling options deserve a closer look, as any scanning system will benefit from profiling. Profiling ensures consistent color reproduction and is part of the basic setup. It should be done before the first scan. Please be aware that profiling is only supported in the Professional edition, not in the Standard edition.*

Input Task	What does it do?
Scan to file	Outputs an image file to the hard disk; this is basic scanning
Copy to printer	Sends image data directly to the printer - or better said the printer driver - without saving it on hard disk
Profile scanner	Creates a profile for the scanner
Profile printer	Creates a profile for the printer
Profile film	Creates a profile for a specific film
Make IT8 target	Prints out an IT8 target for printer profiling

VueScan offers a wide range of Input options in its interface. **Task** ▶ **Copy to printer** is very convenient when you use your scanner as a copier. VueScan will not store the scan, but send it immediately to the printer. Then your scanner works just like any copier.

You can either reset the default state for the complete program (1) or for each tab (2) individually. The option in the tabs only shows up, if you have changed the default configuration of this tab already.

2.2 Color management in a nutshell

Horseshoe chart and color spaces
A common way to visualize different color spaces is the so called horseshoe charts. The horseshoe symbolizes all colors and the triangle is the part of it that a certain color space is able to display. Just compare the horseshoe chart of sRGB with the chart for Adobe RGB. You will see that the triangle for sRGB is much smaller, as sRGB can display fewer colors than Adobe RGB.

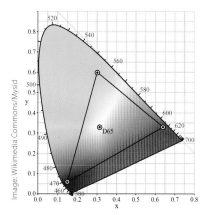

sRGB has the smallest gamut of all popular color spaces.

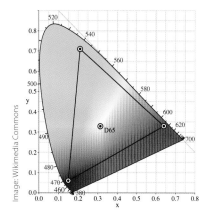

Adobe RGB has a much bigger gamut than sRGB.

A basic problem in digital image processing is that there is no absolute color definition across the entire workflow. In an ideal world, it would be possible to scan the color of the original accurately, display the scan on the monitor, and print it in true colors. Unfortunately, the current workflow cannot do that. The various links in the chain of digital processes each represent colors in different ways.

The most common term in color management is "color space". A color space describes a range of colors. The most popular color spaces nowadays are sRGB and Adobe RGB. The main difference between color spaces is the gamut. The gamut of sRGB is smaller than Adobe RGB. In general, a bigger gamut is better. You can display more colors with a bigger gamut, and clipped images are less likely to occur than with a smaller gamut. There is only one problem with a bigger gamut: most devices are unable to display its colors! The gamut of a good DSLR is much bigger than the gamut of the best monitor you can probably afford. It can capture even more colors than a top-notch inkjet printer can display.

Most modern color spaces are designed for a monitor gamma of 2.2. In the old days, Apple promoted a gamma of 1.8, but this is history. By default, Mac OS now works with gamma 2.2 like any Windows system. But color spaces with a gamma of 1.8, e.g., ECI RGB and ProPhoto RGB, still remain popular.

Every hardware device has its own device-dependent color space. The devices of a standard scanning workflow are the scanner itself, the monitor, and the printer. The scan program and image editor are part of the workflow as well. Each hardware device displays a different range of colors. In VueScan, the internal color space of the scanner is called Scanner RGB. This describes the colors that a specific scanner can read. The gamut of Scanner RGB is different with different scanners; it is not standardized. Neither a monitor nor a printer can display the colors of Scanner RGB. There is an unmanageable variety of devices and device-dependent color spaces.

Device-independent color spaces allow consistent data exchange among applications, e.g., between your scan application and image editor. The image editor (like Photoshop) works internally with a standardized device-independent color space, e.g., sRGB or Adobe RGB. That means you have to convert the device-specific Scanner RGB into a device-independent color space to enable a consistent workflow.

The RAW file of VueScan is never (!) transformed into any color space. But you can configure a color space in **Color** ▶ **Output color space** for your JPEGs and TIFFs. This is where you define the color spaces of the output files and convert the device-dependent color space of your RAW scans into a device-independent color space like sRGB or Adobe RGB.

The default setting of **Color** ▶ **Output color space** is sRGB. This is the smallest device-independent color space, and there are many advantages if you stick with it. First of all, nearly every device can cover it.

Even standard monitors nowadays can display sRGB, and printers cover the gamut of sRGB as well. Most image editors and image viewers run, at least by default, in sRGB mode. Thus you achieve maximum compatibility. sRGB images look nice even when displayed on standard hardware like mobile phones or when viewed over the Internet via a browser.

But from the technical point of view, sRGB is nothing more than the lowest common denominator. Yes, it is convenient, but most devices can display a wider range of colors than sRGB has to offer. If you own a top-notch monitor that is designed to display high-quality photography, it can display larger color spaces than sRGB. sRGB is obsolete in this category, as a good monitor can display the full color space of Adobe RGB with ease. If you run a high-end monitor like this with sRGB, it's like fueling a Jaguar with a two-stroke mixture. A good printer covers more than sRGB as well, which is why Adobe RGB and not sRGB is preferred in the prepress industry.

In theory, a bigger gamut is always better. You can display more colors, and image editing will less likely lead to clipping than with a small gamut. But if you own a good monitor and a good printer and switch from sRGB to Adobe RGB, you will also face the downside of the bigger gamut. Sure, your pictures on your own super screen and your prints from your own printer will look awesome. But if you give your scanned images to a photographic laboratory, the resulting prints may look quite dull if the lab works with sRGB. The fact that Adobe RGB is widely distributed in the prepress industry does not guarantee that every company printing pictures actually uses Adobe RGB!

Similarly, the pictures that look perfectly colored and rich in contrast on your own super screen with Adobe RGB can look quite shabby on the laptop of your neighbor who only has sRGB. You can experience the same effect if you open those pictures on your own computer with an application that does not support color management, like some simple image editors. Color management in Internet browsers is still in its fledgling stages. You can't blame Adobe RGB for any of these effects, but the limitations of many devices out there can cause trouble when you work with any color space bigger than sRGB.

There are workarounds, like working with a wider gamut color space internally (e.g., ProPhoto is much wider than even Adobe RGB) and still using sRGB for the final image output. All in all, using wider color spaces requires time, attention, and expert knowledge of the current technology. The wider the color space, the better the potential image quality—but also the bigger the potential problems, especially when using the pictures for the Internet. There is a bon mot that hits the nail on the head: use Adobe RGB or any other big gamut color space only if you know exactly what you are doing! If you have to ask, you are better off using sRGB. The most common alternative to sRGB is Adobe RGB, which has a bigger tonal range and is widely distributed. Plus, you can display Adobe RGB on your monitor—if you own a very good one. ECI RGB and ProPhoto RGB are even bigger than Adobe RGB; choose them for maximum image quality, but compatibility will definitely be an issue.

Controlling gamut in VueScan
You can use the `Color` ▸ `Pixel col-ors` *option to show if any colors are outside the range (gamut) of the selected color space. If you're scanning pictures of ordinary scenes, you might be surprised to see that sRGB works fine with the images you're scanning. By default, the pixels that are outside the gamut of the color space will be displayed by VueScan in cyan (light blue).*

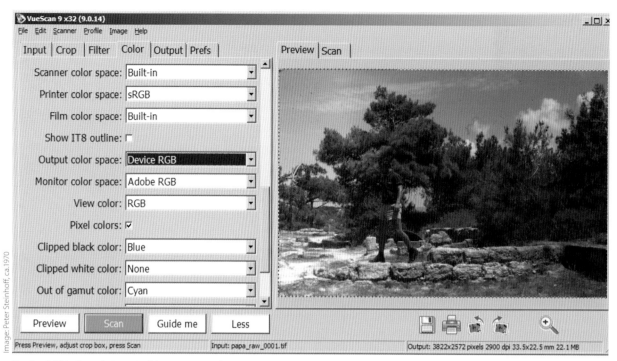

Device RGB is the color space of the scanner, in this case a Nikon Coolscan 5000 film scanner. Here you will have no colors that are out of gamut, because the the color space of the scanner covers all colors the scanning process delivers.

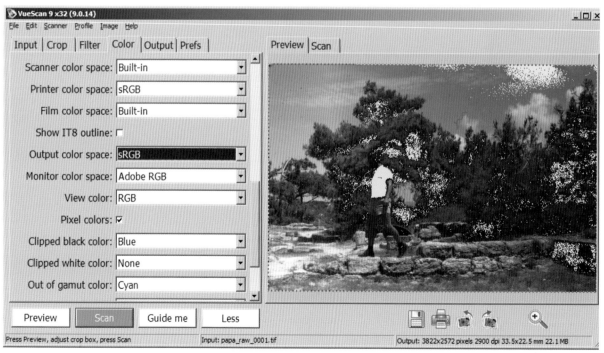

sRGB is a widely distributed color space, but it has one major disadvantage. Its gamut is very limited. Large parts of this Kodachrome scan are out of gamut as you can see by the cyan marking.

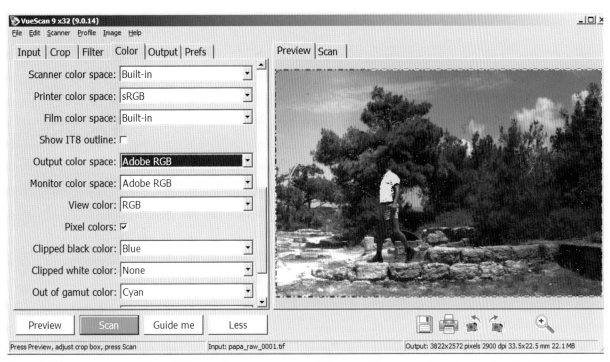

Adobe RGB has a bigger gamut than *sRGB*, but still it can not cover the full gamut of the scanner. At least you reduce the loss of image information compared to the *sRGB* setting.

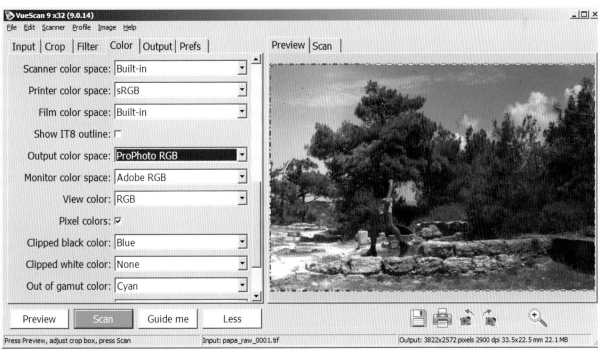

The extremely large gamut of *ProPhoto RGB* can cover the full gamut of the original scan. As you can see there is no out of gamut color here. *Ekta Space* will lead to the same result.

2.3 Defining monitor color space

Without a calibrated monitor, image editing can be almost impossible. It can be difficult to judge whether you are trying to correct a flaw in the image file or whether you are being misled by an erroneous monitor display. There are various hardware and software tools for monitor calibration. Hardware-based tools consist of a measuring device and special software. In the case of software tools, the human eye serves as the measuring device.

Sofware vs. hardware calibration

Truly accurate results are only possible with a hardware tool. Such a tool measures screen colors, compares them with nominal values, and calculates the ICC profile from the differences. For consistent quality, calibration and profiling should be repeated monthly. Software solutions rely on your eye. Their calibration methods are far less accurate than hardware calibration methods, since the color adaptation of eye and brain depends on ambient lighting conditions. Color and contrast adjustments are done directly on the monitor's controls without generating an ICC profile. If you don't want to spend the money for a hardware-based calibration tool, you can at least improve some settings with a software tool.

Monitor color space

The monitor color space defines how your monitor displays colors in the VueScan window. Please be aware that this setting does not affect the image display in other applications. You define it in `Color` ▶ `Monitor color space`. VueScan offers a row of options ranging from individual ICC profiles to device-independent color spaces like sRGB, Adobe RGB, Prophoto RGB, and ECI RGB. sRGB is acceptable as a default setting in case you have no profile for your monitor. But in general, you should avoid device-independent color spaces here. Since a monitor is a hardware device with a device-dependent color space, it will not benefit from device-independent color spaces. You need a specific ICC profile for optimum results.

The best practice is to use a colorimeter (e.g., Gretag Macbeth, La-Cie, or Datacolor) to measure your screen individually. You will have to tell the profiling software the color temperature of your screen (e.g., 6500° Kelvin) and the gamma of your color space (usually 2.2). You may be able to download an ICC profile for your monitor model from the manufacturer's homepage. This kind of service is sometimes supplied for more expensive monitors. However, the better alternative is an individually created ICC profile. The colorimeter will measure the color display exactly, and you can use this information to create an ICC profile that aligns current values with desired values. Occasionally you should create a new monitor profile; the color display may change over time.

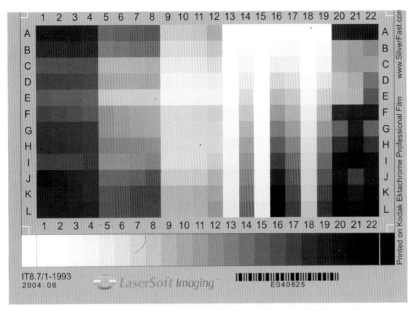

This is a scan by a Nikon Coolscan 5000 scanner that has not been profiled, yet. The green color cast is clearly visible, overall the color reproduction is far from being accurate. An ICC profile is needed to improve scanning quality.

This is another scan with the same Nikon Coolscan 5000, but this time it has been profiled with an IT8 slide and VueScan. Now the colors are much more neutral; overall the scan quality has improved.

2.4 Scanner profiling for positives

The scanner is the most important device in the scanning process. With profiling, you can improve accuracy of color reproduction under certain conditions. First of all, the procedure is designed for positive originals exclusively. It will help you in scanning prints or slides, both black-and-white and color. For negatives, scanner profiling will not have the desired effect.

For scanner profiling, you will need VueScan Professional Edition and an IT8 target—more precisely, one IT8 reflective target (IT8 print) and one IT8 transmissive target (IT8 slide). These are standardized targets that will help you align the scanner's color reproduction to the desired standard.

1. Insert the IT8 target in the scanner tray.
2. Set **Input** ▸ **Task** ▸ *Profile scanner*.
3. Press `Preview`.
4. Rotate the image if needed. If it needs mirroring, flip the original and perform `Preview` again.
5. Adjust the crop manually until the VueScan grid matches the color fields of the target.
6. If the target is skewed, align it properly on the tray and repeat `Preview`. Do not (!) use the skewing option of **Input** tab.
7. Go to **Color** ▸ **Scanner IT8 data** and tell VueScan where it can find the IT8 description file on your hard disk. This file is usually shipped with the target and should be saved in the VueScan folder for convenience. IT8 data can have the file extensions *.it8*, *.q60* or *.txt*.
8. If you have no IT8 description file, get one! The correct file is crucial for the profiling process. Zoom into `Preview`; at the bottom edge, you will see a number (e.g., *E070409*) that you can use to google a matching IT8 file, or you can directly check the manufacturer's website for it.
9. Set **Color** ▸ **Scanner color space** ▸ **ICC profile**. By default, the profile is called *scanner.icc*. Rename it if you use more than one scanner (e.g., *canoscan8800F.icc*) and store it in the VueScan folder for convenience. This will help you to align a scanner and its profile properly even if you're using several scanners at the same time.
10. Go to the menu and execute **Profile** ▸ **Profile scanner**. This will create the profile file and store it at the chosen folder with the appropriate name.

That's it—the scanner profiling process is complete. VueScan will automatically switch among profiles when you are using different scanners. It even notices the difference between reflectives and transparencies. You will need to profile your scanners for reflectives and transparencies separately. If you want to further fine tune the profiles, there are different targets not only for different film brands (Kodak, Fuji) but also for different film types (Kodak Ektachrome, Kodachrome, Fuji Velvia, Fuji Sensia, etc.). But owning a row of targets for all possible circumstances is an expensive affair.

You will not need a colorimeter for the
creation of a printer profile. VueScan will use
any flatbed scanner for this task.

For the creation of a quality monitor profile you need a colorimeter. At a later stage, you can embed the created profile in VueScan.

2.5 Desired vs. actual colors: Scanner profiling

IT8 has its limits; it is not a universal cure. It shows the desired effect only with good scanners. Cheap scanners with trashy color reproduction do not profit from profiling, since colors will still mismatch due to hardware limitations. Even with a good scanner, an expensive IT8 target, and proper profiling, the colors will not be as perfect as you might expect—especially if you are used to the quality standards of modern digital photography. Scanning is an analog-to-digital conversion with all of the inherent restrictions. To demonstrate this, check the desired and the actual colors after profiling. The example below refers to a Nikon Coolscan 5000, one of the best desktop film scanners:

1. Set **Input** ▸ **Task** ▸ *Make IT8 target*.
2. Press `Preview` button.
3. Move your mouse over the white rectangle in the lower left corner.
4. The status information in the VueScan footer will show *Output: 255 255 255*. These are the RGB values for this field; it is pure white with no color cast. The three color channels are perfectly balanced, and the values for each color channel are the same even when you move the mouse back and forth within the field. This is how it should be, and this is the desired effect of scanner profiling. Now compare this with the actual effect of profiling. For the subsequent workflow, it is mandatory that the scanner has already been profiled.
5. Insert your IT8 target and press `Preview` to scan the original. Then set **Input** ▸ **Task** to *Scan to file*.
6. Move the mouse over the white rectangle. The RGB values will change between different parts of the rectangle. Almost every pixel will have a different RGB value. For a profiled Nikon Coolscan 5000, the range on the slide can be between *255/255/246* and *245/250/234*.

Compare these values with the targeted values of *255/255/255* from above. Almost every pixel has a different color, but this is not too surprising. Film surface is never consistently colored due to film grain. Another fact is far more significant: the color channels are not balanced! They should have all the same values; instead, the red, green, and blue channels vary significantly, even after scanner profiling!

Before and after profiling

While this may sound disturbing at first, a look at the unprofiled image will nevertheless show the benefits of profiling. Switch **Color** ▸ **Scanner color space** to *Built-in* for the effect. You will see that the color channels are even more disparate, with RGB values e.g. of *252/242/232*. So the range between the color channels is remarkably bigger than those after scanner profiling. The overall image impression is that the Built-in profile results in images with a visible color cast. The image with the custom profile looks more neutral, even though it is far from perfect. All in all, scanner profiling visibly improves the image and is worth the effort. For color slides it is a must, for reflectives it is recommended as well.

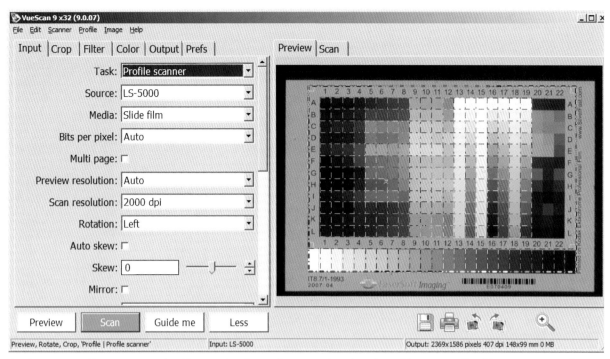

For the scanner calibration you need an IT8 target. VueScan will compare the color values of the raw scan file of this target with a reference file to correct color deviance. Then VueScan can create an ICC profile.

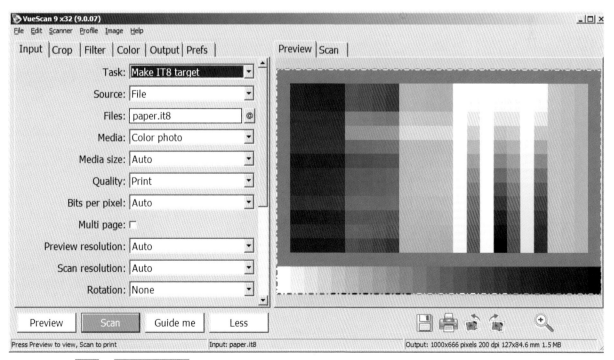

Use the option Task ▶ Make IT8 target to create an IT8 reference image for printer calibration. As a nice side effect you have a test picture that helps you to estimate the effect of different color management settings easily on your screen.

2.6 Printer profiling for true color output

While scanner profiling is complex, it is nothing compared to printer profiling. The quality of a printed image depends on a variety of factors such as the image file itself, its color space, the printer driver, the printer model, the paper brand, and the ink, to name a few. If you are printing from VueScan, however, you can implement a printer profile with little effort. Just be aware that every time you change paper or ink, you should create a new profile. Actually it is not a printer profile, but a profile for printer model + specific paper + specific ink!

Before you profile your printer, you must profile your scanner. This is mandatory, as you will need the scanner profile to create the printer profile.

1. Set **Input** ▶ **Task** ▶ *Make IT8 target*. This will read out the image data of an IT8 target file.
2. Press ⌈Scan⌋. This will open the print dialogue.
3. Print the image with your printer. Do not touch any color management options on the printer driver—neither now nor later!
4. Take the print of the IT8 image out of the printer and put it into the scanner.
5. Set **Input** ▶ **Task** ▶ *Profile printer*.
6. Press ⌈Preview⌋ and adjust the the grid to the image (same procedure as scanner calibration).
7. Rotate the image if needed to align it to the grid. If it is skewed, readjust the print in the scan tray and repeat the ⌈Preview⌋. Do not use the skewing option in **Input** tab.
8. Define the desired output path and file name of the ICC profile in **Color** ▶ **Printer ICC profile**. There is no need to specify the IT8 description file at this time; VueScan will do this automatically.
9. Replace the default name (*printer.icc*) with a more informative one that contains the codes for your printer model, paper, and ink (like *HP-H470WBT_C7040A_C9369E.icc*). If you always use the same printer model with the same paper and the same ink, you can simply keep the default name.
10. Execute Profile ▶ Profile printer from the menu. This will write the new ICC profile to the hard disk.

Color management in practice

Color management is a hype thing. Once it was a topic for publishing houses exclusively; now everybody can buy IT8 targets and calibration devices for comparatively little money. Keep in mind that profiling is just one of many steps on the way to a good scan. You will still have to do a lot of manual post-processing. Let's get things into perspective: if you have no IT8 targets on hand, downloading scanner profiles from the Internet is a feasible alternative and not a reason to postpone your scanning project.

Film profiling for color negatives

The ability to create film profiles with little effort is a remarkable feature of VueScan. This is not (!) an option for vintage films, as you would need to take a picture of an IT8 target with the film you want to profile. The method works only for fresh rolls of film that are still in your camera. If you are still shooting film, film profiling comes in handy. It's a good way to achieve true colors with notoriously difficult color negative films. Profile your scanner before you start creating your film profile.

1. Take a picture of an IT8 target. This can be a reflective or even better a slide. For a picture of a 35mm slide, you will need a slide duplicator. For a $8^{1/2}$" x 11" IT8 reflective, any standard zoom lens will do the job. Ensure that your camera is aligned at a right angle to the target to avoid perspective distortion. Use a lens with minimal distortion that will retain the proportions of the original, like a 50 mm lens.
2. Develop the film and get the negatives.
3. Set **Input** ▸ **Task** ▸ *Profile film* and **Media** to color negative.
4. Insert the negative or slide with the IT8 picture in the scanner and press the `Preview` button.
5. Rotate the image if needed according to the grid. Avoid skewing via the **Input** tab; reposition the original instead and repeat `Preview`.
6. Adjust the crop size and align it to the fields of the IT8 image.
7. Get the IT8 description file for the IT8 target (compare scanner profiling) and copy it into the VueScan folder. Rename it to *film.it8*. (You can give it a different name, but first you must reconfigure the name in **Color** ▸ **Film IT8 data**).
8. If you execute **Profile** ▸ **Profile film** from the drop down menu (!), VueScan creates the file *film.icc* and saves it to the same location as *vuescan.ini* (usually c:\VueScan). You can use a more reasonable name (e.g., *Kodak_Gold400.icc*) if you reconfigure **Color** ▸ **Film ICC profile** accordingly. Alternatively, use **Color** ▸ **Film ICC description**.
9. Since film changes over time, a fresh roll of a specific film will not have the same colors as the same film that was developed 10 years ago. That is the reason why film profiles are a big help but not a universal cure for the problems of converting color negatives.

Embedding existing ICC profiles

You can skip the entire time consuming profiling process if you have ICC profiles already. Just save the existing profiles on your hard disk and configure the options **Color** ▸ **Scanner ICC Profile**, **Color** ▸ **Printer ICC profile**, and **Color** ▸ **Film ICC profile** accordingly. In general it is recommended to renew profiles from time to time. But most modern scanners have LED lamps instead of the old fashioned fluorescent lamps now. And LEDs age less that fluorescent lamps. That means, you can use a scanner profile for a longer period of time. There is actually no need to create new scanner profiles every month or so like it was recommended in earlier times.

Color Space	Gamma	Color temperature	Remarks
Adobe RGB	2.2	6500 Kelvin	Widely distributed color space, good alternative to sRGB since 1998
Apple RGB	1.8	6500 Kelvin	Default setting of old Apple computers
Bruce RGB	2.2	6500 Kelvin	Small output-oriented color space from 1997
CIE RGB	--	--	Vintage color space, even older than NTSC
Colormatch RGB	1.8	5000 Kelvin	Similar to Apple RGB, but different color temperature
NTSC (1953)	2.2	--	Standard for analog TV in USA
PAL/SECAM	2.8	--	Standard for analog TV in Europe
SMPTE-C	2.2	6500 Kelvin	Successor of NTSC
sRGB	2.2	6500 Kelvin	Default setting for Windows computers
Wide Gamut RGB	2.2	5000 Kelvin	Second biggest color space, a further development but not a replacement for Adobe RGB
Ekta Space	2.2	5000 Kelvin	Covers (almost) the range of E6 slides
ProPhoto RGB	1.8	5000 Kelvin	Biggest color range at the moment, even bigger than Wide Gamut RGB
ECI RGB	1.8	5000 Kelvin	Big color space, popular for prepress

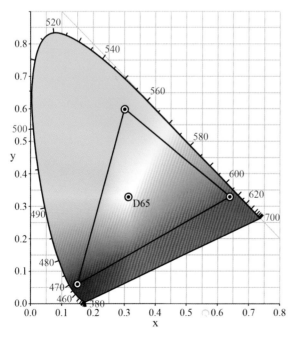

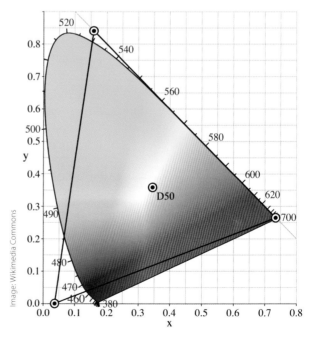

Image: Wikimedia Commons

sRGB has a comparable small gamut. Most devices like scanners, printers and monitors can display sRGB completely.

ProPhoto RGB has an extremely big gamut. There are very few if any devices available that can display ProPhoto RGB completely.

Resolution and Scanning

3

For a beginner, scanning can be quite confusing, as there are some technical terms involved. This is true even if you are an experienced digital photographer, as some things in the world of scanning simply work in a different way. Don't misunderstand me: if you want a quick scan, e.g., if you're using the application as a photocopier, just press a button and that's it. But if you have a more complex task at hand, e.g., if you're archiving your vintage slide collection, that's a completely different story. Then you should know the differences between terms such as spi (samples per inch), dpi (dots per inch), and ppi (pixels per inch). This chapter contains an overview of these basic scanning terms that will help you master the advanced features of VueScan with ease.

Contents

3.1 Talking about resolution: SPI, DPI, PPI, and absolute pixels

Checking image size
You can check the absolute size of a digital image easily in Windows Explorer, or Mac OS X. Just right click on the image file and choose Properties in Windows or Get Info in Mac OS X. In the Details tab you will find the absolute image dimensions. Since a digital image has two dimensions, you will see one pixel value for width and one value for height, e.g., 3008 x 2000 pixels. You will find information about the relative image resolution (e.g., 300 dpi) there as well. But information about the resulting output size from these parameters is missing. The image size information in Photoshop is better, because you can see that a digital image of 3008 x 2000 pixels at 300 dpi will have an output size of 10.027" x 6.67".

Let's begin this chapter with the most basic and most discussed term in the world of scanning: resolution. Despite all the public attention that the topic of resolution gets, there is unfortunately no such thing as "the" resolution of the scanner and/or the scanned image. Resolutions vary depending on what step of the procedure you are actually performing, and mixing them up can cause misunderstandings. However, you can easily avoid any confusion by taking a closer look at the topic.

The size of a digital image is alway defined by pixels. The pixel is the smallest component of any digital image. Pixel numbers are absolute values (e.g., a picture with a resolution of 1668 x 1790 pixels), but at the same time, pixels have limited information value. The reason is that different devices—monitor, printer, scanner—display pixels at different sizes. That is the reason, in most cases, why absolute pixel numbers are set in relation to linear dimensions, like inches (e.g., 300 pixels per inch). These relative values vary between different devices. It makes a huge difference whether an image is displayed on a computer screen or printed out.

3.2 SPI: Adjusting sampling quality

The first step in the scanning procedure is to put the item to be scanned into the scanner. Then you adjust the scanner setting for scan resolution. In VueScan, you will find the setting for scanning resolution on the Input tab. Scanning resolution is a relative value that you must set in relation to the size of the image. The measurement unit that VueScan uses here is dpi. Most scanning software and even scanner manufacturers use dpi in this context. Another common unit is ppi.

Scanning resolution in VueScan
Adjust the resolution of the scanner in Input ▸ Scan resolution *. Don't look for any spi values in the GUI of the program. VueScan uses dpi as this is the common denomination. In this book I will use spi for scanning resolution, as this is the correct and more precise denomination.*

SPI is the correct denomination

The correct unit, spi (samples per inch), is used much less frequently! From a technical point of view, spi is the most precise notation. The scanner will record samples from the image and generate pixels out of that. If it records 2000 samples (=pixels) per inch, the relative scanning resolution will be 2000 spi. The absolute pixel size of the scanned image will depend on the physical image size and scanning resolution.

Example: General calculation of scan sizes

You want to scan a 35mm slide that is 24 x 36 mm. Converted to inches, the size is 0.94" x 1.42" (rounded). With a scanning resolution of 2000 spi, the resulting file will be 1880 pixels (0.94" x 2000 spi) by 2840 pixels (1.42" x 2000 spi).

Determining the original size

Thus, the spi value can be used to determine the size of the scanned image. If you choose a low resolution, you will get a relatively small digital image. If you choose a higher resolution, you will get a relatively large digital image.

Selecting scanning resolution

Setting the correct scanning resolution is a crucial step. You cannot rescale a small scan later for a larger output size without a significant loss in quality. You can, of course, rescale a large scan for a smaller output size. But all in all, you should keep in mind that a scan is not a vector graphic. The quality of a vector graphic remains constant at all sizes, but the same is not true for scans. Upsizing a scan always leads to a loss in quality, and downsizing can have negative effects as well. For example, when you downscale a large scan to a smaller output size, the grain effect may be amplified. Due to this, the scanning resolution should match the desired output size. Then you will not need subsequent rescaling and you will avoid possible negative effects.

Avoid interpolated resolution

In any case, VueScan will only allow scanning up to the optical resolution of the scanner. Since it's a waste of time to scan at higher than the scanner's optical resolution, VueScan won't do this even if you specify a custom resolution. Note also that some scanners can scan at a higher resolution in the stepper motor direction than in the CCD direction. This leads to manufacturer's quoting resolutions of 2400 x 4800 dpi, when in reality the CCD only has enough pixels for 2400 dpi. One last trick manufacturers use is using a high-resolution CCD but low-quality optics. The optics of most flatbed scanners are seldom good enough for more than 1200 to 2400 dpi, so any resolution higher than this is just a waste of storage space.

Interpolated vs. optical vs. effective resolution

Scanner manufacturers know that they can impress their customers with large resolution numbers. For the popular Canon CanoScan 8800F, the interpolated resolution is 19200 spi. That sounds impressive, but scanning with this resolution will just create an unnecessarily bloated monsterfile with no gain in scanning quality. The more interesting value is the optical resolution; for the CanoScan 8800F, this is 4800 spi. At this setting, the scanner will deliver its maximum resolution. Of course, there is still a wide gap between optical resolution and effective resolution, as you can see for yourself with a USAF 1951 testchart. The effective resolution of the CanoScan 8800F is only 1600 spi. That's the maximum you can get when scanning with the full optical resolution of 4800 spi. So for the best scanning quality, you should use optical resolution.

3.3 DPI: Output size in print

When you finish making your scan, you will probably want to obtain a print of the digital image. Glossy photo prints usually require an inkjet printer as an output device. Inkjet technology generates images by propelling droplets of ink onto the paper, thus producing tiny dots on the surface. The image consists of these dots, and the resolution is displayed in dots per inch (dpi).

To achieve sufficient quality for magazine or book reproduction, you will usually need a resolution of 300 dpi. If it is a higher resoltion it will not hurt, but it is not needed. Consequently, your scan will need a resolution that matches the desired dpi output.

Example: Determining maximum print size

You have scanned a 35mm slide that is 24 x 36 mm at 2000 spi. The absolute size of the scan is 1880 x 2840 pixels. To determine the maximum possible print size, you need to know the relative resolution of the print. In this case it is 300 dpi, sufficient for magazine print quality. 1880 pixels equal a print size of 6.27" (1880 pixels/300 dpi), and 2840 pixels equal a print size of 9.47". Thus the maximum print size for a scan of 1880 x 2840 pixels is 6.27" x 9.47, or 15.93 x 24.05 centimeters.

Printing resolution in VueScan
Adjust the resolution of the print in Output ▶ Printed size. *Please keep in mind, that this configuration will not change the absolute size of your image and that many output devices will ignore it. For scanning purpose you can just set it to scan size.*

Printing smaller sizes is always possible, but if you exceed the maximum print size, you will get noticeably pixelized prints of inferior quality. Of course, you can enlarge your scanned images in Photoshop or with applications like PhotoZoom, but keep in mind that these programs have to interpolate the original image to blow it up to the new size. In general, interpolation is not ideal for the high picture quality, since interpolation algorithms only guess how a picture would look if it were larger.

3.4 PPI: Output size on screen

The most common way to view digital pictures is on a computer screen. Computer screens generate an image by displaying pixels. Accordingly, the resolution of a computer screen is indicated in pixels, and the relative resolution is indicated in pixels per inch (ppi). Common values for screen resolution are either 72 ppi (old screens) or 96 ppi (new screens), but neither is precise. There is no such thing as a fixed standard for screen resolution, so the actual ppi will vary. A screen that shows exactly 96 ppi is more the exception than the rule, but in general it will be somewhere around that value. The relative resolution of an average monitor is roughly one third of the printing resolution. If you compare a 300 dpi printout with a 96 ppi screen display, you will discover that the picture on the screen is about three times larger than the printout.

Screen size in VueScan
You can and will have to adjust the screen size resolution exactly in the same way as the print resolution. That means you choose a setting that is either for print or for screen display, you cannot have both in one file. But there is little practical use for a dedicated screen setting as many programs like Photoshop ignore this anyway.

Example: Determining output size on screen

You have a scan with a size of 1880 x 2840 pixels. Let's assume you have a screen resolution of 96 ppi. 1880 pixels equal a screen size of 19.58" (1880 pixels/96 ppi), and 2840 pixels equal a screen size of 29.58" (2840 pixels/96 ppi). The size on the screen is approximately three times larger than print size (300 dpi). Even though the scan in this example is from a relatively small 35 mm slide with only 2000 spi, it will exceed the dimensions of almost every customary screen in the trade. Most scans cannot be displayed on screen in 1:1 scale; they will be scaled down by the viewer application.

3.5 Relative output size does not matter: 300 dpi vs. 72 dpi

Relative resolution is a measurement unit that determines the output size of an image and sets it in relation to an inch of the output or input medium. In file properties of Windows, this relative resolution is stored as additional information. It looks like "horizontal resolution 300 dpi, vertical resolution 300 dpi". The relative resolution of an image file can be reset in image editing programs like Photoshop. Keep in mind that only the absolute resolution of the image determines its size (e.g., 2000 x 3008 pixels), not its relative resolution (e.g., 300 dpi). If you change a 300 dpi image file to a relative resolution of 72 dpi, it has no effect on the absolute image size or the pixel numbers.

The image will be recalculated only if you select the option Resample Image in Photoshop. Resampling is OK if you have to shrink an image, e.g., for mailing it to a friend. Avoid sampling an image at a larger size than the original, as you will gain nothing. In general, if you scan for archival purposes, you should avoid resampling. For example, if you want to scan an average 35mm slide for archival purposes, do so at 2000 spi. It does not really matter whether the relative resolution of the scan is set to 72, 300, or 2000 dpi in file properties. The only important value for picture quality is always the absolute number of pixels the file contains! The relative resolution value is ignored anyway for display in most viewer applications and for opening the image in Photoshop.

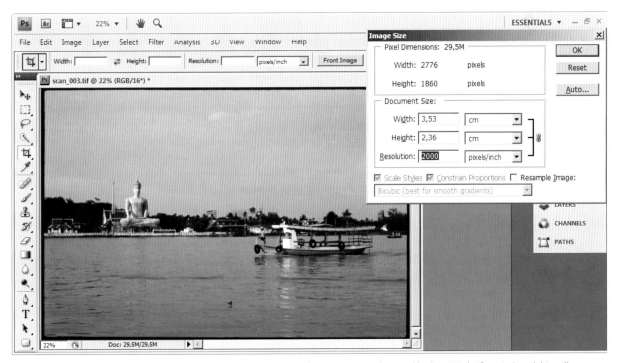

The relative resolution of this scan is 2000 pixels/inch. You can reconfigure it to any value you like (i.e. 300 dpi for print) and this will not affect the absolute image size of 2776 x 1860 pixel, unless you deliberately resample the image of course, but that is a different story.

A print needs more pixels per inch than a monitor display. For a print you need at least 300 dpi, while 72 dpi (sometimes up to 96 dpi, depending on the monitor) is sufficient for the screen. Just compare the difference of these two resolutions in print.

File Formats

VueScan offers a wide variety of formats for file output. Actually it has more options than any other scan program on the market. As a user, you get to pick the best from many different formats. This chapter shows you the pros and cons of every file format in detail.

Contents

4.1 RGB, grayscale, and infrared

VueScan's output options can only process the source data that the scanner itself produces. Thus it makes sense to take a closer look at the operating mode of scanners in order to understand and classify the different output options. Naturally, you have to be aware of the input side before you can discuss output options! Almost any scanner capable of full-color scanning has three different color channels according to the RGB model, similar to typical digital cameras. The three color channels are R for red, G for green, and B for blue. The output file format of a scan can be configured in the `Output` tab.

At this point, we are not (!) talking about output formats, but exclusively about internal color channels. The color depths of these color channels can indeed vary. Low-end scanners may still work internally with 8-bit color channels, but top-of-the-line scanners allow higher color depths. They may have 12-bit, 14-bit, or even 16-bit color channels. This is the internal data used by the scanner. But common output options for color scans are 8-bit or 16-bit only, e.g., as TIFF files.

8/16-bit vs. 24/48-bit

Unfortunately, there are no consistent naming conventions for color depth of image files, such as TIFFs. Sometimes people refer to the color depth of each color channel, like 8-bit or 16-bit; sometimes they refer to the combined color depth of all three channels in RGB mode. As there are three color channels, an 8-bit file (per channel) can be referred to as 24-bit as well (3 x 8-bit). Similarly, 16-bit color channels are sometimes referred to as 48-bit (3 x 16-bit). Although the 8/16-bit is used more frequently than the 24/48-bit, it really is a question of personal preference.

Better scanners have an additional infrared channel that is quite useful if you want to remove dust and scratches from slides or negatives. The information provided by the infrared channel is usually not visible to the user. As a matter of fact, most scanning programs on the market completely hide the infrared channel. They use infrared data only for removing scratches internally and don't usually store it.

VueScan leaves this decision to the user. With VueScan, you can store the infrared data together with the RGB data in a 64-bit RGBI file. Here you have the three color channels (3 x 16-bit = 48-bit) of a common RGB file plus the infrared channel (1 x 16-bit), which together equals 64-bit RGBI (48 + 16 = 64-bit). If you want, you can even save the output of the infrared channel for experimental use as a 16-bit infrared file.

Whatever you want to do with the scanner's internal data, VueScan provides a rich variety of output options ranging from 1-bit black-and-white to 64-bit RGBI. In particular, the different grayscale options can be quite handy. A grayscale image does not have different color channels because there is no color. There is only one channel containing luminance data. You should simply be aware of the fact that every conversion of the original scan data can lead to data loss.

Consequently, if you are scanning for archival purposes, you should at least choose an output option that equals the internal channels of the scanner.

Example:

You own a Nikon Coolscan V, that has a internal color depth of 14-bit and an infrared channel as well. In VueScan there is no 14-bit output option. You can choose either 8-bit or 16-bit. If you choose 8-bit TIFF (like 24-bit RGB) as the output format, you will loose color information but you will get comparably small files sizes. To keep full color information, better choose 16-bit TIFFs (48-bit RGB or 64-bit RGBI). The 48-bit RGB will be twice as large as in 8-bit mode, with the high 14-bits of each 16-bit sample holding the image data, and the low 2 bits filled with zero.

For every option you choose that is below the internal color depth, VueScan has to convert the scanned data. The most common case for this is grayscale. Usually the results of this conversion are satisfying, but keep in mind that a manual conversion in Photoshop with channel mixer can produce even better results.

To sum up: if you are quality conscious (and have sufficient hard disk space), you should try to save all of the data that the scanner can squeeze out of your original. If you want small file sizes and can accept some compromise in quality, use VueScan's downsizing options. All in all, it really depends on the quality of the originals.

Black-and-white scanners

Once in a while, you might find a vintage scanner that can scan only black-and-white. This is very rare, and you would not seriously want to use an old crock like that as a workhorse for productive scanning! Every current desktop scanner today processes colors, and RGB is standard.

Index file – All images in overview

An index print is a relic from analog times that fell partly into oblivion with the success of digital cameras. This was unjustified, as index prints are still quite useful for anyone dealing with analog images. Traditionally, an index print contained all of the images from a roll of film on a single sheet of paper. It's very handy, as you can get an overview of the contents of a film roll with a quick glance. Usually, index films are generated from negative film, but it is possible to have index prints from slide film as well. In **Output ▸ Index file** you can configure VueScan to generate index prints while scanning. You can also use other programs that produce index prints of collections of JPEG or TIFF images. This is possible with many image editing programs like Photoshop.

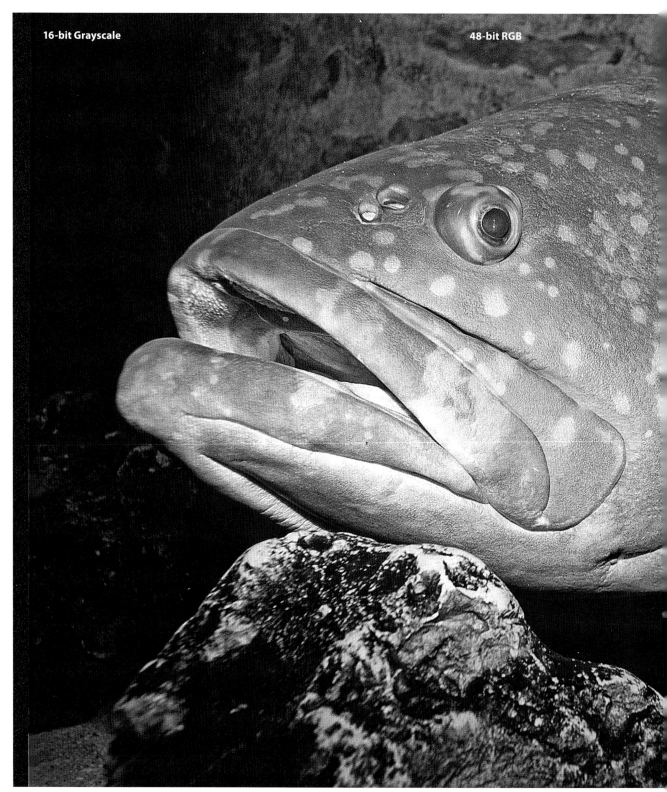

All modern scanners work with 48-bit color depth internally. VueScan can reduce this to grayscale or even to 1-bit B/W if needed. For color output the program has a wide range of options as well.

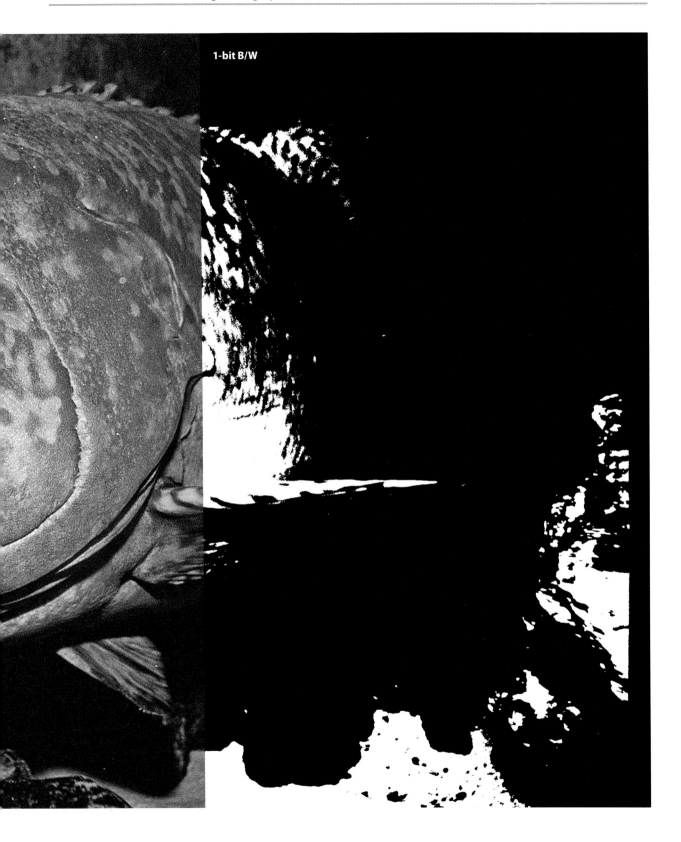

1-bit B/W

4.2 TIFF – Lossless but capacious

TIFF (Tagged Image File Format) is a file format that encompasses many internal formats, several compression methods, and color depths ranging from 1 bit to 32 bits per color channel. VueScan supports only a portion of these options. Still, you will have enough choices to cover all of your needs during the scanning process.

VueScan can store both raw files and processed images in TIFF files, as either **.tif* or **.dng* files. The difference between TIFF and DNG files is that DNG files have a few extra TIFF tags that are used by RAW file converters. The DNG format has two variants—one color per pixel or three (or 4) colors per pixel. Because scanners, by their nature, have three (or 4) colors per pixel, VueScan uses this format. All of Adobe's programs that read raw files can read VueScan's DNG, but Apple's Aperture only supports DNG files with one color per pixel at the moment.

TIFF (and DNG) files are used for both raw files and for color-corrected output files. The main difference is that the raw files contain the data that's received directly from the scanner, usually without any color correction, in the color space of the CCD in the scanner, and with a gamma of 1.0. The color-corrected output files are normally in the sRGB color space (other color spaces are possible with the Professional Edition) with a gamma of 2.2 or 1.8, depending on the color space. This means that if you use a normal image viewer to view the raw files, they will look dark - this is just an artifact of their using gamma 1.0. And that's the difference between 64-bit RGBI DNG-TIFF and raw-data DNG: The raw files have a gamma of 1.0 and the `Output ▸ TIFF file` has the gamma specified by the output color space (1.8 or 2.2).

Scanned TIFF files at 16 bits per color channel contain the maximum image information the scanner can produce. Since many scanners produce raw data with 12-bit or 14-bit color depth, storage space is not fully utilized with a 16-bit TIFF file. A 12-bit scan must be saved as a 16-bit TIFF, which is a waste of storage space. You will not face this problem with a scanner like the Coolscan 5000 that already works with 16-bit color depth internally.

Although VueScan has optional TIFF size reduction, TIFF is still a true lossless image format. The TIFF format does support compression for 1-bit, 8-bit and 16-bit samples, but if you're using 16-bit samples, this compression is only useful if your image has large areas of solid color (i.e. black or white). The 1-bit compression is the CCITT Group 3 fax compression, and results in very small file sizes. A TIFF file stores always the full image information. That's the biggest difference between TIFF and lossy formats like JPEG. JPEG compresses image information. Usually this compression is not visible, but for post-processing in an image editing program, lossy pictures are far from ideal. Even with TIFF, not all image editing programs support every variation. Due to this, it may be wise to dispense with more exotic features like multipage TIFF or compression options. From a quality point of view, TIFF is the best output format if you want to do image post-processing.

From a practical standpoint, the big file sizes can be quite a showstopper, especially if you scan in 48-bit or 64-bit. An average 35mm slide scanned at 4000 spi will have a file size of approximately 135 MB in 48-bit RGB as a TIFF. As a JPEG, it will be much smaller; even a low-compressed JPEG will not be much more than 4 MB.

To sum up: TIFF is a good lossless output format. But due to the large file sizes, it should be used with care. Use it whenever you need good quality and plan to do some post-processing in an external program, like tonal curve adjustments and so on. For scanning negatives and slides, TIFF is perfect, especially in 16-bit color depth. If you do not plan to do image post-processing, if you are short on storage space, or if you simply have scan templates that are of lower value (e.g. plain paper documents, JPEG or PDF format) can be the better choice.

Output ▶ TIFF multi page

This option allows you to combine several scans into a single TIFF file. It can be quite handy, but you should be aware that many image editing programs don't handle this option well. They will show you only the first page of the multi page TIFF, and that's it.

Output ▶ TIFF size reduction

Though TIFFs are great, they are simply too big for many purposes. One way to address this issue is VueScan's TIFF size reduction. This is a kind of downscaling. If you set it to factor three, it will convert a scan resolution of 5380 x 3608 pixels into a file size of 1795 x 1202 pixels. You can achieve the same TIFF size by simply configuring a lower resolution in the scan directly. However, TIFF size reduction can have a positive influence on image noise since this is an identical effect as multi-sampling. For instance, a TIFF size reduction of 2 will take each 2x2 block of pixels and output one pixel, which is equivalent to multi-scanning or multi-sampling each pixel 4 times.

Output ▶ TIFF compression

This option reduces the file size of TIFFs directly and has no effect on image quality or image size. According to VueScan, it can produce a file size reduction of up to 40%; in field use, we found it to be more like 25%. In some cases, the compression can even lead to the opposite effect and increase file size! Due to this, there are two recommended settings: *OFF*, which has no compression but achieves maximum compatibility; and *AUTO*, which VueScan activates only if compression will actually save space. At the end of the day, this setting will produce the smallest archives. The third setting, *ON*, is not advisable as it can produce even bigger files in some cases. Since most image editing programs can deal with compression, compatibility should generally not be an issue. But no compression delivers the best compatibility possible.

4.3 JPEG – Compressing images

JPEG (Joint Photographic Experts Group) is a format well known from digital cameras. It combines small file sizes with at least respectable quality and is very popular, especially with amateur photographers. But even professionals sometimes use JPEG; when small file sizes are important, JPEG is hard to beat.

JPEG is a lossy format

JPEG is by definition a lossy format. It will never (!) preserve the original data of the image. You get small filesize but you will pay by losing details. If you want to postprocess your pictures to some degree, a lossless format like TIFF may be the better choice.

The JPEG format uses compression, and in VueScan, you can configure the compression ratio yourself. This process reduces the raw data from the scanner to a fraction of its original size. When opened, the file is decompressed, and the image expands in RAM. The small file size has many advantages—more files fit on a data carrier, and files can be sent easily over the Internet. Furthermore, JPEG is a popular standard and is supported by practically all image viewers and editors. But it has one major flaw: with compression, some image quality gets lost permanently. Plus, it usually does not support 16-bit color depth, only 8-bit. The JPEG standard allows more than 8 bits per sample, but very few programs actually support this.

High compression results in visible quality decline

The amount of quality degradation depends on the chosen compression ratio. The smallest file size requires the highest compression, which in turn causes the greatest loss of detail. A JPEG file in digital photography can be compared to a print from a lab in analog photography. The quality of the result depends on many factors, most of which are out of your control. There are few possibilities to enhance the image afterwards; you have to accept it the way it is.

JPEG is poorly suited for processing in an image editor. If your goal is high image quality, JPEG should be used only at the very end of the image editing chain. It is fine for simple, quick scans; but if you want to post-process your images, you will quickly run into limitations and choose TIFF or even RAW instead.

Good choice for economical scanning

JPEG is always a good choice when scans need to be done economically. It is perfect for scanning large archives or when you have to ship your pictures over the internet. This is the reason why almost every scanning service uses JPEG by default. TIFF usually costs extra per scan. If you want to squeeze every last bit of information out the template and preserve it in digital form, you are better off with TIFF or RAW. For quick and economical scanning, JPEG is the better choice because it is smaller. And that's its sole key qualification anyway. JPEG is leading in filesize and wide compatibility. In any other discipline, TIFF and especially RAW are of higher value for the user. And there is one thing that you can reason from the wide distribution of JPEG: The majority of users are more interested in convenient handling than in good image quality.

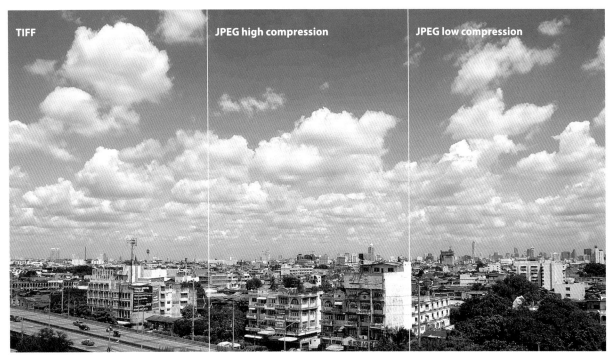

Strong JPEG compression will result in visible artifacts. TIFF will never have these kinds of artifacts, and with low JPEG compression the effect is so minimal, that you can hardly see it; not even when you are using a good screen.

JPEG 2000

Some years ago, there were rumors about a new file format that was expected to replace the old JPEG format within a short time. The name of the saviour was JPEG 2000 and it seemed to combine the image quality of JPEG with the small file sizes of the known JPEG format. JPEG 2000 uses file compression like its predecessor JPEG, but with a difference: The compression of JPEG 2000 is lossless! At least you can choose lossless compression with it, lossy compression is still possible if you need minimal file sizes. That means JPEG 2000 combines small file sizes and full image quality. But despite these nominal advantages, JPEG 2000 never really took off.

The old JPEG is still around, and JPEG 2000 is (at least for the mass market) as dead as the biggest platform that ever used the format in large scale. Just in case anybody remembers, that platform was Second Life. Neither Second Life nor JPEG 2000 no longer play a major role. Still, the format is far from being completely dead, as it survived in several niches in the market. Some companies that are providing large scale archival solutions are using JPEG 2000 as it helps them to save precious storage space. For the average user, the poor compatibility of JPEG 2000 is still an issue. Not even Photoshop can open JPEG 2000 files by default. You have to install a plugin first, and many viewers don't support it. Consequently there is no support for JPEG 2000 in VueScan. Just in case anybody wonders why it is missing.

4.4 PDF – Versatile document format

PDF or image file?

If you're going to do a couple of scans and you aren't sure about the planned purpose yet, stay on the safe side and scan everything in image file formats. You can alway convert the image files into PDFs later; converting PDFs to image files is less advisable.

PDF (Portable Document Format) is a document format, and that already describes what separates PDF from JPEG and TIFF. JPEG and TIFF are image formats that can store original digital images produced by your scanner. In contrast, PDF is a versatile document format that can store text, images, graphics, and more sophisticated things like interactive hyperlinks. While PDF documents can embed images, they should not be considered as full-fledged image repositories. You can extract embedded images out of PDFs later, but usually with limitations in picture quality. Storing full-size scans of your slides and negatives in PDF format is not a very elegant solution. There are better ways to utilize the specific benefits of PDF format. In general, if you are scanning negatives, slides, or photo prints for archival purposes, PDF is not recommended. A true image format like JPEG or TIFF is the better choice.

Facsimile vs. archival scanning

If you are scanning paper documents (or comparable media, like overhead transparencies) there are two ways of doing this, depending on the planned purpose of the scans. The first option would be to do facsimile scans; that would be a common choice if you want to preserve documents like historical certificates. This suitable if you are not only interested in the written content, but you also want to preserve the texture of the original as closely as possible. In this case you should do a high-resolution scan and save this into an image format, not into PDF.

The second option and a common alternative to facsimile scans would be archival scans. In this case you are more interested in the written content than in preserving the analog original 1:1. A common example for this, are old paper records you want to store in digital form for the future. In this case you will be happy to have a digital copy of the original letters or whatever. The convenience of use would be more important for you, than the last bit of image quality.

The perfect electronic document

And this is when PDF kicks in. If you scan a multipaged paper record and let VueScan convert it directly into a multipage-PDF, then you would just have one file from the whole record and you can easily flip through the digital copy with any PDF-reader (like Adobe Reader). If you use OCR, you can even convert the scan into computer readable text. Then you can even use search functionality or little helpers like Copy and Paste with the digital copy. Not to forget that printing of PDFs is quite fool-proof, you can exchange PDFs even with less experienced computer users conveniently. Note also that VueScan can do Optical Character Recognition (OCR) of each page in a PDF file, and output text over the image of each page. This makes the PDF files searchable on Windows and Mac OS X.

PDF is the perfect file type for paper documents. Set **Input** ▶ **Media** either to *Text* (for b/w documents) or to *Lineart* (for colored documents) for clean letter reproduction.

4.5 RAW files – Storing internal scanner data

Scanning in RAW format is a comparably new phenomenon, even though VueScan has supported that functionality for a couple of years already. Most people nowadays are used to RAW workflows from their digital cameras, but in scanning there are some differences. Here we will compare a traditional scanning workflow in VueScan with a RAW scanning workflow.

Traditional scanning workflow

Scan vs. camera RAW

Despite common file formats like DNG you should not mix up scan RAW with RAW files from digital cameras. RAW scans have features like an infrared channel that a RAW file from a camera never has.

A traditional (non-RAW) scanning workflow is quite simple. Select **Input** ▸ **Task** ▸ *Scan to file* and the name of your scanner model at **Input** ▸ **Source**. The result will be an image file like a JPEG or TIFF. You must decide several crucial things before scanning: do you need dust and scratch removal, and if so, to what degree? Do you need color restoration? Do you need to filter out grain? All of these choices will be hard coded into the image file, though the infrared channel is not stored. The maximum color depth of the resulting TIFF will be 48-bit.

This process is quite convenient, but it can be dangerous as well—especially when you do batch scanning. If you make a mistake in any of these options, you will have to rescan the slide. There is little room for corrections after you start the scan. Consequently, you need an experienced scan operator who will stay focused on the task to avoid errors.

As everybody knows, scanning is time-consuming, and as a result the traditional process is error-prone and laborious—at least when you want to achieve maximum quality. But if you are happy with VueScan's standard settings during simple tasks, e.g., when using it as a photocopier, you will probably not see any need for rescanning.

RAW scanning workflow

Whereas the traditional workflow is a one-way process, the RAW scanning workflow is a two-way process. First, you perform a standard scan, just as in the traditional workflow, with **Input** ▸ **Task** ▸ *Scan to file* and **Input** ▸ **Source** set to the scanner you use. The difference is in the output: instead of standard JPEG or TIFF, choose a RAW format like DNG. This way you can store the full 16-bit color depth of every color channel, plus the 16-bit infrared channel. A genuine RAW file contains the same information that the scanner uses internally. This results in a 64-bit file. You can choose other options if you don't need full quality. But if you are serious about RAW, you should not downscale but instead use all of the information supplied by the scanner internally! After you press the Scan button, the scanner will save the RAW file. This file can be processed via VueScan as well, but first you have to change a setting: Change **Input** ▸ **Source** to *File*. This allows you to do a kind of virtual scanning. By accessing the RAW file on the hard disk, VueScan can perform almost all of the actions that are usually only possible with the scanner.

RAW scanning from disk is fast

The biggest advantage of RAW scanning is that VueScan does not have to wait for the scanner; it imports the RAW file from the hard disk, which is a very fast process. Then you can jump between filter configurations with just a mouse click—e.g., it is extremely convenient to try out the various settings of `Filter` ▸ `Infrared Clean` without any holding time. All in all, RAW scanning is a good method if you want to separate the input operation from the processing.

Limitations of RAW

Choosing RAW files does not in and of itself guarantee good scanning results. The idea, "If I do some quick RAW scans, every configuration can be done in the second step," sounds too good to be true—and it is more wishful thinking than reality. You can compare it with RAW files from digital cameras. The best RAW format of a digital camera will not help you get a proper picture if you overexpose during shooting. For scanning, the situation is similar.

During scanning, you have to ensure that the RAW file actually contains the proper and complete data, starting with the scanning resolution itself. If you want to max out your scanner's quality reserves completely, use the optical resolution of the scanner if it is justified by the template. For a film scanner like a Nikon Coolscan 5000, this would be 4000 spi for a color slide. Check this setting on the `Input` tab. If you choose a setting like `Input` ▸ `Quality` ▸ *Email* by mistake, your RAW files will be tiny and of little use.

Always focus before you scan

The same thing can happen if there is anything wrong with the focus. Good filmscanners are able to focus and usually do this automatically, most flatbedscanners don't have this feature. In the menu `Scanner` ▸ `Focus` you can do it manually via shortcut `Ctrl`+`F` as well. There is a blinking focus point in the `Preview` tab. If you want to change its location, use `Crop` ▸ `Focus x offset` and `Crop` ▸ `Focus y offset`. Normally this is not an issue, but misconfigurations of the focus point can lead to unusable raw scans.

The crop itself is another potential source of error. If you accidentally crop a piece of the slide, it is lost. The automatic frame detection of VueScan helps minimize this risk, and it works quite reliably. But for difficult images, like low-contrast night shots, it's best to check the frame setting before scanning. Alternatively, you can enlarge the crop to cover the full preview window and crop later. That way you will not have to check cropping any more, but the file sizes of the scans will be significantly larger. Multi sampling, multi exposure, and color brightness are other options that you cannot simulate on the raw level. To make use of them, you must configure them before scanning.

Camera RAW in VueScan

VueScan can process RAW files from a number of different camera manufacturers, e.g., Canon, Nikon, Olympus, Pentax, Kodak, Fuji, and Sigma. That's a nice extra, but if you compare VueScan with programs like Adobe Lightroom or Apple Aperture, you will see that VueScan gets the short end of the stick when processing Camera Raw. VueScan uses the same dcraw.c code from Dave Coffin that most other raw converter programs use. But it has of course not the post processing abilities of dedicated programs like Adobe Lightroom or Apple Aperture..

4.6 DNG vs. RAW-TIFF

In VueScan, the RAW file option lets you choose between TIFF and DNG formats. DNG files are the same as TIFF files, but they have a few extra TIFF tags. When introducing the raw scanning feature, this RAW-TIFF was the first file format supported. It still is fully functional, but there are some disadvantages in daily use. First of all, in the explorer view on your hard disk, it is impossible to tell what a standard-TIFF and what a RAW-TIFF is. This might lead to some confusion unless you use file names that give a clue—try beginning file names of RAW-TIFF files with "RAW".

Viewing RAW-TIFF

** Display file extensions*

By default Windows systems nowadays hide file extensions. You have to enable the feature manually in the Folder options of Windows if you want to display the extensions.

Plus, if you display a RAW-TIFF via any picture viewer or Photoshop, it will look dull and much too dark. The reason for that is that raw files contain data straight from the CCD of the scanner, and the CCD uses gamma 1.0 (while normal TIFF files are gamma 2.2). You are better off, if you use the widely supported DNG format, since they assume gamma 1.0 and are then displayed properly. The file extension will help you to recognize RAW files in Explorer view*. Plus the DNG is displayed correctly in most image viewers, i.e. in Adobe Bridge. This allows you to flip through your DNG-RAW archives more conveniently than through RAW-TIFF. VueScan reads RAW-TIFF and DNG files identically, since internally they are actually almost identical—there are just a few extra TIFF tags in the DNG files.

Color depth in RAW

Last, but not least, you should be aware of the color depths you have to configure, no matter what file format you choose. A real RAW scan is 64-bit—48-bit from RGB and 16-bit from the infrared channel. There are some templates that do not profit from the infrared channel, like classic black-and-white negatives and prints. In those cases, you don't need the infrared channel. VueScan provides you with many additional options, from 1-bit black-and-white to grayscale and various RGB options—but all of them reduce the amount of information provided by the scanner. While this can be convenient and space-saving, it is no longer true RAW scanning.

How and when to use RAW

If you sum up the pros and cons of RAW scanning and compare it to traditional scanning, you will see that both methods are justified. RAW scanning is a good way to separate the physical input of data (within the above-described limitations) from the processing of data. For batch scanning, this is perfect. You can save a lot of energy during the scan itself and do most of the configuration retroactively.

RAW in daily use

But this convenience comes at a price. First, RAW scans are big by nature; second, you would need to produce another image file for every scan, as you cannot use the RAW file for direct editing. Traditional scanning is much leaner, even though it offers less flexibility. For scans where a fast workflow is more important than getting the best quality out of the original, scanning into (non-RAW) TIFF or JPEG is the smarter choice. It all depends on what you want to do, how much time and energy you want to invest, and your personal expectations in regards to quality.

Lightroom and Aperture

Adobe Lightroom and Apple Aperture have some very good tools for the comprehensive processing of RAW files. Lightroom can read the standardized DNG format used by VueScan, since Adobe's programmers implemented the full DNG specification. Apple's programmers didn't implement the full DNG specification, so Aperture can't read VueScan's DNG files.

But still, there are some limitations in the use you should be aware of. Specific scanning functionality, like Infrared Clean, is not (!) supported by RAW editing programs designed for Camera RAW. In this case, you would still have to use VueScan to perform dust and scratch removal—assuming that you stored the infrared channel during scanning. Consequently, Lightroom and Aperture cannot be regarded as complete alternatives to the workflow that uses VueScan for generating image files and Photoshop to process them. Scan RAW is not identical to Camera RAW!

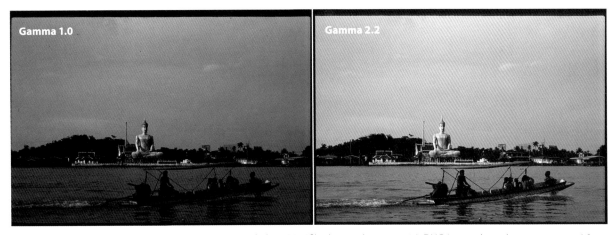

Most viewing applications display RAW-TIFF images too dark, as RAW files have only gamma 1.0. DNG-images have the same gamma 1.0 as RAW-TIFF, but most viewing appplications automatically detect DNG as a raw file and display it in gamma 2.2.

File size comparison (4000 spi scan of 35mm slide, 24 x 36 mm)

File Type	Color Depth	Infrared Channel	Compression/ Quality	Absolute Size (KB)	Absolute Size (MB)	Relative Size (%)
DNG (RAW)	48-bit RGB	16 bit	n/a	167,414	167,41	100,00%
TIFF	48-bit RGB	16 bit	OFF	165,337	165.34	98.76%
TIFF	48-bit RGB	16 bit	ON	125,538	125.54	74.99%
TIFF	48-bit RGB	--	OFF	125,568	125.57	75.00%
TIFF	48-bit RGB	--	ON	150,614	150.61	89.96%
TIFF	24-bit RGB	--	OFF	62,799	62.80	37.51%
TIFF	24-bit RGB	--	ON	46,673	46.67	27.88%
JPEG	24-bit RGB	--	100	17,187	17.19	10.27%
JPEG	24-bit RGB	--	75	2,342	2.34	1.40%
JPEG	24-bit RGB	--	50	1,391	1.39	0.83%
JPEG	24-bit RGB	--	25	798	0.80	0.48%
TIFF	16-bit Grayscale	--	OFF	41,861	41.86	25.00%
TIFF	16-bit Grayscale	--	ON	48,132	48.13	28.75%
TIFF	8-bit Grayscale	--	OFF	20,930	20.93	12.50%
TIFF	8-bit Grayscale	--	ON	13,256	13.26	7.92%
JPEG	JPEG black/ white	--	100	10,993	10.99	6.57%
JPEG	JPEG black/ white	--	75	1,969	1.97	1.18%
JPEG	JPEG black/ white	--	50	1,194	1.19	0.71%
JPEG	JPEG black/ white	--	25	678	0.68	0.40%
TIFF	1-bit black/ white	--	OFF	2,619	2.62	1.56%
TIFF	1-bit black/ white	--	ON	103	0.10	0.06%

The RAW file is the reference for all other file formats, as this is the full information the scanner uses internally.

■ In some cases, TIFF compression actually increases the file size instead of decreasing it.

Scanning Media Types

5

There is quite a range of media types in the world of scanning, and each has its own particular characteristics. First of all, it makes a big difference whether you are scanning reflective media, like paper documents, or transmissive media, like slides and negatives. While you can use any standard flatbed scanner for reflective media, transmissive media is more demanding: you will need a scanner with a transparency unit for this task.

But choosing different hardware is the easiest part of the job. If you dig deeper, you will soon find out that paper documents, newspapers, magazines, and photo prints may all be reflectives, but due to different printing technologies they have very different characteristics that require different scanning techniques. Regardless of the type of media you scan, one thing is for certain: VueScan has a specific configuration for it.

Contents

5.1 Transmissive media – Color slide (E6)

Film profiles for slides
Even though color slides are positive
images that don't usually need spe-
cific correction, VueScan offers some
film profiles for color slides, e.g., for
Kodak Ektachrome. These are de-
signed to achieve a realistic impres-
sion of the original scene. If you don't
use them, you will get a scan that
exactly reproduces the color charac-
teristics of the original slide. It's more
or less a question of personal taste.

Color slides offer the maximum obtainable image quality in a purely analog workflow. They offer more vivid images than color negatives, and their contrast range is higher as well. With color slides, the processing lab has little impact on the image result. As a photographer, you will most likely get the picture you actually took, and you will have good control over the final image. Film development for color slides is standardized by the E6 process; almost every lab that processes film can handle E6. For decades, these advantages made color slides the professional photographer's first choice.

Slides are superior to negatives because they have finer grain, more contrast, better color depth, and a much better density range. However, slides demand accurate exposure by the photographer, as there is little margin for error. Even a small exposure error will affect the image. In comparison, you have much more leeway with exposure when using color negative film.

In addition, slides make much greater demands on scanning hardware than negatives. For example, scanning slides using low-end scanners often leaves much to be desired, since such cheap scanners cannot typically handle the wide range of colors, contrast, and density inherent in slides.

Common scanning resolutions for color slides range between 2000 and 4000 spi. Higher resolutions demand not only a high-end scanner but also high-quality templates. If you have medium or large format slides, you can reduce the scanning resolution to avoid monster-sized files.

Still, if you have a good quality scanner, your scans of slides will be more brilliant than your scans of negatives. Due to their relatively fine grain, color slides are the perfect source material for poster-sized prints. Another big advantage of color slides is that they are positives. There's no need to invert color, and there's no orange mask as with color negatives. As a result, you can directly compare your scanned image to the original color slide.

With IT8 calibration, you can scan your slides with true colors as well. However, IT8 calibration does not automatically guarantee the perfect colors you might expect. It simply reproduces colors 1:1 from the original slide. If the original slide is faded or has a color cast, you will need to do some post-processing to achieve a presentable result, whether you use IT8 calibration or not.

This Fuji Velvia slide was used for the scans on the opposite page.

Pros and cons: E6 slide

- ⊕ Infrared-based dust and scratch removal possible
- ⊕ Most brilliant colors of any film type
- ⊕ High contrast
- ⊕ Fine grain, especially for low-density film
- ⊕ Insensitive to scratches on film surface
- ⊕ True color scanning with IT8 calibration possible
- ⊖ Good (that means unfortunately expensive) hardware needed for best scanning results
- ⊖ Exact exposure is mandatory when taking photos

This is a scan of a 35mm slide with a dedicated filmscanner Nikon Coolscan 5000. A true filmscanner like the Nikon has no glass supporting layer between its optics and the slide.

The scan with an Epson V750 shows remarkably less details and brillance than the film scanner. The flatbed scanner has a glass supporting layer between optics and slide. This is one key factor for the comparably inferior quality.

5.2 Transmissive media – Kodachrome slide (K14)

Kodachrome films are color transparency films that have been on the market for more than half a century. This is genuine vintage material, once the standard film for generations of press photographers. But Kodak has already stopped manufacturing this film; when the remaining stock is sold out, Kodachrome will not be available on the market.

Professional photographers benefitted from some special Kodachrome features that still cannot be matched by any other film. The colors are quite consistent throughout the Kodachrome family. For example, in a slideshow, you can easily mix Kodachrome 25, Kodachrome 64, and Kodachrome 200. When it comes to archiving, Kodachrome is also without equal. Kodachrome can be stored for decades and still maintain consistent colors. That sounds too good to be true, and there is another side of the coin. Kodachrome is very sensitive to light, so if you want to preserve it, store it in a dark, cool, dry location.

Kodachrome is in many ways a dinosaur. It could not be developed by the standard E6 process for color slides; it needed the special K14 process. You had to send your exposed Kodachrome film directly to Kodak for development. Nowadays, not even Kodak is developing Kodachrome any more. K14 is different in many ways from E6; you could say that Kodachrome is not genuine color film, but rather black-and-white film to which Kodak adds some colors. In fact, this difference in technology is something you need to take into account when scanning.

Standard infrared cleaning with Kodachrome is a different than with E6-slides. Usually Infrared Clean works fine even with Kodachrome. But there are some exceptions to the rule. If the film wasn't developed properly, it can still contain silver halides that will affect the filter in a negative way. While it will remove dust and scratches, it will also remove desired details due to the difference in film structure. Enable `Color` ▸ `Pixel colors` and you can survey the scratch detection sensitivity in VueScan and switch off Infrared Clean if needed. Kodachrome slides should not be scanned with an E6 profile. Use VueScan's Kodachrome film profiles; they will produce much more vivid colors.

Common scanning resolutions for Kodachrome slides range between 2000 and 4000 spi. Higher resolutions demand not only a high-end scanner but also high-quality templates. If you have medium or large format slides, you can reduce the scanning resolution to avoid monster-sized files. Keep in mind that Kodachrome in general needs good scanning equipment to deliver respectable results.

Image: Peter Steinhoff

This Kodachrome slide was used for the scans of the opposite page.

Pros and cons: K14 Kodachrome slide

➕ Characteristic colors throughout the Kodachrome family
➕ Fine grain, especially for Kodachrome 25 and 64
➕ Infrared-based dust and scratch removal is in general possible
➖ Most scanners do not support special dust and scratch removal needed for Kodachrome
➖ Sensitive to scratches on film surface
➖ Good scans only possible with expensive scanners
➖ Kodachrome dyes fade quickly when exposed to light—store in dark places!

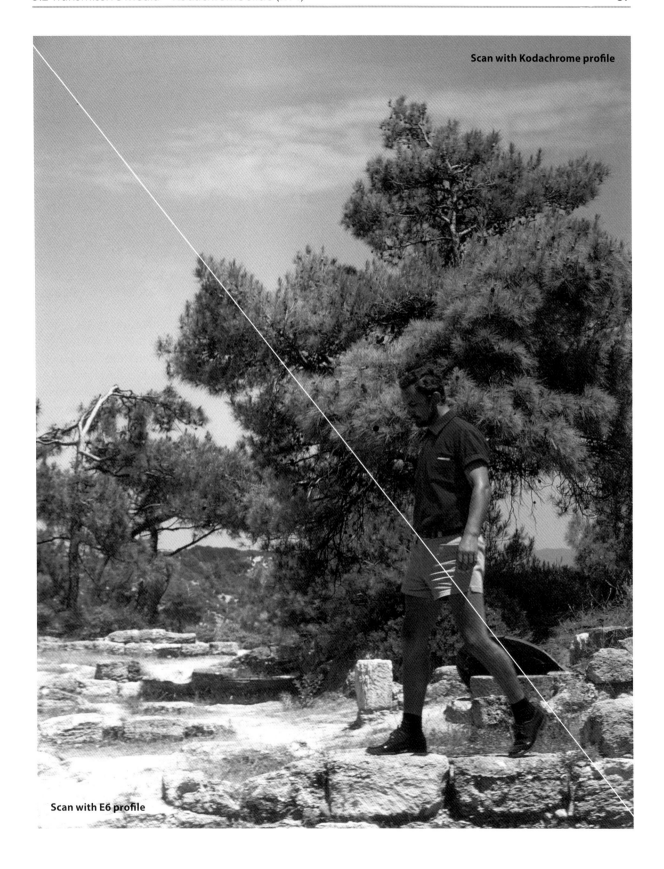

Scan with Kodachrome profile

Scan with E6 profile

5.3 Transmissive media – Color negative (C41)

Color negative film has been the most widespread film material for decades, at least for amateur photographers. In the past, there were a couple of good reasons to use these films. Now, though, if you want to convert your old color negatives into digital images, you will soon find out that they are a pain in the neck. This is mainly due to their orange mask. Of course, there are some workarounds to address this, but positive scan originals, like color slides, are much easier to handle than negatives.

Let's start with the positive points. Color negatives are not only quite cheap, but also quite robust regarding exposure. Even if you expose the film sloppily, you can still get usable photos back from the lab. Because of this, the quality of many old color negatives is quite good for scanning purposes.

Common scanning resolutions for color negatives range between 2000 and 4000 spi. If you have medium or large format negatives, you can reduce the scanning resolution to avoid monster-sized files.

Due to their comparably low dynamic range, even an inexpensive scanner can yield acceptable results when scanning color negatives. But for the same reason, the color and contrast of color negatives will never reach the level of good color slides. In addition, the film base of color negatives is relatively sensitive and susceptible to scratches. You can get good scans from color negatives only if you use a scanner with good infrared-based scratch removal.

A big issue when scanning color negatives is wrong colors. Keep in mind that IT8 calibration is for positive pictures only—it's useless for negatives. Negatives have an orange mask that makes it almost impossible to judge the original colors of the scenery. Just scanning and inverting the colors is not enough; removing the orange mask is the tricky part of the process. Since the characteristics of film emulsions are as manifold as the offerings of color negative films, there is no universal setting that fits every color negative original.

You will need a specific film profile for each color negative film type you want to scan. VueScan offers a big range of film profiles that covers most films on the market. But these film profiles will not automatically produce great colors in every case. Remember that film fades out and colors shift over time. All in all, it takes more effort to get proper colors from negative originals than from positive originals. Manual corrections in Photoshop are needed frequently.

This color negative was used for the scans on the opposite page.

Pros and cons: C41 Color negative

- ⊕ Infrared-based dust and scratch removal possible
- ⊕ Acceptable scan results even with inexpensive scanners
- ⊕ Tolerant against wrong exposure
- ⊖ Colors and contrast less vivid than color slides
- ⊖ Sensitive to scratches on film surface
- ⊖ Impossible to compare scanned image with original negative
- ⊖ Specific film profiles needed for each film type
- ⊖ Manual correction often needed in spite of film profiles

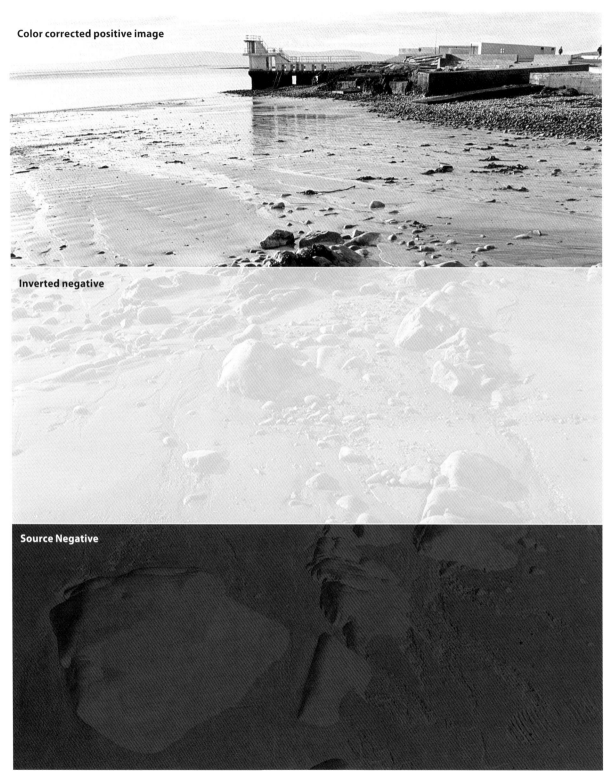

Color corrected positive image

Inverted negative

Source Negative

A simple inversion of the original negative will usually not bring the desired effect. Almost every negative film on the market has a colored mask, for a color negative it's usually orange colored. Use a film profile to convert the inverted negative into a presentable image.

5.4 Transmissive media – Black-and-white negative

Scanner lamps and B/W
Black-and-white film is quite picky concerning scanner lamps. Even expensive scanners like Nikon film scanners do not guarantee a good result. Nikon uses harsh LED light that's perfect for brilliant color slide reproduction. For black-and-white scans, old-fashioned fluorescent lamps—as used in vintage Polaroid Sprint Scan 120 scanners—are the better solution.

Common scanning resolutions for classic black-and-white negatives range between 2000 and 4000 spi. If you have medium or large format negatives, you can reduce the scanning resolution to avoid monster-sized files.

Black-and-white negative film has been around for ages. Ever since the first Leica camera hit the market in 1925, people have used black-and-white film in the same 35mm format we have today. Due to this, there are a lot of black-and-white pictures and negatives around. If you have some really old negatives, they will probably be black-and-white film. Scanning of these old and frequently worn originals requires a lot of manual work. As with color negatives, black-and-white negatives suffer from dust and scratches; but in this case, hardware-based scratch removal does not work at all. In fact, Infrared Clean actually decreases scan quality. The reason you can't use infrared light to find dust and scratches is that black and white negatives look exactly the same in visible light as infrared light. Silver particles look the same in both types of light. This is a general physical symptom that affects all scanning programs, not only VueScan. Other infrared-based dust and scratch removal software, e.g., Nikon's Digital ICE and Canon's FARE, struggle with the same problem. Due to this, automated dust and scatch removal is not possible with black-and-white film. You must correct abberations manually in Photoshop. This general rule applies to almost all black-and-white film—but, of course, there is no rule without an exception. The exception is chromogenic black-and-white film. This film contains no silver halides and instead uses a technology similar to color negatives. Chromogenic black-and-white film is processed in C41, the standard development process for color negatives.

Films like Ilford XP2 Super, Kodak BW400CN, Konica Monochrome VX400, Tura BW-C41, and Fujifilm Nexia Sepia are chromogenic. With these films, infrared-based dust and scratch removal is possible. Classic black-and-white films like Kodak T-Max, Ilford HP5, and Fujifilm Neopan are all silver-based, and VueScan's Infrared Clean will not work with them. Many black-and-white films have a masking layer that can lead to color casts if you scan in RGB. You can avoid color casts by scanning them as grayscale. VueScan offers specific film profiles for black-and-white films like Kodak T-Max 100/400/3200. Scanning black-and-white film is an elaborate process, as this film is designed for purely analog use. But apart from the retouching, it is more convenient to handle than color negatives. A missing film profile for a specific film can be tolerated easily. All in all, it's just black-and-white.

Pros and cons: Classic black-and-white negative

- ➕ Good scan results even with inexpensive scanners
- ➕ No color correction needed if scanned as grayscale
- ➖ Sensitive to scratches on film surface
- ➖ Infrared-based dust and scratch removal not possible
- ➖ Elaborate manual retouching often necessary

Black-and-white negatives can suffer heavily from dust and scratches. Especially when they are old and storage conditions are not ideal. The film surface is prone to damages of any kind.

Infrared clean works very well for this sample, but this is a rare exception for black-and-white film. This negative is from Ilford XP2 and that film is chromogenic. With classic black-and-white film like Kodak T-Max, Infrared clean can not work due to physical restrictions.

5.5 Reflective media – Paper documents

The overwhelming majority of documents from the analog age are simple paper documents. Analog archives may contain tons of paper sheets that have been written by hand, composed on electronic typewriters, or printed out with old-fashioned dot matrix printers, inkjet printers, and laser printers. If you want to scan these kinds of documents, first ask yourself these questions: are you interested in preserving the whole document as is, or do you just want to keep the written content and convert it into an electronic document? In the first case, you would scan the document at high resolution and in full color to reproduce it as precisely as possible. This scanned facsimile could be used for a reprinting that is true to the original.

Skipping color information for smaller files

In the second case, when you are only interested in the written content, you don't necessarily need high resolution and you usually won't need full RGB information. This will allow you to produce much smaller scan files. If you are scanning a couple of old letters, scan file size is not important. But if you are going to digitize an entire archive, scan file size will have a big effect on your budget and should be considered carefully.

Facsimile scanning is pretty much like picture scanning, but you need to invest more energy to convert analog text into computer-readable digital information. The method behind the conversion is OCR (Optical Character Recognition). It helps you to convert the image provided by the scanner into editable digital information. VueScan has a built-in OCR module that allows you to do OCR within the scanning program.

In general, OCR has reached a high level of text recognition over the years, thanks to improved algorithms and the sheer increase of processing power in computers. Now everybody with a standard computer can do text recognition at home. The method is not yet perfect; in particular, the recognition of handwritten text is a serious challenge for any OCR program, especially if the handwriting is messy. On the other hand, if you have a clean, laser-printed document that does not use unusual type fonts and that is written in English, you will have a very high recognition rate with minimal manual corrections. Exotic languages are more difficult to handle. But all in all, OCR is a convenient and well-engineered technology that covers most applications very well.

Common scanning resolutions for facsimile reproduction of paper documents are between 300 and 600 spi. You should scan RGB if you want to retain the original colors of the documents, including age-related discoloration. If you only want to convert analog text into digitized text, you can reduce the resolution and switch to grayscale. Avoid using full optical resolution on flatbed scanners for big templates like paper documents. You will produce gigabyte-sized files that will bring most computers to their limits without a significant gain in picture quality.

Pros and cons: Paper documents

⊕ Good scan results even with inexpensive scanners
⊕ OCR allows digital conversion of analog text without the need to retype everything
⊖ Paper does not have much latitude for enlargement, film is the superior analog medium

5.6 Reflective media – Scanning paper prints

In the analog age, paper prints were the most common way for photographers to display pictures. Usually pictures were taken on film; then a photographic laboratory developed the film and enlarged the comparatively small film pieces into larger paper prints. Therefore, the original picture is always on the film, and the paper print is just an analog copy. There are exceptions, like instant pictures (e.g., Polaroid and Fuji Instax), but in general you should have the original film in your archive for every paper print.

To preserve the image quality of the original, you should scan the film directly and not the paper print. If you use a good quality scanner, you will get a much more detailed and high-contrast digital image from the negative than from the print. Plus, you have more latitude for enlargement with film. Unfortunately, sometimes all you have is a paper print and you have to deal with what's there. A good print can be an acceptable template for scanning. As with any other recording techniques, the quality among prints can vary widely. For example, an old-fashioned enlargement made with worn-out laboratory equipment will be of lower quality than an up-to-date inkjet print.

In all cases, you have to deal with the limitations of paper as the carrier medium. If you are aware of the limits, you can still get some decent scans out of paper prints. While you can use film scans to produce poster-sized image files, a paper scan is suitable for 1:1 reproduction. Of course, you can enlarge it beyond 1:1, but be aware that the quality will suffer visibly.

Rasterization in books, magazines and newspaper scans

When scanning photos out of a book, magazine, or newspaper, you will confront a side effect of the normal printing technique: rasterization. In a magnified view, you can see that the photos are rasterized. VueScan offers a descreening filter that helps remove the raster from the scanned image. Whether you use this filter or not is more a personal decision than a technical necessity. With standard settings VueScan will reproduce the raster exactly and this will result in a busy appearance of the scan. If you use the descreening filter you will get a better looking image, but this comes at a price. Image sharpness and some loss of details are side effects of the descreening.

Common scanning resolutions for paper prints are between 300 and 600 spi. There are some printers around that claim to reach higher resolutions, e.g., around 1200 dpi, but for this purpose 300-600 dpi is regarded as sufficient. Please keep in mind that paper is an undesirable medium for subsequent enlargements. The scan from a standard print is suitable for 1:1 reproduction, not for producing poster-sized enlargements.

Pros and cons: Paper prints

➕ Good scan results even with inexpensive scanners
➖ Paper does not have much latitude for enlargements (film is the superior analog medium)
➖ If possible, scan the original source slide/negative and not the print

5.7 The originals: To dump or not to dump?

After you have successfully scanned your originals, you will probably ask yourself whether there is still an urgent need to keep them. Nobody would flip through shoeboxes of negatives when all the data is easily accessible on your computer, right? Well, that's a difficult question to answer, and you should think twice before dumping anything.

First of all: once you discard or destroy your originals, you will obviously have no chance to scan them again. At the very least, you should ensure that you have a good, working backup; otherwise, you might dump the originals and later lose all your scans because of a stupid thing like a crashed hard disk. Since things like that can always happen, redundant data storage is a must.

The other consideration is that your current scans might not have squeezed all of the image information out of your originals due to technical limitations. This can and will probably happen, e.g., with 35mm film. While modern scanners deliver good results, there is still something left to be desired. If you keep the originals, you can profit from future scanner enhancements. However, if you are just scanning a couple of old insurance documents for your personal archive, the situation is quite different. In that case, you have no desire for enhanced scanning, plus you are usually happy to get rid of those old paper files.

About the value of analog originals

When it comes to originals that have emotional value, e.g., family photographs, you should definitely keep them. Aside from practical reasons, it is a different and valuable experience to see analog originals that you can actually hold in your hands. Flipping through vintage Kodachromes and checking them with a loupe on a lightbox is a nostalgic experience that is hard to match on the digital level. The better alternative to completely dumping old archives is to sort them properly and to discard only bad pictures. This will dramatically reduce your needed storage space. Almost every archive contains a lot of mediocre and simply bad shots among the good ones. Consequently, if you sort out the bad stuff, you will have a much leaner image collection. As scanning is quite time-consuming, sorting beforehand is advisable anyway. You can save lots of time by scanning only the good pictures and eliminating the bad shots. To sum it up in short: Always keep good analog originals! They have their own value, no matter if you have a digital copy of them or not.

Image: Wikimedia Commons by musee.louvre.fr

◄ It is old, it is fissured and the image quality is for sure inferior to modern painting styles. But nobody ever even thought about dumping the analog original of the Mona Lisa, not even a correction filter had been applied so far. Happily enough the museum still keeps it like it is. Even so, they made a couple of high quality scans of it in the meantime.

Special Scanning Techniques

Scanning can be much more than a simple 1:1 reproduction of the original in the tray. Actually, if you employ the same standardized scanning technique for all of your originals, you are unlikely to achieve the best possible image quality in every case. When carefully used, techniques like multiscanning, multi-exposure and descreening can make the difference between a mediocre and an optimal scan.

Contents

6.1 Multiscanning

Standard scanning requires only one pass for the entire original. The scanner collects data samples from the surface of the original line by line and uses that data to generate the scan file. However, this is not necessarily the best option. You can often improve the overall image quality by repeating the process. Instead of scanning the original once, VueScan can scan it multiple times and combine the images into one final file. This process is called multiscanning.

You can use multiscanning either with transparencies or reflectives, but it is more common with transparencies. In VueScan, you can choose any value between scanning twice (2x) and 16 times (16x). With each additional pass, the time duration of the overall scan adds up and it uses more RAM .

The benefits of multiscanning may justify the effort. First of all, the overall quality of the scan data should improve. Like any digital camera, a scanner produces not only the desired information signal but also a good portion of undesired interference. This interference is the notorious image noise. For example, when you take a photo of a pitch black night with your digital camera, you will get some erratic green, red, or blue pixels for no obvious reason; scanning suffers from the same effect. Due to image noise, some pixels will be miscolored. At an average viewing distance, this will give the picture a slightly uneven appearance. If you enlarge it in Photoshop, you will easily see the miscolored pixels. Multiscanning visibly reduces image noise and can also improve the color gradient and the grain appearance of the scan.

However, multiscanning can have side effects and therefore does not automatically lead to an overall improvement in image quality. During multiscanning, the scanner must reposition itself a couple of times. Since scanning hardware does not always work with the utmost precision, the result can be blurry, unsharp images. You simply have to try out multiscanning with your particular scanner to see if its application is justified. The benefits and side effects amplify with each additional pass; thus, a 2x scan may be preferable to a 16x scan in some cases. In the end, it all depends on the precision of your scanning hardware. A little loss in sharpness seems to be inevitable with multiscanning, but this effect should be balanced out by decreased image noise.

Nikon and Minolta film scanners have very accurate repositioning of the scanner at the start of each scan pass, so the results with multi scanning are quite good. But in comparison to a standard scan you will always experience loss in sharpness.

The low-cost versions of the Nikon film scanners (Nikon Coolscan III, Coolscan IV, Coolscan V) do not support multi-sampling, but work well with multi-scanning. Multi-scanning is only useful for film, since the density range of reflective media is much less than an inexpensive CCD can record in a single pass. Multi scanning helps mostly in reducing noise in the dark areas of slides, and is less useful for scanning negatives. The dark areas of negatives aren't very dense compared to slides.

Number of samples/passes

In VueScan, you can configure multiscanning in the Input *tab. Depending on your scanner, you will either see the option* Input ▸ Number of samples *or the option* Input ▸ Number of passes *. For* Number of samples *, the scanner reads each line several times during multisampling. This is the best option for multiscanning with the least probability of inaccuracies, but your scanner hardware needs to support it.* Number of passes *scans the whole image several times consecutively. Here the scanner must reposition itself before each pass, making it somewhat less precise than the first option.*

1x scan

16x scan

4x scan

Image: Peter Steinhoff, ca. 1977

Multiscanning can improve image noise and reduce grain. On the other hand the overall image sharpness can suffer from mulitscanning. In the end it really depends on the specific scanner if multiscanning leads to an overall image improvement.

6.2 Multi-exposure

In the slow-moving world of scanning, multi-exposure is something like le dernier cri. Actually, it has been around since 2008, but it is still a greenhorn compared with other scanning methods. Multi-exposure resembles multiscanning with a few important distinctions. First of all, multi-exposure is designed for transparencies only; it will not work with reflectives. Multi-exposure scans an image two times completely, you simply enable it in the `Input` tab by ticking the `Multi exposure` option. It resembles an average 2x multiscan with `Input` ▸ `Number of passes`. The difference lies in the exposure. Traditional multiscanning exposes all passes in the same way. With multi-exposure, every pass has a different exposure.

Practical effect of Multi-exposure
The effect of multi exposure depends very much on the scanner used. A good scanner can cover the dynamic range of a slide completely. In this case you will not need multi-exposure. Cheaper scanners with a lower dynamic range can indeed improve their dynamic range very much by using multi-exposure.

HDR for scanners

Multi-exposure works very much like the popular High Dynamic Range (HDR) imaging method in digital photography. With HDR, the photographer takes an exposure bracketing series of a single image. Some of the pictures are exposed correctly, some are underexposed, and some are overexposed. Because the dynamic range of digital SLRs is limited, you cannot expose the full range between highlight and dark areas correctly in one shot. With HDR, you can combine several images into one image that covers the full dynamic range from highlights to shadows.

In scanning, you have a similar initial state. The dynamic range covered by analog originals is bigger than the dynamic range of most scanners. With multi-exposure, you can increase the dynamic range of a scanner, very much resembling HDR. But unlike HDR with DSLRs you have to keep in mind that you are working with analog originals. Multi-exposure is only effective if you have good analog originals.

2x multiscan automatically included

Multi-exposure in VueScan works with two passes. The first pass has a normal exposure, and the second pass has a longer exposure. The combination of the two produces an image that usually shows more detail in the shadow regions compared to a standard scan. Multi-exposure elongates scanning times similar to a standard multiscan and shares the same side effects. Blurred images can result if the scanner is not positioning itself corrrectly, and even under the best conditions there can be a slight decay in image sharpness (although this decay may not be obvious when using a good scanner). On the other hand, film grain and image noise usually improve, so all in all multi-exposure is a good option to expand the capabilities of your scanner. In VueScan, you can even combine multiscanning with multi-exposure if you like. But keep in mind that by default, only originals that have a bigger dynamic range than the scanner can benefit from multiscanning. Thus, cheap scanners benefit more than high-class scanners from the use of multi-exposure.

Standard scans sometimes lack details in the shadows, Photoshop cannot fix this completely.

With multi-exposure the scanner catches more details in the shadows and Photoshop can make use of this.

6.3 Scanner exposure

Scanner exposure is usually taken care of automatically by the scanning program as part of exposure control. For film with normal exposure, this function is not really necessary and the exposure may be left at its default setting. For underexposed or overexposed pictures, manipulating scanner exposure can in some cases produce better image results.

Scanner exposure vs. multi-exposure

Multi-exposure produces an effect that is similar to scanner exposure; but, in contrast, it expands the dynamic range of the scanner on the whole, which is the better technology. My advice is: if you need more structure in dark areas of your original, try multi-exposure first. If that does not have the desired effect, then try scanner exposure as a last alternative. With a properly adjusted scanner and well-exposed images, you will not need to touch scanner exposure.

RGB Exposure and Analog Gain

VueScan provides two options for controlling scanner exposure when scanning transparencies: Input ▸ RGB exposure and Input ▸ Red/Green/Blue analog gain. RGB exposure controls the overall exposure for all three color channels together; it is available with most scanners. Analog gain is a special feature of some Nikon scanners that allows you to control the brightness of each color channel separately. Most scanners will not support Analog gain, but some do. In both cases, you physically control how much light is used for the scan. These settings even affect the appearance of the RAW file and should not be mixed up with the settings in the Color Tab. In the Color Tab, you only configure how the RAW file is processed, and that is a different cup of tea.

Scanner exposure directly controls the scanner hardware. It governs exposure time, i.e., how long the scanner lamp shines through the film. The same effect cannot be produced later in image processing; more light must be physically projected through the film. VueScan shows the effect in the preview window to give a point of reference. Configuring scanner exposure makes sense only if your computer monitor is calibrated. Often, a scanned image looks too dark or too bright simply because the monitor is not adjusted properly. If you try to compensate for poor monitor adjustment with scanner exposure, the scanned files will not be usable on a calibrated monitor.

The effects of scanner exposure are fixed in the image file. Since scanner exposure represents a change at the hardware level, a poor setting cannot be fixed later in Photoshop or in VueScan with the Color tab. One negative side effect of increasing scanner exposure can be an increase in image noise. On average the automatic calculation of the scanner exposure will work fine. You seldom need to manually set this. But you can try manual settings: For overexposed images, reduce scanner exposure to lessen image noise. This may salvage image areas that would be blown out by the scanner light on the standard setting. For underexposed images, increase scanner exposure.

Scanner exposure does not work miracles; it merely helps to recover some detail in poorly exposed images. The results of using scanner exposure can never match a properly exposed shot. The best practice is always to ensure correct exposure at the moment you take the picture.

6.4 Descreening

The printing methods used for books, newspapers, and magazines must be cost efficient; this factor is more important than anything else. Since halftone printing is the most economical way to produce huge print runs at affordable costs, it is used for virtually every mass-printed item available on the market. If you want to scan an image from a book, newspaper, or magazine, you will for sure run into challenges due to its halftone printing, or better put, to its raster.

In halftone printing, every digital image file is converted for the print. The pixels of the source file transform into a printable raster. You can check this raster easily; just grab your grandmother's reading glasses and examine any picture printed in this book. The distinctive raster is easily visible.

During scanning, you may want to convert this raster image back into a proper image, but that is difficult. First, there is a good chance that you will get some moiré when scanning the raster image. Second, you usually don't want to scan a facsimile of the printed image, but rather to rebuild the original image as closely as possible. However, the printed raster contains much less image data than the original source file, and thus it is impossible to get the original image back via scanning. Your only option is to restore the scan as far as possible with the descreening functionality of VueScan.

Descreening is activated by default when you scan magazines or newspapers. You cannot switch it off in this mode, only choose its magnitude (1 to 300 dpi). For a quick comparison between a descreened scan and one that has not been descreened, do a preview and switch `Input` ▸ `Media` from *Magazine* to *Color Photo*. Especially when you zoom in, the difference is quite obvious. The descreening filter polishes the scan, and the printing raster disappears. As a side effect, the overall sharpness of the scan suffers a little bit.

Finding the correct setting is tricky, as there is no standard raster around. In many cases, a setting of 75 dpi produces good results, but if you want to find the best setting you may have to experiment. The optimum setting depends not only on the printing method but also on the paper. You can save a lot of time during the process if you scan in raw mode. In that case, after you scan the original once, you can produce a couple of scans at different settings with no holding time in between. If you have to rescan, this surely takes more time.

Descreening in VueScan

VueScan offers an integrated filter at `Input` ▸ `Descreen dpi`. It pops up when you choose the options *Magazine* or *Newspaper* in `Input` ▸ `Media`. You can only choose descreening for reflective originals; it is not accessible for transparent media because they use a different printing method.

Descreening is not a must
If you are a minimalist and just want to reproduce the print 1:1 (e.g., for a facsimile), scan it like a photo print without any descreening. This will ensure optimal sharpness, but you will have to live with the raster.

Consumption of processing power
Descreening is a filter that consumes quite a lot of resources even when you own a modern multicore computer system. If you descreen high resolution scanning files of large analog originals, you can bring almost any current computer system to its limit, especially when you use it in combination with the output size reduction. Having a 64-bit operating system with sufficient RAM is definitely an advantage in this case.

This is the analog original of a book cover. See the enlarged scans on the next page.

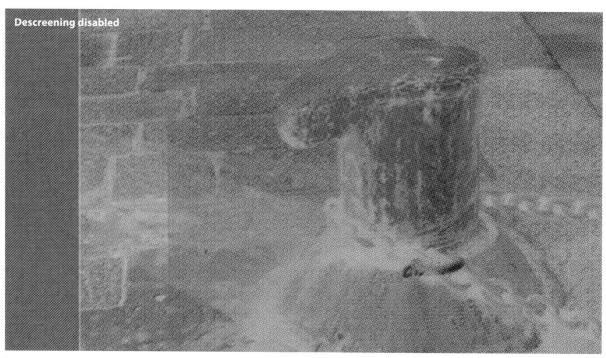

Pictures in magazines or books show distinctive patterns especially when scanning with high resolution. You can reduce this raster with a Descreening filter in VueScan.

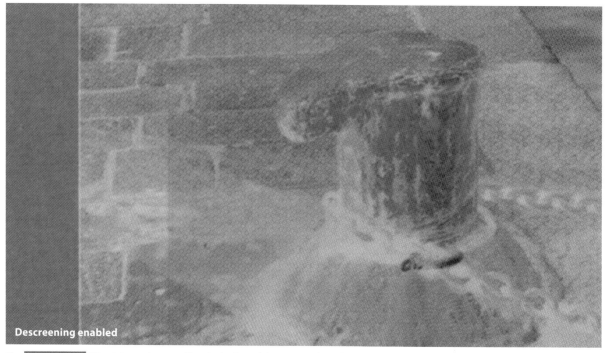

The Descreening filter deburrs the scan. The single dots of the print are less obvious after filtering but the overall sharpness will suffer a little bit. Descreening consumes a lot of processing power, especially with big scans.

Scanning Workflows

Proper scanning workflows are a matter of nuts and bolts when you are serious about archiving your analog documents as digital files. Every document type needs its own specific workflow. This depends not only on the analog original and the scanner, but also on the intended use of the files in the future. This chapter contains an overview of general workflow suggestions and specific recommendations for current types of analog originals, both for flatbed and film scanners.

Contents

7.1 General workflow suggestions

In general, there are two ways to scan your analog originals: the fast way and the accurate way. Both are not possible at the same time, so you need to find a compromise for economical scanning. This may be disappointing from a pixel peeper's point of view, but everybody who has to scan more than a handful of originals will appreciate this approach. And that's what it's all about: you want a good result in reasonable amount of time, which requires different workflows for different types of originals. Don't try to achieve the absolute best quality! Instead, try to discover the most suitable settings for your individual purpose.

Input tab

The most important settings on the `Input` tab are `Input` ▸ `Scan resolution` and `Input` ▸ `Bits per pixel`. These settings determine the size of the RAW scan that VueScan will have to handle internally. If you use the maximum settings, you can easily bring even a powerful computer system to its knees. For example, scanning an $8^{1/2}$" x 11" paper document in 64-bit RGBI with a full optical resolution of 4800 spi will result in a 16.6 GB monster file! Scanning the same document in 48-bit (you don't need the infrared channel here) with a resolution of 300 spi will result in a much smaller image file, approximately 50 MB.

Please keep in mind that we are talking here about the input side of the scanner—i.e., the raw image file that the scanner has to handle internally. The actual output is configured in the `Output` tab, and that's a completely different story! The lower the resolution and color depth, the faster your scanner will work. Using features like `Input` ▸ `Multi scanning` and `Input` ▸ `Multi exposure` will increase the size of the raw file at least as long as the scanner is working. For multi exposure, it will double, and for multi scanning, the factor will be identical to the number of passes/samples. In both cases, output size is not affected, but internal processing speed will be.

Crop tab

Cropping is an essential part of every scanning workflow, but there are definitely smarter ways to do it than adjusting the crop box individually for each scan. The best practice is to use fixed crop sizes for standardized analog originals like $8^{1/2}$" x 11" paper documents. Then all you have to do is change the documents, and there is no need to worry about the crop.

Slides and negatives present a different issue. They may be all 35mm film, but the actual size of each image will vary from camera to camera, and even the lens can have an effect. Using *Auto* for `Crop` ▸ `Crop size` is not 100% reliable, although it usually delivers good results. One solution is to simply scan full frame (e.g., 24 x 36 mm) and do the cropping afterwards. Just remember to configure `Crop` ▸ `Buffer` accordingly to keep the black borders from having an effect on the exposure.

Batch scanning

One option that can save you lots of work is using document/film feeders. Instead of having to change the originals manually, you can just start a batch with an automatic feeding unit and let it work unsupervised. With `Crop` ▸ `Multi crop`*, you can do batch scanning e.g., with a flatbed scanner that has several slides in the scan tray at once.*

Filter tab

In many cases, filtering is both crucial and a good opportunity to wreck your scans completely. There are two ways to handle it: either use a setting that matches your scans 100%, or use RAW scanning instead. With RAW scanning, you can conveniently try different settings without a single rescan. If you apply the filters directly to the image file—as with TIFF or JPEG—you should be confident about what you are doing. The *Medium* setting of `Filter` ▶ `Infrared clean` is usually a good choice for negatives and slides; grain reduction is more of an issue, as the amount of grain can vary even among different slides of the same film. However, subsequent changes are only possible in the standard workflow if you rescan. Scanning raw is the better option.

Color tab

Similar to the filtering options, this tab offers a row of different settings for color correcting your scan. Color correction can be tricky, especially for slides and even more so for negatives. Due to the aging process of film, a matching film profile in VueScan cannot guarantee perfect colors, and manual correction may be needed. Thus the recommendation is standard settings for uncritical originals; for the rest, raw scanning is simply the best choice.

Output tab

The `Output` tab is the point of no return. Here you decide the type and specifications for the output images. The options are RAW, PDF, TIFF, and JPEG, and you can find detailed descriptions of them in chapter 4, which deals with file formats.

Raw scanning is perfect, but only if you are willing to open the file once more in the scan program for conversion to another image format. You can, of course, post-process DNG in Adobe Lightroom, but the full scanning functionality is only available in VueScan. PDF is a very convenient and widely distributed format for electronic documents, but it is not well suited for post-processing. Use PDF when you are happy with your files as they are, as everybody can easily handle even multipaged PDFs. For electronic document transfer, they are perfect.

For image post-processing, TIFF is the best choice. If you want to tweak your scans in Photoshop, TIFF is definitely better than PDF. Remember that PDF is not an image format, and this comes with certain restrictions. JPEG is a native image format, but due to the compression algorithms it has some shortcomings that you can easily avoid by using TIFF, especially the 16-bit version.

All in all, the file format you choose depends on what you want to do. For post-processing scans, choose RAW; for image post-processing, choose TIFF; for immediate output with little or no post-processing, choose JPEG or PDF (i.e., JPEG for images and PDF for documents).

Using file compression
An important factor in the output process is file compression, with various options depending on the file type. By all means, use these options to reduce your image file size and save precious storage space, but be aware of potential quality and compatibility issues that might pop up due to inappropriate settings.

7.2 Clever use of output size reduction

For maximum image quality, you should use the highest optical resolution for scanner input—but only if the analog original requires it! With VueScan's output size reduction feature, you can reduce the scan's file size in many cases without any effective loss of image quality—as long as you know what you're doing! Check these factors:

1. **Nominal** optical resolution of the scanner (see the scanner packaging)
2. **Effective** optical resolution of the scanner (check good reviews like www.filmscanner.info)
3. Quality of the analog original (this depends on various factors)
4. Pixel size of the raw data that VueScan uses internally (see `Input` ▸ `Scan resolution` and `Input` ▸ `Bits per pixel`)
5. Pixel size of the output file (reduce it with size reduction in the `Output` tab)

The following examples show how to approach for different scanner types. It depends all on the effective resolution of the scanner used.

Scanning 35mm with a good film scanner

The Nikon Coolscan 5000 has a nominal optical resolution of 4000 spi. Its effective optical resolution is roughly 3900 spi, a minimal difference. You could say that its optical and effective resolutions are more or less equal. If you scan a slide at 4000 spi, the scan file will have roughly the same quality. The question now is: Will the slide actually need a 4000 spi resolution that produces 160 MB TIFF monster files in 64-bit?

In most cases you will get no effective gain in image quality when you use 4000 spi instead of 2000 spi with the Nikon. The scanner can deliver this resolution, but most analog originals simply don't have the quality to justify 2000 spi. Instead, you only waste storage space on a large scale by doing so.

There are now two ways to create an output file at 2000 spi with the Nikon. The first is to scan directly at 2000 spi. Resolution-wise, this is sufficient, and it's actually the fastest way as scanners tend to work faster when scanning lower resolutions.

But for maximum image quality, you should use output size reduction instead. Configure `Input` ▸ `Scan resolution` at 4000 spi and `Output` ▸ `TIFF size reduction` at factor *2*. This will convert the 4000 spi scan into a 2000 spi file—effectively, the file size will shrink from 160 MB to 40 MB! But the main reason for using output size reduction instead of scanning directly at 2000 spi is reducing image noise. Shrinking a 4000 spi scan to a 2000 spi output file has a positive effect on image noise—there is simply less of it left. That's the reason why it can be justified to scan 4000 spi, even when your desired output size is only 2000 spi.

Scanning 35mm film with a good flatbed scanner

The Canon CanoScan 8800F has a nominal optical resolution of 4800 spi. The effective optical resolution is roughly 1600 spi—quite a big difference. For best quality you will still have to use the 4800 spi setting, that will result in files sizes of hefty 240 MB if scanning 35mm slides in 64 bit. That means you will waste storage space on a large scale, as the effective resolution is just 1600 spi. Scanning at a lower resolution than 4800 spi might not use the full optical quality of the scanner—which is desired for color slides. The question is now: How can you scan in 4800 spi and still produce an output file that just covers the effective resolution of 1600 spi?

The first step in the example above is to find out the precise desired output size. A scan file is not a vector file that you can scale without side effects to any desired size (in this case, 1600 spi). Instead, if you just divide the optical resolution by even numbers, you will get resolution steps of 4800/2400/1200/600/300 spi. Accordingly, for 1600 spi, we have to pick the 2400 spi output size in this case. Configure `Input` ▸ `Scan resolution` at 4800 spi and `Output` ▸ `TIFF size reduction` at factor *2*. This will convert the 4800 spi scan into a 2400 spi file and effectively shrink the file size from 240 MB to 60 MB. You will preserve the full optical quality of the 4800 spi scan—effectively, a puny 1600 spi—and you will reduce image noise as an appreciated side effect as well. 240 MB may not sound much when you have a multiple-gigabyte sized hard disk, but if you scan more than a couple of originals, storage place will definitely become an issue.

Image editing: VueScan vs. Photoshop

For the best image quality, every scan can potentially benefit from manual corrections, e.g., tonal and contrast corrections and unsharp masking. By default, most scans look a bit dull, like raw diamonds that need cutting to shine in full grandeur. VueScan offers some basic options for color and tonal value adjustments directly in the program. Most of them (though not scan-specific things like film profiles, of course) can be configured either in Photoshop or in VueScan. And that's what the user has to decide: Do you use VueScan or Photoshop for image editing?

In the author's humble opinion, VueScan is a great scan program, but Photoshop is definitely better suited for image editing. Therefore, the guideline for all workflows in this chapter is, "Adjust what is necessary in VueScan, but do the fine tuning in Photoshop during post processing". This is more convenient and usually delivers better results, than trying to do everything in VueScan. Photoshop has more sophisticated options and tools for image editing than any scan program on the market. You can of course use any other good image editing program, there are many like the open source program GIMP.

Absolute filesize and resolution
In general, the bigger the source file, the better the image noise reduction if you use downsizing. In theory, that would justify a 4800 spi scan for 300 spi output, but this would cause problems—especially for larger originals. Apart from the super-slow scanning process at high resolution, the computer cannot process a file like this. An 8$^{1/2}$" x 11" print scanned at 48-bit (no need for Infrared clean at this point) has terrifying size of 12.4 GB. Even the fastest 64-bit computer system will struggle with it, and of course the whole scenario is like cracking nuts with a sledgehammer. Better to use an input scan resolution of 600 spi (that's 200 MB the computer has to process) and reduce the file to 300 spi during output. Then you will have a 50 MB TIFF file which is much leaner than the original input size.

7.3 Generic RAW scanning workflow

The difference between the classic scanning workflow and the RAW workflow may seem tiny at first, but it is actually significant. A RAW file is more than just another output file. Let's take a look at the **classic workflow** first:

1. Insert analog original in scanner
2. Make comprehensive adjustments in scan program
3. Scan analog image
4. Output image file

This is a lean workflow, and subsequently you can post-process the scans in an image editor if needed. This workflow is perfect for quick results, but it has a major disadvantage: if you configure some adjustments wrong, you will have to rescan the analog original. In many cases, a rescan is the only option if you are not happy with the outcome of the first scan. This scenario can generally be avoided if you use a RAW scanning workflow. The RAW workflow has more steps:

1. Insert analog original in scanner
2. Make basic adjustments in scan program
3. Scan analog image
4. Output RAW file
5. Input RAW file in VueScan
6. Make advanced adjustments in scan program
7. Scan RAW file
8. Output image file

The big advantage of the RAW workflow is that it separates pure scanning from processing. Of course, there are some physical limitations to consider. If the crop of the first scan is too tight, you will have to rescan, no matter whether you used RAW or TIFF in the first place. The same is true of settings like `Multi exposure` and `Multi scanning`. But usually it's the tricky color and filtering options that give you a hard time, and this is where the RAW workflow scores better than the standard workflow. You can try out different settings and create different output files without having to rescan once. This works perfectly even with `Infrared clean`.

Archiving in RAW

RAW file output is the perfect method for archiving. Nowadays VueScan uses DNG for RAW output, and you can easily administer this in RAW converters like Adobe Lightroom (but only to some degree). Lightroom, Aperture, and the like are all designed for digital camera RAW. Thus they have no specific options for scanning. For full functionality you will need to use VueScan for the conversion process. Still, with DNG you have a wide option of viewing programs and image editors for further processing. That's a big improvement compared to the TIFF-RAW that VueScan used in the early days of raw scanning. RAW output is now a suitable alternative for building up an archive.

Mandatory configuration steps before scanning RAW

Raw scanning involves more than just inserting the original into the scanner and pressing a button. There are some configuration steps that you must execute first. What you're doing is creating the basis for a good RAW file, and if you make a mistake you can easily wreck the whole process. Below is a list of the configuration steps to do before scanning in RAW.

1. **Input** ► **Bits per pixel**
2. **Input** ► **Scan resolution** / **Quality**
3. **Input** ► **Number of passes** / **Number of samples**
4. **Input** ► **Multi exposure**
5. **Input** ► **Lock exposure** (rarely needed in daily use)
6. **Crop** ► **Crop size** (if you don't want to crop now, scan full size with **Crop** ► **Buffer**)
7. **Crop** ► **Focus X/Y offset** (focusing before scanning is important if your scanner supports it)
8. Output file format: TIFF RAW or DNG RAW
9. Color depth: 24-bit for reflectives and 64-bit for transparencies are in general recommendable.

The option **Input** ► **Lock image color** has no effect on raw scans, none of the options in the **Color** tab have an effect either. You might not need to configure each option for all scans, but if you need them, you must configure them before the scan. Other options like image rotation, skewing, or mirroring are not mandatory, and you can easily do them later—though it is more convenient for post-processing if you do them right away in the scanning workflow.

None of the settings in the **Color** tab are saved into the RAW file. You can conveniently try out different settings at a later stage without rescanning when you do raw output.

7.4 Paper documents – Scanning text

This workflow is for scanning text, like black-and-white computer printouts or typewritten documents. The aim is not a 100% true-to-detail facsimile, but rather a lean and economical digital conservation of the analog text. This is the perfect workflow for scanning large document archives.

Basic workflow			
Tab	**Option**	**Setting**	**Remarks**
Input	Media	Text	The options *Color photo* or *B/W photo* would work as well, but the *Text* option does most settings automatically.
Input	Media size	*As needed*	When scanning standardized paper documents like $8^{1/2}$" x 11", it is useful to configure `Media size` accordingly. The scanner will save time by only scanning that portion of the tray.
Input	Bits per pixel	1-bit B/W	This option is for typewritten documents or black-and-white prints. The aim is not to create a 1:1 facsimile but to preserve the analog text digitally.
Input	Multi page	*As needed*	Enable this option if your original document has more than one page and you want to output the whole document as a single file.
Input	Scan resolution	300 dpi	This is the fastest and easiest setting for 300 dpi output.
Input	Auto save	Scan	This option saves the scan automatically after scanning.
Crop	Crop size	Maximum	Note that size configuration is done already on the `Input` tab.
Color	Threshhold	*As needed*	Usually the default setting is fine, but if necessary you can change the threshold between black and white manually.
Output	PDF file	Enable	For documents, PDF is usually the best choice.
Output	PDF multi page	*As needed*	Enable this option if your original has more than one page (compare `Input` ▸ `Multi page`) and you want the output of the whole document in a single PDF file. If not selected, you will get a separate PDF file for every page.
Output	PDF file type	1-bit B/W	--
Output	PDF compression	On	This option will switch the embedded image file from TIFF to JPEG, further shrinking the file size.
Output	PDF paper size	*As needed*	Use this option to switch to the desired output size. Usually it equals the `Media size` of the `Input` tab.

For all variations, use the basic configuration of the workflow above and change only the settings described below.

Variation A - Using OCR text recognition			
Output	PDF OCR text	Enable	When this option is enabled, OCR tries to recognize the scanned text. You can then use the copy, paste, and search functions for your PDF.
Output	OCR text file	Enable	This option writes the OCR text into a separate text file. This is the easiest way to edit the text manually.
Output	OCR text language	*As needed*	Use this option to select the text language. It improves the OCR recognition rate remarkably.
Variation B - Scanning full color			
Input	Media	Color photo	This option enables full-color scanning. Full-color scanning needs much more storage space than grayscale scanning.
Input	Bits per pixel	24-bit RGB	This option enables full-color scanning.
Filter	Sharpen	Enable	This option makes the output crisper.
Color	Various options	*As needed*	In this mode, you have full access to options like `Color balance`, `Curves`, etc. Usually you do not need them for scanning text.
Output	PDF file type	24-bit RGB	This option enables full-color output.
Variation C - Scanning grayscale			
Input	Media	B/W photo	This option enables grayscale scanning.
Input	Bits per pixel	8-bit Gray	This option enables grayscale scanning.
Filter	Sharpen	Enable	This option makes the output crisper.
Color	Various options	*As needed*	In this mode, you have full access to options like `Curves`.
Output	PDF file type	8-bit Gray	This option enables grayscale output.

7.5 Newspapers – Scanning text and pictures in black-and-white

This workflow is only for scanning black-and-white newspapers. Scan full-color newspapers like magazines. The aim is to conserve the original analog text and pictures in a lean and economical way. Since the quality of the originals is usually quite poor, descreening helps to squeeze the best possible scans from the analog originals.

Basic workflow			
Tab	**Option**	**Setting**	**Remarks**
If the backside of the page shines through during scanning, it helps to put a piece of black cardboard behind the newspaper page.			
Input	Media	Newspaper	This setting is mandatory, as it enables the descreening option. It also sets some of the subsequent options automatically. If you do not want to use descreening, switch over to *B/W photo*.
Input	Descreen dpi	75	This default setting works very well for most newspapers.
Input	Media size	*As needed*	Newspaper sizes are not standardized and are usually much bigger than $8^{1/2}$" x 11". Use an 11" x 17" scanner for full-format scans and set the Media size to *Maximum*. For cropping, use the Crop tab.
Input	Bits per pixel	8-bit Gray	Using grayscale is mandatory for preserving the images. 8-bit is usually sufficient for newspapers, as the print quality is quite low.
Input	Multi page	*As needed*	Enable this option if your original document has more than one page and you want to output the whole document in a single file.
Input	Scan resolution	300 dpi	This is the fastest and easiest setting for 300 dpi output.
Input	Auto save	Scan	This option saves the scan automatically after scanning.
Crop	Crop size	*As needed*	Configure the crop size to cover the entire newspaper page. For subsequent pages, you won't need to readjust the crop.
Filter	Sharpen	Enable	Remember that the output is PDF, so you must sharpen in VueScan.
Color	Color balance	White balance	You can do a lot of labor-intensive fine tuning in the Color tab. For scanning newspapers, it is usually sufficient to switch to *White balance*.
Output	PDF file	Enable	For documents like newspapers, PDF is usually the best choice.

Output	PDF multi page	*As needed*	Enable this option if your original has more than one page (compare **Input** ▶ **Multi page**) and you want the whole document in a single PDF file. If not selected, you will get a separate PDF file for every page.
Output	PDF file type	8-bit Gray	This option is needed to preserve the color information of the scan.
Output	PDF compression	On	This option switches the embedded image file from TIFF to JPEG, shrinking the file size.
Output	PDF paper size	*As needed*	This option switches to the desired output size, which should be at least the same as the input size. In general, it is best to use one of the standardized paper sizes in the dropdown list.

For all variations, use the basic configuration of the workflow above and change only the settings described below.

Variation A - Using OCR text recognition

Output	PDF OCR text	Enable	When this option is enabled, OCR tries to recognize the scanned text. You can then use the Copy, Paste, and Search functions for your PDF.
Output	OCR text	Enable	This option writes the OCR text into a separate text file. This is the easiest way to edit the text manually.
Output	OCR text language	*As needed*	Use this option to select the text language. It improves the OCR recognition rate remarkably.

Variation B - Facsimile scanning

Facsimile scanning is the 1:1 reproduction of the analog original. Thus, it is slightly sharper than a descreened scan. However, the fonts are more difficult to read, and the pictures show the distinctive marks of the printing method. Facsimile scanning is used to preserve the original newspaper when you plan to do some post-processing later. For any kind of retouching and restoration, a facsimile is the perfect ground-level state.

Input	Media	B/W photo	This option enables grayscale scanning.
Filter	Sharpen	Disable	If you do post-processing, sharpening should happen at the very end of the workflow and not during scanning.
Output	TIFF file	Enable	For post-processing, TIFF is the best choice.
Output	TIFF file type	8-bit Gray	You can upgrade to 16-bit if you like, but for most originals this is simply not needed but only a waste of precious storage space.

7.6 Magazines – Scanning text and pictures in full color

This workflow is for scanning full-color magazines and full-color newspapers. The aim is to conserve the original analog text and pictures in a lean and economical way. When compared to newspapers, the print quality of magazines is usually better because the paper quality (not necessarily the printing method) is better. Spending more effort on full-color originals results in better scans. Descreening is a powerful tool to help squeeze good scans even out of demanding analog originals.

Basic workflow			
Tab	**Option**	**Setting**	**Remarks**
If the backside of the page shines through during scanning, it helps to put dark cardboard behind the page. Due to the better paper quality of magazines as compared to newspapers, this is seldom necessary.			
Input	Media	Magazine	This setting is mandatory, as it enables the descreening option. It will set some of the subsequent options automatically. If you don't want to use descreening, switch to Color photo instead.
Input	Descreen dpi	75	This default setting works very well for most magazines.
Input	Media size	*As needed*	The size of magazines is usually around 8$^{1/2}$" x 11". If the magazine does not match one of the predefined values, choose the smallest dimension that fits the original and make fine adjustments in the Crop tab.
Input	Bits per pixel	24-bit RGB	24-bit is usually sufficient for magazines, as the print quality in absolute terms is quite poor.
Input	Multi page	*As needed*	Enable this option if your original document has more than one page and you want to output the whole document in a single file.
Input	Scan resolution	600 dpi	You can reduce image noise if the input resolution is higher than the output resolution. Scanning at an even higher resolution takes more time as well, so 600 dpi is a good compromise.
Input	Auto save	Scan	This option saves the scan automatically after scanning.
Crop	Crop size	*As needed*	Configure the crop size here to cover the entire magazine page. For subsequent pages, you won't need to readjust the crop.
Filter	Sharpen	Enable	Remember that the output is PDF, so you must sharpen in VueScan.
Color	Color balance	Auto levels	It is usually sufficient to switch to *Auto levels*; this will produce scans rich in contrast. For neutral colors, choose *White balance* or *Neutral*.

Output	PDF file	Enable	For documents like magazines, PDF is usually the best choice.
Output	PDF size reduction	2	Factor 2 shrinks a 600 spi input file to a 300 dpi output file. For higher in-out resolutions, use adequate factors.
Output	PDF multi page	*As needed*	Enable this option if your original has more than one page (compare **Input** ▸ **Multi page**) and you want the output of the whole document in a single PDF file.
Output	PDF file type	24-bit RGB	This option preserves the color of the scan.
Output	PDF compression	On	This option switches the embedded image file from TIFF to JPEG, shrinking the file size.
Output	PDF paper size	*As needed*	This switches to the desired output size, which should be at least the same as the input size. In general, it is best to use one of the standardized dimensions in the dropdown list.

For all variations, use the basic configuration of above and change only the settings described below.

Variation A - Using OCR text recognition

Output	PDF OCR text	Enable	When this option is enabled, OCR tries to recognize the scanned text. You can then use the copy, paste, and search functions for your PDF.
Output	OCR text	Enable	This option writes the OCR text into a separate text file. This is the easiest way to edit the text manually.
Output	OCR text language	*As needed*	Use this option to select the text language. It improves the OCR recognition rate remarkably.

Variation B - Facsimile scanning

Facsimile scanning is the 1:1 reproduction of the analog original. Thus, it is slightly sharper than a descreened scan. However, the fonts are more difficult to read, and the pictures show the distinctive marks of the printing method. Facsimile scanning is used to preserve the original magazine when you plan to do some post-processing later. For any kind of retouching and restoration, a facsimile is the perfect ground-level state.

Input	Media	Color photo	There is no descreening in this mode.
Filter	Sharpen	Disable	If you do post-processing, sharpening should happen at the very end of the workflow and not during scanning.
Output	TIFF file	Enable	For post-processing, TIFF is best choice.
Output	TIFF file type	24-bit RGB	You can upgrade to 48-bit, but that would be like cracking nuts with a sledgehammer.

7.7 Photo prints – Scanning printed images

This workflow is for scanning photo prints. The aim is to conserve the original analog pictures in a lean and economical way. As the quality of photo prints is usually much better than magazines, you can get much better image quality from photo prints. But if you have the source negative or slide, that is even better than the print. Scan prints only if the source negative or slide is not available.

Basic workflow for color prints			
Tab	**Option**	**Setting**	**Remarks**
Input	Media	Color photo	--
Input	Media size	*As needed*	Prints usually have a standard size, and you should configure to it if possible. If the print size does not match one of the predefined values, choose the smallest format that fits the original and make fine adjustments in the `Crop` tab.
Input	Scan resolution	600-1200 dpi	You can reduce image noise if the input resolution is higher than the output resolution. Use 600 dpi as the default and upgrade to 1200 dpi for a bit of extra quality if needed.
Input	Auto save	Scan	This option saves the scan automatically after scanning.
Crop	Crop size	*As needed*	Configure the crop size here to cover the entire print.
Filter	Sharpen	*As needed*	Apply the sharpening filter only if you are 100% sure that you won't do any post-processing.
Color	Color balance	Auto levels	You can do a lot of labor-intensive fine tuning in the `Color` tab. For scanning prints, it is usually sufficient to switch to *Auto levels*; this will produce scans rich in contrast. For more neutral colors, choose *White balance* or *Neutral*.
Output	TIFF file	Enable	For images that you are going to post-process in Photoshop, TIFF is usually the best choice.
Output	TIFF size reduction	2-4	This factor depends on the combination of your input resolution and your desired output resolution. If you choose 600 dpi for input and want 300 dpi for output, you need a factor of 2. If you scan at 1200 spi and want 300 dpi output, you need a factor of 4. In most cases, an output resolution of 300 dpi is fine.
Output	TIFF file type	24-bit RGB	Switch to 48-bit if you have appropriate data input. Usually 24-bit is fine.

Output	TIFF compression	Auto	This option enables TIFF compression if it will actually save space. Use this option only if you are sure that your image editor can handle it!

For all variations, use the basic configuration of above and change only the settings described below.

Variation A - Scanning black-and-white prints			
Input	Media	B/W photo	--
Input	Bits per pixel	8-bit Gray	This is usually sufficient for prints. For a bit of extra quality, switch to 16-bit and accept the subsequently bigger file size. If you want to get the best result possible at a great expense, scan in RGB as described above and do the conversion manually with Channel Mixer in Photoshop.
Output	TIFF file type	8-bit Gray	Use grayscale output only if you are sure that your image editor can handle it. The best compatibility is with 24-bit RGB, but this option needs three times more space.

Variation B - Batch scanning of photo prints			

The batch scanning workflow described for slides in this chapter also works well when you have more than one photo in the scan tray. Please compare the appropriate section.

Old and faded paper prints are in many cases the only analog originals that withstood the ravages of time. When the source negatives are lost, you can use those old photos for scanning as well. If the negative is still at hand, you should prefer using that negative.

7.8 Color slides – Scanning E6 and K14 transparencies

This workflow is for scanning color slides. In general, film is the only type of analog original that can be enlarged during output. In theory, you can generate A3+ poster sized prints from an analog slide (though the conversion from analog to digital takes its toll). You are better off with smaller output sizes. The quality can be very satisfying if you scan a good slide with accuracy.

For any film scan, the RAW workflow described below is highly recommended. Only a RAW file allows you to try various settings for a complete roll of film without rescanning; this is quite handy, as there are many filtering options and color corrections available. If you prefer the classic scanning method, just combine the two workflows into one and skip the options related to RAW input and output.

Basic RAW workflow I - From E6 slide to RAW file			
Tab	**Option**	**Setting**	**Remarks**
Input	Task	Scan to file	--
Input	Source	*Your scanner*	--
Input	Media	Slide film	--
Input	Bits per pixel	64-bit RGBI	--
Input	Scan resolution	*Depends on your scanner*	Use the highest optical resolution of your scanner for best scanning quality. For a Nikon Coolscan 5000 film scanner this is 4000 spi; for a flatbed scanner Canon 8800F it is 4800 spi. You can simply pick the highest resolution that VueScan displays here, but keep the resulting size of the RAW file in mind. For 35mm, there will be no problems, but once you start scanning medium or large format slides you might have to reduce the resolution a little bit.
Input	Auto save	Scan	This option saves the scan automatically after scanning.
Perform the Preview. You can skip this to save time if the initial setup is OK.			
Crop	Crop size	*As needed*	Use a setting that covers the whole area of the slide, including the black borders. This will prevent problems with cropping, and you can process the scans faster. As a side effect, the file size will increase slightly. Instead of that, you can adjust the final crop size at this stage.
Crop	Buffer	*As needed*	This setting compensates for the effect of the black borders on the exposure. Usually 10% is sufficient.
Output	Raw file	Enable	--

Output	Raw size reduction	*Depends on your scanner*	This option reduces the high-input resolution to a level that matches both the quality of your slide and the effective resolution of your scanner. Use factor 2 for either a film scanner (e.g., Nikon Coolscan 5000, 4000 spi to 2000 dpi) or a flatbed scanner (e.g., Canon 8800F, 4800 spi to 2400 dpi). An output resolution higher than 2000 dpi is only justified if the slide is of excellent quality and the scanner's effective resolution is higher than 2000 spi. You can do this output size reduction at a later stage, too, but shrinking at the RAW level saves more storage space.
Output	Raw output with	Scan	--
Output	Raw DNG format	Enable	--
Perform the scan. The scanner input will be written to a RAW file.			
Basic RAW workflow II - From RAW file to TIFF/JPEG			
Input	Task	Scan to file	--
Input	Source	File	This option directs VueScan to the storage location of the RAW file.
Input	Mode	Transparency (or *Your Scanner*)	
Input	Media	Slide film	--
Input	Quality	Archive	This preserves the original pixel size of the scan.
Input	Bits per pixel	Auto	This option uses the settings of the RAW file. If you want to change it for any reason, perform a Preview to update the GUI and Preview pane.
Input	Scan resolution	Auto	This uses the original resolution of the RAW file.
Perform the Preview. With a RAW file as data input, it only takes a second.			
Crop	Crop size	Auto	The *Auto Crop* setting is convenient. In the vast majority of cases, it delivers good results with no effort. If it fails, you can still adjust the crop manually.
Filter	Infrared clean	*As needed*	Check the effect of this option on different correction levels, and choose the weakest setting that delivers satisfying results. In general, the *Medium* setting works well for most slides.

Color	Color balance	Neutral	For post-processing in Photoshop, *Neutral* is in general the best setting. But it preserves the original color casts of the slide as well. If you want more correction by VueScan, try *White balance* instead. *Auto levels* is more of a setting for JPEG output when you don't want to do any post-processing.
Color	Slide vendor	*As needed*	Adjust these settings according to your source slide. If there is no profile for your film, use the GENERIC profile. In some cases, you can achieve good results with a profile designed for another film. Even when you are using film profiles, some manual correction in Photoshop is usually required.
Color	Slide brand	*As needed*	Compare above.
Color	Slide type	*As needed*	Compare above.
Output	TIFF file	*As needed*	Use this option if you want to post-process the image in Photoshop. Choose 48-bit RGB for the best quality.
Output	JPEG file	*As needed*	Use this option if you do not want to post-process the image in Photoshop. Keep in mind that you will get more artifacts if you dim the settings for JPEG quality.

Perform the scan. This will convert the data input from the RAW file into a JPEG or TIFF.

For all variations, use the basic configuration of the two workflows above and change only the settings described below.

Variation A - Batch scanning with flatbed scanner

Every flatbed scanner can carry more than one slide at a time. This is perfect for batch scanning. Just insert the slides, do all the configurations, and then go off and do something else when the scanner works unsupervised. In general, it is best to do different batches for different types of originals. Don't mix color slides with negatives, or photos with magazines or newspapers. Correctly sorted scanning is much easier.

Basic RAW workflow I - From E6 slide to RAW file

Crop	Multi crop	Custom	Here you enable more than one crop at the same time. Usually VueScan detects film holders automatically, but you can configure it manually, too. Switch between different frames via **Input** ▶ **Frame number** or by clicking in the **Preview** pane.

Perform the Preview.

Input	Batch scan	All	Use this option if you want to scan all the frames in the batch. Choose *List* if you want to select frames.

Output	Auto file name	Enable	If you enable the option, VueScan will write the scans onto the hard disk withour further inquiry.
Prefs	External viewer	Disable	When this option is enabled, the viewer window will pop up after each scan.
Prefs	Beep when done	Enable	VueScan will beep when the batch is done, so you don't have to keep checking the status of the batch.

Perform the scan.

Basic RAW workflow II - From RAW file to TIFF/JPEG

The workflow described above also works fine if you are using RAW files instead of a physical scanner. For easier processing, store all of the RAW files from one batch in one folder on your hard disk. You can configure the settings for each frame individually if needed, e.g., different color settings for each frame. VueScan saves the settings individually for each frame, but only for the current batch. With the next preview, all individual settings are wiped out! Then all frames will have the settings of the frame chosen during the preview. It's best to do just one preview for each batch to avoid confusion. If you want to assign the current color settings of a single frame to the full batch without a new preview, you can use the option `Color` ▸ `All frames`. Select it, and all frames will have the same settings. The `Crop` tab has an *All frames* setting as well, but usually it is of little use as the crops may vary.

Variation B - Batch scanning with a film scanner

Many film scanners have an automated feeding unit; one that can either handle batches of framed slides or an automatic feeder for filmstrips that works with unmounted slides and with negatives. In contrast to batch scanning on a flatbed scanner, the originals are moving. That's why a preview of all frames is difficult to impossible, and the crop settings are not really accurate.

Basic RAW workflow III - From E6 slide to RAW file

| Input | Batch scan | Off | If you switch it *On*, the preview is performed for all frames of the slide feeder, which is time-consuming and unnecessary. For the final scan, the feeding unit has to transport every frame again, and the position can vary. Do a preview of the first frame only. |

Perform the Preview.

Crop	Crop size	*As needed*	Use a setting that covers the whole area of the slide, including the black borders. This will prevent problems with cropping, and you can process the scans faster. As a side effect, the file size will increase slightly.
Crop	Buffer	*As needed*	This setting compensates for the effect of the black borders on the exposure. Usually 10% is sufficient.
Crop	All frames	Enable	All crops will have same size and position.
Output	Auto file name	Enable	VueScan will write the scans directly onto hard disk.

Prefs	External viewer	Disable	The viewer window will not pop up after each scan.
Prefs	Beep when done	Enable	VueScan will beep when the batch is done, so you don't have to keep checking the status of the batch.

Perform the scan.

Basic RAW workflow IV - From RAW file to TIFF/JPEG

This workflow is the same as for the flatbed scanner.

Variation C - Scanning Kodachrome slides (K14)

The structure of Kodachrome is similar to classic black-and-white films. That's why they can't use standard E6 processing but instead require the K14 process. Due to this, `Infrared clean` may not work very well; but this really depends on the scanner and on the development of the Kodachrome. Do some sample scans to find out whether `Infrared clean` is a good or a bad idea for your scanner.

7.9 Color negatives – Scanning C41 negatives

The workflow for scanning color negatives is very much the same as for E6 slides. The only difference is that `Input` ▸ `Media` should be set to *Color negative*. Along with that, you will usually have to do a bit more post-processing in Photoshop, especially if you are using generic film profiles. But this issue is not related to the scanning process itself, that is basic image editing.

7.10 Black-and-white negatives – Classic and chromogenic film

The workflow for black-and-white negatives is in general the same as the workflow for color slides. Apart from the fact that `Input` ▸ `Media` should be set to *B/W negative*, of course. To use `Infrared clean` properly, you have to know exactly what kind of film you are using.

a) Classic black-and-white film

This is silver-based, and `Infrared clean` will not work. So do your scan without the infrared channel. A pixel depth of 16-bit grayscale is the best choice for both input and output.

b) Chromogenic black-and-white film

There are a couple of black-and-white films that you can develop in C41 like any standard color negative film. These films are chromogenic and not silver-based. In this case, `Infrared clean` works perfectly, and you should scan with the infrared channel activated. However, VueScan does not yet support scanning with the infrared channel activated in grayscale mode. If you want to do raw scanning with the infrared channel, you have to use 64-bit RGBI. There is no way to save grayscale with the infrared channel, at least not at the program's current stage of development. If you want to avoid big files, you can either skip the raw process completely or use `Output` ▸ `Raw save film` instead. In this case, film corrections like `Infrared clean` are written irreversibly into the RAW file, and you will not need a separate infrared channel. Then you can choose 16-bit grayscale for output.

Reference – Input Tab

The **Input** tab is the first and the most important tab in the graphical user interface of VueScan. Here all configuration options for data input are available. With average scanning applications, the input options are moderate—usually little more than access to the physical scanner as a data source. With VueScan, however, this is only one of many choices. The most outstanding feature of VueScan is the ability to do virtual scanning, i.e., using RAW files to scan directly from your hard disk. You don't even need to attach a physical scanner.

Contents

A complete reference for the **Input** tab

8.1 Reference – Input tab

The **Input** tab lists a variety of input options; basically, here you configure how VueScan reads the analog original. Please be aware that most settings in this tab influence any raw file as well. This tab also influences all other tabs, as many functionalities vary with different Input options.

This chapter lists all of the options that VueScan provides in this tab. Sooner or later, you may end up searching for a specific option described here that seems to be missing from the application. In most cases, this is due to the fact that VueScan fades out or even removes options that are not needed for specific tasks or that are not supported by the hardware. If your hardware actually supports the functionality, check your settings in the other tabs.

If a changed setting does not create the desired result, look at the **Input** tab. Most likely a change of configuration in this place will restore the missing function. At the end of the day, the entire scanning process depends on data input and its appropriate configuration, which is why this tab is so important.

Input ▸ Task

This is the most used option in VueScan. Here you can tell the application what data input you have and how to control the input process. There are many more input options in VueScan than just plain scanning, as described below.

▸ Scan to file

This is the most commonly used option. Here you instruct the application to do basic scanning. The scan (not necessarily from a physical scanner!) will be stored on hard disk. The exact storage location can be changed in **Output** ▸ **Default folder**. This option covers the standard scanning task, but there are a couple of other options available for specific cases.

▸ Copy to printer

Scanning a document and saving it on your hard disk can be cumbersome if you just want a quick photocopy. In this case, use **Input** ▸ **Copy to printer** instead. The scanner will send the data directly from the scanner to the Windows print dialogue.

If you have more than one printer installed on your system, choose the appropriate printer first. In this mode, VueScan will not save the scan in the **Output** ▸ **Default folder**. Assuming that you don't touch the default *Auto* values of **Input** ▸ **Media size** and **Input** ▸ **Scan resolution**, and that you set **Input** ▸ **Quality** to *Print*, you will get a good quality printout that has the same dimensions as your original. This is a handy option if you want to use your scanner as a photocopier.

▸ Profile scanner

This option ensures that the scanner can read the image data correctly, which is crucial for exact color reproduction. Color characteristics can vary not only among different types of scanners, but also among scanners of the same model and type. Wear and tear is another reason why scanners have different color characteristics. To ensure that your scanner delivers repeatable results, you must profile it from time to time, with an

Profiling vs. color balance

Please be aware that the results of profiling your scanner are independent from what you configure in **Color** ▸ **Color balance**. Set **Color balance** to *Neutral* if you want the profiled scanner to deliver the authentic color of the original.

IT8 target—i.e., an IT8 reflective or transparent original. By comparing the scan data with the target's stored color information, the scanner can create a profile and reproduce colors more accurately.

▶ Profile printer

If you want to print scanned images via VueScan on your own printer with exact colors, the above-described scanner profiling is only the first step. You also need to profile your printer to ensure that it will print out the correct colors. Unfortunately, you might need not only one, but several profiles for just one printer. A printer profile is only valid for a specific printer/paper/ink combination. If you use different paper, you have to create a new printer profile. If you buy another ink, you have to create a new printer profile as well. Even when you use the same printer the whole time, you will need several printer profiles. That's a lot of work, but it is necessary to produce consistent colors.

Additionally, you should be aware that each time you change the setup of your printer, you must create new profiles. The easiest way to get around this is to use one type of paper and to avoid changing your printer setup once you've found the right working configuration. Please be aware that the VueScan printer profile has no effect if you use another application (e.g., Photoshop) for printing. All in all VueScan is a highly sophisticated scanning application and printing is not its primary field of application. Use the integrated printer calibration of VueScan as it is convenient and free of charge. For more sophisticated purposes you should invest in a dedicated colorimeter and use other output applications instead.

▶ Profile film

If you have already profiled your scanner, you may find it confusing that there is an additional dropdown option for creating film profiles. The solution for this is quite simple: IT8 calibration only works for positive targets, like slides or reflectives. For negative film, you need separate film profiles.

The colors of negatives are not only inverted, but also the film has some masking applied. Standard masking for color negative film is orange. In the old days, this masking made it easier for photolabs to work with film in their chemical processes. But in regards to scanning, the inversion plus the masking presents difficulties. It's quite tough to get a scan with correct colors from a negative. Specific film profiles can be a big help. Although VueScan comes with film profiles for Agfa, Fuji, Kodak, etc., you still may need an individual profile if you use an exotic film. To profile a specific negative film, grab a roll, put it in your camera, and take a picture of an IT8 target. After the film is developed, you can use this frame in **Input** ▸ **Profile film** to create your individual film profile.

Film profiles and their limits

Please keep in mind that while film profiles for negative film can be useful, they are far from a universal remedy. Film changes its characteristics over time. If you generate a film profile from a fresh roll of Kodak Gold 100, it will not necessarily match your archived negatives of Kodak Gold 100 from the 1990s. In the best case scenario, a film profile can alleviate post-processing complexity, but manual corrections are often needed nevertheless.

▶ Make IT8 target

VueScan already contains the image data for an IT8 scan. If you use **Input** ▸ **Make IT8 target** and press the `Scan` button, VueScan will print out an IT8 target. If you want to see the image, press the `Preview` button. An IT8 target will show up that can be "scanned" just like any image you physically put in the scanner. **Input** ▸ **Make IT8 target** is used solely for printer profiling. It cannot be used for scanner or film profiling. But you can actually use it to generate an image file that serves as a perfect blueprint of how the color reproduction of your scanner should be.

Input ▸ Source

This option allows you to choose where VueScan gets its data. With **Input** ▸ **Source**, you can switch between different data sources. Data sources for VueScan include all scanners installed on the system plus the *File* option where you can access image files stored on your hard disk. If VueScan does not find a scanner on the system, **Input** ▸ **Source** is not displayed but VueScan automatically sets it internally to *File*.

If you have more than one scanner installed, you can use all of them at the same time. Just open as many instances of VueScan as you like and use them as separate applications. While this is convenient, you need a powerful computer, preferably a multicore system, for working smoothly with several scanners at once.

Input ▸ Files

You can use this option to specify the path where VueScan can find RAW scan data on your computer. By default, this option points to the same path specified in the **Output** ▸ **Default folder**.

Input ▸ Mode

This option allows you to switch between different scanner modes. Better flatbed scanners usually have two modes. The first is *Transparency*, which means the transparency unit is used for scanning slides or negatives. The second is *Flatbed*, which means you can scan reflective material. The dropdown options in this option will vary depending on your scanner.

Input ▸ Media

The dropdown options in this option will vary depending on your configuration of **Input** ▸ **Source** and **Input** ▸ **Mode**. Here VueScan identifies whether your media is reflective (e.g., a printed photo) or transmissive (e.g., a negative or slide).

Option	Transmissibility	Type	Color gradient	Remarks
Color photo	Reflective	Positive	Continuous tone	---
B/W photo	Reflective	Positive	Continuous tone	---
Line art	Reflective	Positive	Bi-level	---
Text	Reflective	Positive	Bi-level	---
Magazine	Reflective	Positive	Halftone	Contains a color descreen filter
Newspaper	Reflective	Positive	Halftone	Contains a b/w descreen filter
Image	Transmissive	Positive	Continuous tone	no film correction applied
Slide film	Transmissive	Positive	Continuous tone	Changes default film type
Color negative	Transmissive	Negative	Continuous tone	Changes default film type
B/W negative	Transmissive	Negative	Continuous tone	---
Microfilm	Transmissive	Positive	Continuous tone	---

If you are scanning slide film, you can choose either *Image* or *Slide film*. If you choose *Slide film*, film profiles will be applied in the **Color** tab. If you choose *Image*, no film profiles will be applied. The reason behind film profiles is that each slide film has a different color characteristic.

If you want to preserve the film's color cast, use the *Image* option during scanning. If you want your scans to match the original scenery as closely as possible, use *Slide film* instead and pick the matching film profile in the **Color** tab. The film profile will try to remove the film's color cast. The option you choose is a matter of personal taste, as there are good reasons to justify both decisions.

Input ▶ Descreen dpi

The halftone printing method used for magazines and newspapers can cause unwanted effects, e.g., moiré, when scanning. To produce better scan results, use VueScan's integrated descreening functionality. Usually the descreening default value is set to 75 dpi, which covers most imaginable cases.

But for specific purposes, you can adjust **Input ▶ Descreen dpi** in Advanced mode. Unfortunately, there is no rule of thumb to determine the best setting. It depends not only on the printing method but also on the paper. You will have to make some sample scans at different settings to find the best setting for a specific original.

Input ▶ Microfilm zoom

This option is designed for scanning microfilm or microfiche. Because microfilm contains a small-scale version of the original document, it makes little sense to reproduce the original at a scale of 1:1. In order to restore the original, you have to enlarge the scan adequately. Typical zoom values for microfilm range from a factor of 8 to a factor of 14.

Input ▶ Media size

This option helps you determine the size of any reflective media you're scanning with your flatbed scanner. In *Auto*, the application previews the full size of the flatbed unit (which equals the *Maximum* setting) and tries to detect the size and location of the media. This auto detection is quite reliable but not necessarily as exact as a manual adjustment.

Fixed setting vs. automatic detection

If you prefer to choose a size manually in **Input ▶ Media size**, you can skip the preview step and scan directly. This is quite handy, e.g., if you are scanning letter sized reflectives on a letter sized flatbed scanner. You choose the media size only once, which save a lot of time during scanning.

Input ▶ Quality

This option is used to specify the scan resolution automatically. Since transparencies, like slides, allow large magnification scales, it can be helpful to determine the purpose of the scan in advance to save some storage space. For reflectives, in most cases, this is not really an issue. Usually you reproduce reflectives 1:1. Magnification is, of course, technically possible but not advisable.

If you tell VueScan what kind of output you need, it recalculates the scan resolution (i.e., the input quality) accordingly. Determining the best scan resolution, however, can be tricky. For this, you need to know the size of the scanned media, which should be available at **Input ▶ Media size**. Then, you need to know what output size (e.g., 4" x 6") is desired and what your output media is. For screen display, anything above 96 dpi is sufficient; for good quality prints, you need at least 300 dpi. VueScan offers some standard resolution figures for different purposes, which may vary for originals of different sizes as you can see in the following table.

Option	Dimensions in pixels	Spi	Remarks
Slide 24 x 36 mm (Nikon Coolscan 5000, max. 4000 spi)			
Email	708 x 472	500 spi	---
Web	1417 x 945	1000 spi	---
Print	2834 x 1890	2000 spi	---
Edit	2834 x 1890	2000 spi	---
Archive	5669 x 3780	4000 spi	max. optical resolution
Reflective 8$^{1/2}$" x 11" (Scanner: CanoScan 8800F, max. 4800 spi)			
Email	620 x 875	75 spi	---
Web	1240 x 1750	150 spi	---
Print	2480 x 3501	300 spi	---
Edit	2480 x 3501	300 spi	---
Archive	2480 x 3501	300 spi	---

If you set **Input** ▸ **Quality** to one of these values, **Scan resolution** will be set to *Auto*. As these standard values cannot offer a perfect solution for every circumstance, it is recommended that experienced users configure scanning resolution manually.

More control with manual resolution setting

Just to reiterate: the **Input** ▸ **Quality** option is designed for inexperienced users. If you are a user who understands the basic principles behind scanning, you are probably better off setting the scan resolution manually. In that case, VueScan will hide the **Input** ▸ **Quality** option.

Input ▸ Bits per pixel

Here you can specify how many bits you have for each pixel of the scan, i.e., the setting for the color depth of the image file. By default, this option is set to *Auto* and depends on the chosen media in **Input** ▸ **Media** (if you don't change it manually). Usually, a modern scanner can save 16 bits per pixel for each color channel. As scanners operate mostly in RGB mode, they have three color channels (red, green, and blue). A scanned image file can therefore contain a maximum of 48 bits (3 x 16 bits) of image data.

Better filmscanners and some flatbed scanners also have an infrared channel (I), since they scan the film surface with infrared light for dust and scratch detection. If you want to keep all information the scanner can gather, you should save your scans as 64-bit RGBI (RGB + infrared) files. The big advantage of this file format for RAW scans is that you can decide, even after scanning, if and at what amount you want to use dust and scratch removal via infrared cleaning. This is not possible with any pixel depth in VueScan except with 64-bit RGBI.

However, RGBI requires a lot of storage space, and for many purposes the scans would be oversized. Regardless of your scanner's actual abilities, you can configure any bit depth you like in **Input** ▸ **Bits per pixel**. If you are scanning negatives and slides at high resolution, you can save storage space if you switch to 24-bit color depth instead of 48-bit. This will accelerate the scanning process for some scanners, and in most cases there is hardly any visible difference between a 24-bit and a 48-bit scan. Keep in mind that you cannot store infrared data in 24-bit scans. For infrared, you need 64-bit RGBI.

Disable infrared channel, save space

For any originals that cannot benefit from infrared cleaning, i.e., all reflectives and classic black-and-white negatives, you should disable the infrared channel to save precious storage space.

Input ▶ Make gray from

A scanner usually has three color channels: red, blue, and green. All three of them are used for a full-color scan. A good film scanner has an additional infrared channel as well. But if you are scanning grayscale, the RGB samples that the scanner picks need to be converted into just one channel: the grayscale channel. By default, **Input** ▶ **Make gray from** is set to *Auto*. Depending on which scanner you use, the conversion is either processed by the scanner hardware or by VueScan. In *Auto*, VueScan uses all of the RGB channels for that, but mainly the green color information. With **Input** ▶ **Make gray from**, you can choose one specific color channel to deliver the raw data for grayscale conversion: the red, green, blue, or even the infrared channel. For old silver-based black-and-white negatives, give the red channel or even the infrared channel (!) a try if standard settings do not deliver sufficient results.

RGB scanning for black-and-white originals?

VueScan's auto conversion to gray scale is quite convenient and delivers acceptable results under normal circumstances. But if you are a quality-conscious pixel peeper, you should not use it. In fact, you shouldn't even use grayscale. Instead, scan your black-and-white negatives in full-color RGB and convert them manually in Photoshop. That way, you can use Photoshop's RGB mixer to determine the perfect setting before you actually convert the scanned image into grayscale. These workflow steps give you maximum control over the resulting image. For everyday use, however, this sophisticated approach is quite cumbersome. Besides, the characteristic color casts of aged black-and-white negatives can give your scans a nice vintage look. If you want to retain those color casts, simply stay in RGB mode.

Input ▶ Threshold

This option appears in the GUI of some scanner devices during 1-bit, black-and-white scanning. You can use this setting to define the difference between black and white. For example, if your original has lightly colored type fonts, you can increase the default value from 128 to 200 or even more. But for most modern scanners, this option is meaningless, and consequently it does not appear in the GUI.

Input ▶ Batch scan

This option appears in the GUI when VueScan determines a setting that can be used for batch scanning. This can happen under the following conditions: first, if you are using a flatbed scanner and you scan more than one picture at a time; second, if your scanner is using a slide/negative feeder; and third, if you are processing more than one scan file directly from the hard disk and the **Source** is *File* and not a scanner.
In all of these cases, you can either switch batch scanning *Off*, enable it via *All*, or choose specific files via *List*. Batch scanning from the hard disk is by far the most convenient option, as you have almost no holding time. If you are right in the middle of a batch scan, there are two ways to stop it. The first and fastest way is to press the Abort button, but this can lead to a half-written file. The second way is simply to change the batch setting to *OFF*. The application will finish processing the current file and then stop.

Input ▶ Batch list

This option pops up when you specify *List* in **Input** ▶ **Batch scan**. Here you can select frames for processing if you don't want to process the whole stack with the same settings. This option is more powerful than it looks at first glance, but it's not really user-friendly. Each frame is numbered. You can select frames individually and separate them by a comma (e.g., 1,3,5), choose a range of frames (e.g., 1-5), or combine both methods (e.g., 1-3,5). Additionally, you can rotate each frame number individually, i.e., 90 degrees to the right by adding an R, or 90 degrees to the left by adding an L (e.g., 1,2L,5R). You can even allocate mirroring by adding an F to the frame number (e.g., 1F). You can only allocate one letter per frame. That means you cannot both flip and rotate an image during batch scanning (e.g., 1RF will not work). VueScan only processes the last letter associated with a frame and skips the letter in the middle.

Input ▶ Multipage

If you have a multipage paper document and want to convert it into a single multipage PDF or a single multipage OCR, choose this option. The `Preview` window and button will disappear, which is quite surprising to beginners. In this mode, you actually have to press the `Scan` button to generate a preview! After each scan, you can exchange the originals until you have processed your stack. When the last scan is finished, press the button `Last page`. This will eventually generate the image file. You can choose either multipage TIFF or multipage PDF, but PDF is usually the better choice due to its superior compatibility.

Input ▶ Frame number

During batch scanning, the scanner has to process more than one frame. This happens when you attach a slide or negative feeder to a film scanner. If you insert a filmstrip with six negatives, six different frames will appear in the GUI. With **Input** ▶ **Frame number**, you can switch back and forth between these frames. The same effect can be observed when you use more than one image file as a source, e.g., when you do RAW scanning from the hard disk. But even when you just use your plain flatbed scanner, there can be frame numbers. When you select **Crop** ▶ **Multicrop**, you can scan more than one frame on the flatbed unit at a time, e.g., negative strips.

Input ▶ Frame offset

This option only affects scanners that work with a film feeder, like Nikon scanners (Nikon LS-30, LS-40, LS-2000, LS-4000, LS-8000, LS-9000), the Canon FS4000 with a feeding unit, and the Polaroid SprintScan 120 with a medium-format adapter. Here you can adjust the frame offset manually, which can be helpful in scanning panoramic pictures or in correcting a frame offset.

Image editor more comfortable and accurate

Although the workings of the VueScan system are not difficult to understand, the author occasionally experienced some surprises—especially when batch scanning RAW files. Sometimes rotation was not processed, and sometimes the preview window and the file output did not match (even though `Preview` had been executed). Due to their long-winded handling and sometimes erratic behavior, the mirroring and rotating functions in VueScan's batch scanning mode cannot really be recommended at the current state of the application. Any image editor will allow you to readjust your scans more conveniently during post-processing.

Editing the PDF

In the time between scanning and file generation, VueScan offers a row of editing options via the Page settings of the menu bar. The preview windows will be populated after the scans. You can flip through the stack. Each page is a separate frame. **Input** ► **Frame number** display the chosen frame number and at the very bottom of the VueScan window you can find it too. You can move pages back and forth, deleting and adding pages as you like, and control in detail the appearance of the PDF. After pressing the `Last page` button, however, no more changes are possible within the scanning program-VueScan. To edit your PDF further, choose an appropriate application like Adobe Acrobat.

Input ► Frame spacing

This is another option for scanners with a film-feeding unit. Here you can set the spacing between the different frames manually. Usually the automatic frame recognition should sort this out, but if necessary, you can adjust these parameters manually.

Input ► Preview resolution

By default, the resolution for the `Preview` is set automatically by various predefined steps. The default value is *Auto*, but in some cases it can be useful to set it manually. A high-resolution preview allows you to zoom into the preview window at a larger scale; as a side effect, the time needed for the preview scan will be longer. To speed up the workflow, you can set the resolution lower. In most cases, the default value is fine and there is no urgent need to change it manually. If you choose **Custom**, the option **Input** ► **Preview dpi** will pop up.

Input ► Preview dpi

This option allows you to fine tune the preview resolution even further. You can choose any value in the range of the scanner's optical resolution. This is more a gimmick than a useful feature, as VueScan will simply rescale the scan. Usually you are better off choosing one of the proposed values in the dropdown list at **Input** ► **Preview resolution**, or just sticking with the *Auto* value. In contrast to the final scan, the preview scan is usually not saved anyway, so there is no reason to invest much energy in the perfect preview setting.

Input ► Scan resolution

By default, the scan resolution is set to *Auto* and follows the setting chosen in **Input** ► **Quality** (e.g., *Print*, *Edit*, *Archive*, etc.). To configure it manually, choose one of the resolution values in the dropdown list. For an CanoScan 8800F in transparency mode, this would be 4800, 2400, 1200, or 600 dpi. (Keep in mind that the correct unit for scanning resolution still is spi, not dpi as it is labeled here.) If you switch to reflective mode, 300, 150, and 75 dpi will be added to this list. Consequently, the dropdown choices depend not only on the scanner, but also on the scanning mode. Alternatively, you can choose *Custom*, which allows you to choose scanning resolution as described below.

Input ► Scan dpi

This option pops up whenever you set **Input** ► **Scan resolution** to *Custom*. You can either type in the required scan resolution manually or use the slider for the same purpose. The maximum value is the optical resolution of the scanner. As with **Input** ► **Preview dpi**, this is not really a useful feature.

A scanner can scan properly only at its optical resolution (e.g., 4800 spi) or parts of it (e.g., 2400, 1200, 600, or 300 spi). If you choose 297 spi, the scanner will actually scan at 300 spi and scale the image down to 297 spi. Avoid this, as image quality does usually not benefit from rescaling. It's better to choose one of the values that VueScan proposes in the **Input** ▸ **Scan resolution** dropdown list.

Input ▸ Rotation

Here you can rotate the image. There are four options: *None* (no rotation), *Right* (90 degrees clockwise), *Flip* (180 degrees clockwise), and *Left* (90 degrees counterclockwise/270 degrees clockwise). So, you can rotate the image in all four possible directions. The rotation is effective even in RAW files, and for TIFF, JPEG, and PDF files as well. To minimize post-processing effort, it is wise to rotate images here; but keep in mind that this operation needs some extra memory. If you have a modern computer with at least 2 GB of RAM, this should not be an issue. Note: although **Input** ▸ **Rotation** is located above **Input** ▸ **Mirror**, the rotation is actually performed after mirroring.

Input ▸ Auto skew

A common problem during scanning is pictures that are not aligned correctly. Even when you insert an original with care, it is almost never aligned straight to the grid. In this case, you can use the **Input** ▸ **Auto skew** option. In most cases it works fine, and it can be switched on by default.

Input ▸ Skew

This option works similarly to **Input** ▸ **Auto skew**, the only difference being that the user decides if and at what degree the skew angle should be corrected. If you want no skewing at all, just uncheck **Input** ▸ **Auto skew** and don't touch **Input** ▸ **Skew**. By default, they are set to 0, which means no correction at all.

Input ▸ Mirror

Here you can mirror an image. Apart from experimental use, this option is used only when scanning transparencies—more precisely, transparencies that you inserted upside down in the scanner by mistake. While you can use **Input** ▸ **Mirror** to fix this, the better alternative is to insert the originals correctly in the first place. In most scanners, the film emulsion side should be face down to guarantee optimal scanning quality. To sum up: try to avoid mirroring and invest more energy in properly positioning the originals on the tray.

Confusing rotation directions?

Please note that these rotation options do not correlate with the pictures shown in the Preview/Scan window. Instead, they relate to the unrotated image from the scanner. This can be confusing, especially when you are trying different settings. In this case, set the rotation back to *None* and then choose the setting you need directly. The rotation buttons directly below the Preview window (Rotate clockwise / Rotate counterclockwise) are more user-friendly. Just click a couple of times and watch how the settings change at **Input** ▸ **Rotation**.

How to determine the emulsion side of film

If you hold a slide at an angle and look at both sides, you will see that one side is glossy and has no visible structure. That is the supporting level. The other side will show structure like a relief image. That is the emulsion side, and it should point towards the sampling unit of the scanner. While it is possible to scan through the supporting level of the film, it will lead to a minor decrease in scanning quality.

Input ▶ Autofocus

First of all, congratulations if you see this option in your VueScan GUI! In that case, you most likely own a high-quality film scanner; cheaper scanners cannot usually do autofocus. Focusing can be an issue when you scan transparencies, but for reflectives it is of no concern. Nevertheless, autofocus functionality is a must for expensive scanners with marginal depth of field. There are four options: *Manual*, *Preview*, *Scan*, and *Always*. Performing autofocus takes some time, and with the Input ▶ Autofocus option you can configure when you want to focus.

Setting	Focusing	Advantage	Disadvantage	Recommendation
Manual	Only by user	Focusing can be done precisely when it is needed	You can easily forget the focus, and this will result in unsharp images	For control freaks only
Preview	Before Preview. You focus only once per image, and the Preview focus is used for the scan as well	Preview image will be sharp, allowing you to make your best judgment of the original	In some cases, you can do the scan without a Preview. In this case, the scanner will not focus at all. In very rare cases, the slide can bend between scanning and be out of focus. The same thing can happen when using slide/negative feeders.	Default option that works well with most standard scanning operations
Scan	Before Scan. No focus before Preview	Will ensure a sharp final scan	Preview might be unsharp in some cases	Focusing before scanning is the best way to ensure a sharp scan
Always	Before every Preview and every scan	Preview and scan will both be sharp in any circumstances	This mode is time-consuming and in many cases not needed	From the quality point of view, this setting is perfect, but it will slow down your workflow

In general, the focus settings for `Preview` and `Scan` will be the same, but there are some exceptions. In very rare cases, the scanner light source can heat up the slide over time, causing it to bend and subsequently be out of focus. As modern scanners usually use cold LED lights, this is no longer an issue, and the few devices with old-style lamps usually don't have autofocus. If you use a slide/negative feeding unit that moves the originals, refocusing before every scan can be a good idea.

As with any other focusing mechanism, a scanner's autofocus can only focus on one appointed area. This focus point is marked by an animated crosshair in the Preview window. You can specify the placement of the focus point at **Crop** ▸ **Focus X/Y offset**. If you have a curly piece of film, you must place it carefully on the scanner—the area of greatest focus will not cover the whole negative!

Manually triggering autofocus

Use the shortcut `Crtl`+`F` to start autofocusing manually. You can perform this in any mode of **Input** ▸ **Autofocus**.

Input ▸ Focus

Here you can adjust the autofocus manually if (!) your scanner supports autofocus and (!) you have set **Input** ▸ **Autofocus** to *Manual*. Please keep in mind that you must do another preview scan before you can see the effect of the focus change in the **Preview** tab. If you actually want to see the effect, set the preview resolution up to the optical resolution of the scanner and zoom in to the **Preview** tab. You can either use the slide control or focus with the shortcut `Crtl`+`F`.

Input ▸ Auto scan

Pressing the `Scan` or the `Preview` button is not a big deal when you insert a slide into your scanner. But if you scan a few hundred slides in a row without the help of a slide feeder, it would be nice if the scanner started working directly when you insert an original. With the **Input** ▸ **Auto scan** option, you can trigger either a *Scan* or a *Preview* automatically. Once you abort one of these operations, the option is reset to its default, *None*, and you must enable it again manually.

In some circumstances, this feature can be a pain—e.g., if you are working with a film adapter, like the SA-21 for Nikon scanners, and you have a film offset. In this case, you waste a lot of time on preview only to find out that all of the images are shifted, and you have to do previews for the whole filmstrip again. But if you are working with a single slide mount adapter, like the MA-21 for Nikon scanners, then **Input** ▸ **Auto scan** is indeed very helpful. Blessing or curse, it all depends on your scanning hardware.

This option is only displayed when the scanner can sense inserted media or when the scanner is capable of addressing frames separately. Some scanners, especially the Nikon film scanners, can sense when you've inserted a slide or a film strip. You can use this option to configure an automatic action when a slide or film strip is inserted. The option is only used when the scanner can sense a media change - either a page inserted in a document feeder, a slide inserted into a scanner, or a strip of film inserted.

Input ▸ Auto save

Scanning and saving an image are generally two separate steps in the workflow. You can see this when you set the **Input** ▸ **Autosave** option to *None*. After each scan is completed, you must press the `Save` button to save the image on the hard disk. The automatic setting via preview or scan is more convenient. After the preview or scan, the resulting file is stored automatically.

The location of the folder is determined in the **Output** tab at the corresponding file type. As a default setting, the *Scan* option is recommended; storing previews is an interesting gimmick but usually not reasonable.

Input ▶ Auto print

This output option may be helpful in some cases. Here you can print automatically after each preview or scan. By default, it is set to *None*, which means no automatic printout. If you just want to use the scanner as a photocopier, use **Input** ▶ **Task** ▶ *Copy to printer* instead, but the scanned image will not be stored on the hard disk. **Input** ▶ **Auto print** is just another output option that allows printing parallel to saving. It may be preferable simply to trigger a print manually after preview or scan via the command File ▶ Print Image or the shortcut Ctrl + P .

Input ▶ Auto repeat

Unique to VueScan, this option provides timer functionality that starts scanning at a specified offset. You can determine whether it is really useful or not, but either way it is an interesting gimmick. By default, it is disabled via *None*. If you change the setting to *Continuous* and press the Scan button, the scanner will start to scan in an endless cycle. After each completed scan a new scan will start—all of the same original! While this is a nice feature for fatigue testing your scanner, it is not necessarily useful in daily life.

Alternatively, you can choose time intervals ranging from 2 seconds to 8 hours. This is useful if you have a sophisticated workflow, e.g., if you are scanning a batch of prints and you want to do nothing more than change the originals in the tray. From a manager's point of view, **Input** ▶ **Auto repeat** is perfect, as you can dictate the desired working speed to your assistant! OK, in all seriousness, if you are doing monotonous scanning operations, this option can be helpful—provided you can swap the originals in the scan tray during the specified time frame. Of course, any scanner with an automatic feeding unit is a smarter solution for this kind of scanning task.

Input ▶ Auto lamp off

Some scanners can switch their lamps on and off via software. Modern scanners that use LED lights usually do not have this feature, but occasionally you can still find it. LEDs need no preglow time, but old-style fluorescent lights do. If you switch the old lights on and off via software, there will be some time delay until the scanner is ready to operate again.

When you choose *None*, the scanner lamp is always on and never switches off. The option *Always* switches the lamp off after each scan and when you exit VueScan. If you choose *5 minutes*, the lamp turns on when VueScan starts and turns off when the application exits. Five minutes after the end of the scan, the lamp turns off as well. The last option, *Exit*, ensures that the lamp turns on when VueScan starts and turns off when the application is closed.

Input ▶ Auto eject

This option is a useful feature when you are working with automatic feeding units like the Nikon SA-21 for Nikon Coolscan V and Coolscan 5000. In any case, you will need hardware that provides eject functionality, and a simple flatbed scanner does not. **Input** ▶ **Auto eject** allows you to eject the originals automatically under certain conditions. With *None*, the scanner never auto ejects the originals. You can eject them with the shortcut Ctrl + J or via the menu command Scanner ▶ Eject. With *Preview*, the auto eject happens after the preview scan. Usually this is not recommended, as you still want to do the scan. With *Scan*, the auto eject happens after the scan. In general this is useful, but sometimes it is quite the opposite.

For example: you want to scan a filmstrip (6 separate images) with a Nikon Coolscan 5000 and an SA-21 film feeder. You scan the first image with no batch scanning, as you want to scan each image individually. After the first scan, VueScan ejects the filmstrip although there are still 5 images to go. This can be rather annoying. But if you scan all of the images on the filmstrip in a batch, that's a different story. Then VueScan ejects the filmstrip after scanning the last image, which is very useful. The last option is *Exit*, which ejects the filmstrip when VueScan exits. This is convenient, because otherwise you would have to restart VueScan to release the filmstrip.

Input ▸ Number of samples

If your scanner supports multisampling, this option will be visible. By default, the number of samples is *1*, which equals a standard scan. The technology behind multisampling is simple: each line is read multiple times before the scanner advances to the next step. For noise reduction purposes, you can increase the number of samples up to *16*—which will extend the required scanning time considerably. Multisampling can improve overall image quality, image noise, and grain, but image quality will not necessarily improve with every additional pass. As an unwanted side effect, the overall sharpness may suffer a bit. But this really depends on the scanner you are using. You will have to do some sample scans to find out how pronounced this effect is with your hardware.

Input ▸ Number of passes

For those who do not own a scanner that supports multisampling, here is the solution: Input ▸ Number of passes. When you use this option, the entire image is scanned completely and repeatedly. The benefits and side effects are similar to the multisampling, and the chance of getting a blurred image is slightly increased. But the results ultimately depend on your hardware, and you will have to do some sample scans to find the best setting.

Input ▸ Grain dissolver

This option exclusively affects owners of the vintage Minolta Scan Elite 5400 I. This scanner has a hardware-based light diffuser to enhance grain appearance. A similar system is used nowadays by some high-priced Hasselblad scanners. You can also find it in some accessories like the Scanhancer (www.scanhancer.com), but for desktop scanners it no longer plays an important role.

With this option, you can enable the grain dissolver in the Minolta scanner that by default is turned off. Minolta disposed of the whole idea quite quickly, and the Minolta Scan Elite 5400 II was delivered without the grain dissolver. Then Minolta was swallowed by Sony, but that's a different story.

Input ▸ Frame alignment

Here is another specific feature that only affects Nikon scanners with filmstrip adapters (Coolscan IV/4000 and Coolscan V/5000). With this option, VueScan analyzes the small border between the first and the second frame of the filmstrip and uses that information for alignment. By default, this option is enabled but you can disable it if needed.

Sometimes the automatic frame alignment doesn't work, depending on the type of film or the contrast between the image and the gap between the images. In this case, turn this option off, do a preview of the second frame, move the cursor to where the gap between the frames starts, look in the lower right corner for the Y offset (in millimeters), and type this value into the Input ▸ Frame offset option. Then re-do the preview of the second frame and see if everything is aligned properly.

Input ▶ Fine mode

This is an option for the Nikon Coolscan 5000 and Nikon Coolscan 9000. These scanners have multiline CCD sensors; the Coolscan 5000 has a sensor with two lines, and the Coolscan 9000 has a sensor with three lines. If `Input` ▶ `Fine mode` is enabled, VueScan uses only one line. This reduces the scanning speed, but in some cases it can improve the scan quality if you have dark film originals. By default, this option is disabled.

Input ▶ Multi-exposure

This is an interesting option when you are scanning transparencies; it is not available for reflectives. Multi-exposure increases the dynamic range of your scanner and can help get additional details out of an image, especially in the darker regions. It resembles a 2x multisampling/multipassing, but there is a major difference. With multi-exposure, only the first pass has a normal exposure. The second pass has a longer exposure to get more details out of the shadows. Multi-exposure merges the two images into one, and the new image subsequently has a higher dynamic range than a standard scan. This option extends scanning times and shares the same side effects as multisampling and multipassing.

Input ▶ Lock exposure

With this option, you can lock the exposure of the image when scanning transparencies. Similar to a digital camera, the scanner analyzes the image and tries to find the appropriate exposure time via exposure measurement. Under normal conditions, the exposure measurement happens for each image separately. If you enable this option, the exposure will be locked for subsequent images. By default, it will keep the settings calculated for the most recent preview or scan. To configure the exposure value manually, use `Input` ▶ `RGB exposure`. You will save time by locking the exposure, as the exposure measurement will be skipped. This can be useful during batch scanning, especially when you are scanning a roll of film and want to produce consistent colors. It will lock the exposure of the raw files only without directly affecting the final images. This must be done by enabling `Input` ▶ `Lock image color`. By enabling `Input` ▶ `Lock exposure`, the additional options `Input` ▶ `RGB exposure` and `Input` ▶ `Infrared exposure` will appear in the GUI.

Input ▶ RGB exposure

This option allows you to control the exposure time of the scanner by controlling RGB brightness, provided you have a scanner that can vary its CCD exposure time. Under normal conditions, there is no reason to adjust exposure time manually; the automatic exposure is quite reliable. Like `Input` ▶ `Lock exposure`, this option affects the raw file, and the final image output can be different due to the settings in the `Color` tab. Changes in `Input` ▶ `RGB exposure` can have some unwanted side effects. By increasing the exposure, you can in fact squeeze out some more details out of dark areas of the slide. But the dynamic range of a scanner is limited, and most likely your scan will have clipped highlights. In rare cases, you can use this option to save some details in underexposed or overexposed originals. But for daily scanning, you are better off not touching this option. Using `Multi exposure` is usually better than tweaking the exposure.

Input ▶ Infrared exposure

This option controls the exposure of the infrared channel, if your scanner has one. The infrared channel is not a visible part of the final image. Its information is used internally for dust and scratch removal via `Filter` ▶ `Infrared clean`. Thus, you can use `Input` ▶ `Infrared exposure` indirectly to control the filter impact. It is a nice feature to play around with, but there is usually no reason to touch it.

To control the filter impact, use the various options in **Filter** ▸ **Infrared clean** instead. However, if you are generally unsatisfied with the filtering quality of your scanner, you might want to try a different setting.

Input ▸ Red/Green/Blue analog gain

Nikon scanners can control the exposure time for each color channel separately; this is called analog gain. Apart from the separate control for each channel, it is identical to **Input** ▸ **RGB exposure**. Whether you increase a setting in **Input** ▸ **RGB exposure** or all three channels with the same value in **Input** ▸ **Red/Green/ Blue analog gain**, the result is actually the same. Please be aware that the setting in both options adds up if you use them at the same time.

Input ▸ Lock film base color

Every film has a base color that needs to be corrected independently from the image's exposure, color casts, etc. You can see this easily with color negative film. It is not only inverted but also has a prominent orange mask. VueScan tries to correct this base film color automatically and independently from the other color settings. If you are scanning a roll of film you can—and, as a matter of fact, you should—lock these base color corrections for consistent scanning results.

This is easier said than done, as this option is well hidden in the guts of VueScan. First, you have to select **Input** ▸ **Lock exposure**. Then, you have to perform another preview scan. After the preview, the option **Input** ▸ **Lock film base color** will pop up (but only if **Input** ▸ **Media** is set for film originals!). If you select it, you will notice that three new options will appear in the **Color** tab (**Film base color red** and **Film base color green** and **Film base color blue**). These display the automatically generated values for the film base color, and you can configure them manually as you like.

Input ▸ Lock image color

This is another option that's remarkably well hidden in the depths of the VueScan GUI. First, you must select **Input** ▸ **Lock exposure**, then perform a preview scan. After the preview, the option **Input** ▸ **Lock film base color** will pop up. If you select it, eventually **Input** ▸ **Lock image color** will be visible. This option locks the black and white points used in the most recent preview or scan. It is helpful when you are scanning a series and want to provide consistent lighting for all of the images.

Input ▸ Default options

This is a convenient way to reset all of the options in the **Input** tab to default values. If you accidentally click it, you will lose all your manually configured settings in this tab and have to start from zero.

Reference – Crop Tab

Cropping is an indispensable part of the scanning process, and VueScan offers a wide rage of parameter adjustments for this work step. Whether you want to determine the frames manually or cede this step to the scanning application, there is definitely more than one road leading to Rome. It's your choice as to which of these options suits your individual scanning needs best.

Contents

A complete reference for the **Crop** tab

9.1 Reference – Crop tab

The crop area in VueScan serves two purposes. First, it marks the area that is actually going to be scanned by framing it with a blinking dashed line. Everything outside the crop area will—surprise, surprise—be cropped. Second, the crop area plays an important role in calculating color balance, histogram, and other exposure settings. If needed, VueScan has some options that allow you to configure exposure settings independently from the crop.

VueScan offers a wide range of cropping options—manual, automatic, and in-between. For a preview of the cropped original, switch over from the `Preview` window to the `Scan` window. The cropping frame can be adjusted in the corresponding tab or simply via the mouse in the `Preview` window. The easiest way to change the coverage of the crop is the mouse. Position the mouse pointer over the blinking line, click and hold the left button, and drag the line to the desired position. If you position the mouse pointer at a corner of the crop, you can change its size vertically and horizontally at the same time. For repositioning the whole crop without any size change move the mouse to the center of the crop box and drag it into any position you like. The cursor will change then. Cropping should be executed with care, as the options in this tab influence even the raw file. What you cut off during scanning cannot be reproduced at a later stage.

Crop ▶ Crop size

This option determines the size of the crop area in VueScan. If you change the size of the crop frame via the mouse, you will easily see changes here. Moving the whole crop without changing its size has no effect. Although it may look easier at first glance to use the mouse instead of the menu, the menu can be the better option for many scanning tasks. Let's look at the different options in detail.

▶ Manual
This option allows you to configure the crop manually. If you change the size (not the position!) of the crop manually, the setting jumps to *Manual* immediately.

▶ Auto
This setting automatically determines the size and position of the crop frame. `Crop` ▶ `Auto` is enabled automatically. If and to what degree this setting is useful depends on the type of analog original. For transparent media like slides, it is in general useful. Due to the sharp contrast between the slide and the dark, unexposed border of the film, VueScan can detect the image reliably. It's a different story with night shots that are low in contrast; if your eye can not detect the difference between the image and film border, any automatic setting is bound to fail. Even with standard paper documents (black print on white paper), automatic cropping can fail here and there. To sum up: automatic cropping can be useful in certain circumstances, but it is never as precise as the human eye.

▶ Maximum
This is not actually a cropping option, as the scanner simply scans the whole tray. It is quite handy when scanning RAW, but there are some things you should know. First, the scan file will be larger than needed, which can be a serious issue depending on the size of the original and the chosen resolution. Second, the whole tray will be used for the exposure measurement, which can lead to negative side effects if there are thick black borders.

▶ Specific sizes
Here you will find cropping templates for standard analog originals—from tiny APS slides to huge 11" x 17" documents. The choices in the dropdown list will not necessarily reflect the abilities of your scanner.

The list is the same for all scanners that VueScan supports. If you choose an option that is larger than your scanner's tray, the crop will simply cover the whole area. Selecting one of these standard sizes can be extremely helpful during document scanning. If you scan a stack of $8^{1/2}$" x 11" paper documents and convert them into PDF files of the same size, there is no need to fool around with cropping. In this case, the input and output sizes are exactly the same, which makes life easy. Just set the crop size to $8^{1/2}$" x 11", position the originals properly on the scan tray, and start scanning. Other settings like 35mm film and 35mm slide are less easy to handle because the standardization of these originals is less strict. The actual image size of 35mm film depends not only on the camera but also on the lens. There are slight variations, plus you have to take care of the notorious film offset for the proper positioning of the crop.

Crop ▸ X/Y size

Here you can set the crop size manually and define it with more precision than by using the mouse. This option is displayed only if `Crop` ▸ `Crop size` is set to *Manual*. The X size determines the horizontal resizing, and the Y size the vertical resizing. The unit is millimeters by default; you can change it in `Prefs` tab.

Crop ▸ Auto offset

Detecting the proper position of the analog original is an important workstep when the original is much smaller than the scan tray. If you enable `Crop` ▸ `Auto offset`, the application will try to find the position automatically. In general, this function is quite reliable, but there are some limitations already described above in the *Auto* setting of `Crop` ▸ `Crop size`. With `Crop` ▸ `Auto offset` enabled, VueScan needs to perform a preview before actually performing the scan. For batch scanning, it should be disabled.

Crop ▸ X/Y offset

Here you can configure the offset of the crop manually if `Auto offset` is disabled. This is more precise than using the mouse for repositioning the crop box, but it is quite cumbersome to handle. In most cases, using the mouse is more convenient. You can enhance the precision of manual offset either by using a big screen (for a big preview window) or by zooming in to the preview on a smaller screen if needed. This will combine sufficient accuracy with comfortable handling.

Crop ▸ Multi type

This option is displayed when you are using a film scanner for 35mm slides with the option `Crop` ▸ `Crop size` set to *Auto*. By default, `Crop` ▸ `Multi type` is disabled and the scanner will search for standard-sized 35mm frames (24 x 36 mm) only. But if you enable `Crop` ▸ `Multi type`, it will search for more exotic size variations of 35mm film as well (10 x 13 mm, 24 x 18 mm, 28 x 28 mm, 28 x 36 mm, and 40 x 40 mm). Enable this option only when needed to avoid erroneous detections.

Crop ▸ Multi crop

This option is used for scanners that can have more than one original in the scan tray at a given time. A typical example is a flatbed scanner with a transparency unit that are uses black plastic masks for the tray. Here you can process whole filmstrips or multiple slides at a single blow. Of course, you don't want to scan the whole tray as a single image; you want to choose the images separately. With `Crop` ▸ `Multi crop`, you can tell VueScan (or let it detect automatically) how many frames you need for your scan operation. There are three options. If you disable it with *Off*, you will have only one frame for the whole tray.

Displaying and handling multi crops

If you want to see all the frames of the multi crop, enable `Crop` ▸ `Show multi outline`. By default, you will only see the selected frame, which might be confusing if you are working with multiple crops. You might have to rerun the preview to actually show them. If your mouse pointer is located over the crop, VueScan will display the corresponding frame number inside the grid. With one click, you can select the appropriate frame directly; there is no need to use `Input` ▸ `Frame number`. The frame number will only be displayed for frames that are currently inactive. Once you choose a frame, its frame number will no longer be displayed in the grid.

If you set it to *Auto*, VueScan will try to detect the number of analog originals on its own. The hit rate varies, depending on the originals; in general, it is advantageous to use original film holders to improve the detection rate. If you set it to *Custom*, you can manually configure the number and size of frames needed. For details, please compare the next option.

Crop ▸ X/Y images

Here you can configure how many separate frames you need when using `Multi crop` ▸ *Custom* . With `Crop` ▸ `X images` (e.g., 2 frames), you determine the number of frames in the horizontal line. With `Crop` ▸ `Y images` (e.g., 3 frames), you determine the number of frames in the vertical line. The absolute number of frames is the scanning grid, i.e., the product of X and Y (e.g., 2 horizontal x 3 vertical frames = 6 frames overall). Only one frame is displayed at a given time, which might be confusing for beginners—most scanning applications from hardware manufacturers work differently.

In the author's opinion, the multi crop implementation of VueScan needs an overhaul—but once you are familiar with it, it's good enough. If you change to `Input` ▸ `Frame number`, you can switch back and forth between the frames. Any chosen frame of a multi crop can be configured like any frame of a standard single crop. You can change the size and position of the crop as you like, even rotate it. In case you get lost, the current frame number is always displayed in the footer of the VueScan GUI.

By default, the frame grid is identical with the crops of the different frames. You can reconfigure each frame's size and location separately if needed. In this case, the grid will still be displayed in the background.

Crop ▸ X/Y spacing

The option only shows up when `Crop` ▸ `Multi crop` is set to *Custom* and more than one frame is specified via `Crop` ▸ `X/Y images`. This option determines the absolute widths (X spacing) and the heights (Y spacing) of all frames of the multi crop. Actually, the nomenclature is somewhat misleading, as you define the size of the individual crops here. For 10 x 15 cm prints you would have to set `Crop` ▸ `X spacing` to *100* and `Crop` ▸ `Y spacing` to *150* (if the crop unit is millimeters). In general, these sizes should equal the sizes of the analog originals. You can change easily the crop units from millimeters to inches in `Prefs` ▸ `Crop units`.

Crop ▸ X/Y padding

By default, the grid with the cropping frames is centered in the preview window. Use `Crop` ▸ `X/Y` padding if you want to change this. You can only do so if `Crop` ▸ `Multi crop` is set to *Custom* and if there is more than one frame. Correct positioning of the grid with this option can be tricky, as you will soon find out when playing around with it.

Crop tab

Crop ▸ X/Y linked

By default, the configuration of a film offset is valid only for the chosen frame. With `Crop` ▸ `X/Y linked`, you can link the frames in a horizontal (X) or vertical (Y) direction. The offset of one image will be applied to the whole filmstrip. This is a very useful option when you are scanning filmstrips with an automatic film feeding unit.

Crop ▸ Show multi outline

This option shows the lines that define the multi crop boxes in the Preview window. By default, you will only see the selected frame. This can be quite confusing when you are working with multiple crops. But you can fix this easily. You have to rerun the preview. This will actually show you the multiple crops in the Preview window.

Crop ▸ Auto rotate

This option works only with a single crop; multi crop is not supported. `Crop` ▸ `Auto rotate` will automatically rotate the crop into portrait or landscape alignment. The rotation direction will depend on the crop size; `Crop` ▸ `Auto rotate` will try to cover as much of the image as possible. Of course, this will work only if the crop is small enough to be rotated within the preview area in both directions. It is useful for some slide scanners that allow you to insert the slide in any direction.

However, Nikon film scanners will not benefit from this option, as there is only one way to insert a slide properly. If you do it the other way, this will result in cutting the edges. Preview is mandatory for this option, so it should be disabled for batch scanning.

Crop ▸ Crop orientation

`Crop` ▸ `Auto rotate` rotates the crop (specified in `Crop` ▸ `Crop size`) automatically, and `Crop` ▸ `Crop orientation` is the manual alternative. Here you can align the crop as a *Portrait* (long side vertical) or as a *Landscape* (long side horizontal) by choosing the appropriate adjustment. This option shows up only when `Crop` ▸ `Auto rotate` is disabled. Another thing worth mentioning: multi cropping is not supported with this option.

Crop ▸ Lock aspect ratio

By default, this option is disabled (*Off*), and you can change the aspect ratio of the crop box by dragging it with the mouse. If you choose `Crop` ▸ `Lock aspect ratio`, you can still modify the crop size, but the aspect ratio will not change. With *Image size*, the aspect ratio is inherited from `Output` ▸ `Printed size`. With *Manual*, you can configure it as you like; compare below.

Crop ▸ Aspect ratio

This option shows up when you choose `Crop` ▸ `Lock aspect ratio` with the setting *Manual*. The value 1 will produce a perfect square; if you increase the value, it will convert into a rectangle. If you need a crop with an aspect ratio of 2:3 (e.g., for a 4" x 6" print), you must divide the longer edge by the shorter edge for a value of 1.5 (3/2 = 1.5). This option is very useful if you need the scans for a dedicated output size and you don't want to crop them again in post-processing. It is a great help if you want to produce consistent scans and for batch scanning, too.

Crop ▸ Border (%)

This option effectively enlarges or diminishes the scanned area beyond the crop box. Since the scan exposure measurement only includes what is inside the crop, you can use this option to create a security margin that ensures you will not accidentally crop an edge of the original. The default value is 0; if you increase it (e.g., +10), the scan will be bigger than the crop.

If you decrease it (e.g., -10), the scan will be smaller than the crop. The values are a percentage of the original crop size. Unfortunately, there is no way to display the border area, which makes the configuration somewhat imprecise. To see the effect of this option, you must change from the `Preview` window to the `Scan` window and pull the slider of `Crop` ▸ `Border (%)`.

Crop ▸ Buffer (%)

Unlike `Crop` ▸ `Border (%)`, this option leaves the effective crop size untouched. It causes VueScan to ignore some of the image data at the inside edges for exposure management and color balance. This is perfect for raw scanning. Slides can be scanned full size, and you don't have to worry about the black edges that can wreck a scan. With `Crop` ▸ `Buffer (%)`, VueScan will simply ignore the border areas of the image. It should be noted that the buffer value is a percentage of the effective crop size, and there is no feasible function in VueScan to show you its coverage.

As stated above, the effective and the displayed crop are not identical if you use `Crop` ▸ `Border (%)`. In that case, the official VueScan reference recommends setting `Crop` ▸ `Border (%)` slightly higher than Buffer values, but this is only needed if you are enlarging the effective crop size via a positive value for `Crop` ▸ `Border (%)`. If you are diminishing the effective crop size with a negative value, you will not need this. As VueScan has no proper preview function to show you the coverage of Buffers and Borders, it is best to use only one of these options at a time. Actually, `Crop` ▸ `Buffer (%)` is more precise as the displayed crop is identical with the scanned image.

Crop ▸ Preview area

By default, the scanner will display the whole scan tray for the preview. In some cases, however, this is not desirable or necessary. Scanning 35mm slides is a common example, as most scanners use only a small area in the middle of the scan tray for this purpose. Another example is scanning $8^{1/2}$" x 11" documents. Most scanners have a scan tray that is slightly bigger than $8^{1/2}$" x 11"—so if you reduce the `Preview area` to $8^{1/2}$ x 11", you can reduce scanning time without effectively losing anything.

With *Manual*, you can define the size and position of the preview area exactly. This can be a bit tricky, as there is no preview functionality for this option. You will have to perform a `Preview` to check your settings. The *Crop box* is easier to handle, as the current crop box is the preview area. After performing a preview, the setting automatically changes to *Current*. You cannot configure this setting; it is just a status notification. *Default* and *Maximum* are in most cases identical. *Maximum* displays the full scan tray, and this is usually the default setting, too. Small originals can be placed on the scan tray either in portrait or landscape alignment. For most scanners, landscape is the better option because in that position, the stepper motor moves as little as possible. Consequently, scanning in landscape mode is faster than in portrait mode. Especially when you do batch scanning, this can help you to save some time

Crop ▸ Preview X/Y offset

The option `Crop` ▸ `Preview X/Y offset` allows you configure the position of the preview area with `Crop` ▸ `Preview` set to *Manual*. The general process ist describe in `Crop` ▸ `Preview X/Y size` below.

Crop ▸ Preview X/Y size

This option configures the size of the Preview area. There is no preview functionality for size and/or offset, so it can be cumbersome to find the best setting—especially when the preview is not clinging to the upper left corner of the scan tray (i.e., where X offset = 0 and Y offset = 0). The only way to check your settings is to run Preview after each configuration change. This will take some time and that's why the use of this option is not really easy to handle at the current development stage of VueScan.

Crop ▸ Focus X/Y offset

Better film scanners have autofocus functionality that allows you to position the autofocus measuring field at will. Crop ▸ Focus X/Y offset and the blinking cross that marks the autofocus measuring field are only visible if your scanner supports autofocus. After you change the offset configuration, you will have to perform a preview to update the position of the blinking cross. Good film scanners, e.g., Nikon scanners, have an extremely small depth of field. It is actually smaller than the depth of field needed to scan a curly piece of film accurately across its width. The depth of field is less than 1 mm and that is not enough for curly film.

There are two ways to deal with curly film. The easiest is to locate the focus point on the most important part of the picture—e.g., for a portrait, that usually would be the eyes.

If you closely examine a piece of curly film, you will see that the curling is usually most pronounced in the middle of the film strip. In general, depth of field covers some of the area in front and behind the actual focus point; this effect is well known, as photographic lenses and scanner lenses work similarly. For optimal depth of field, the focus point should be located somewhere between the image center and the border. As most originals tend to show a degree of sharpness at the border anyway—a well-known limitation of most lenses—the focus point should be closer to the image center than to the border. In general the only way to completely avoid this problem is to use perfectly flat originals. Easier said than done, as film tends to get more curly during aging. But actually that is not an exclusive problem of scanners. It starts much earlier while the film is inside the camera where the film strip is never completely flat. There were cameras like the Contax RTS III that even had a little vacuum pump built into the camera body, which was intended to enhance the flatness of the film. I am not sure if the Contax system really worked, but especially for small film formats like 35mm flatness of the film always has been an issue.

Crop ▸ All frames

By default, the settings in the crop tab apply only to the chosen frame. If you enable this option, the configuration will apply to all frames equally. Crop ▸ All frames is visible when you use multiple frames.

Crop ▸ Default options

Here you can reset the default configuration of this tab with a single click.

Slide mounts vs. film holders

For good scans, you should ensure that the film you are scanning is as flat as possible. There are special slide frames on the market (e.g., Wess) with tensioning features. These devices flatten any piece of film more efficiently than the film holders provided by scanner manufacturers. You can use slide frames for negative film if you don't mind cutting your negative strips. In any case, a flat original is the basis for a good scan.

Crop tab

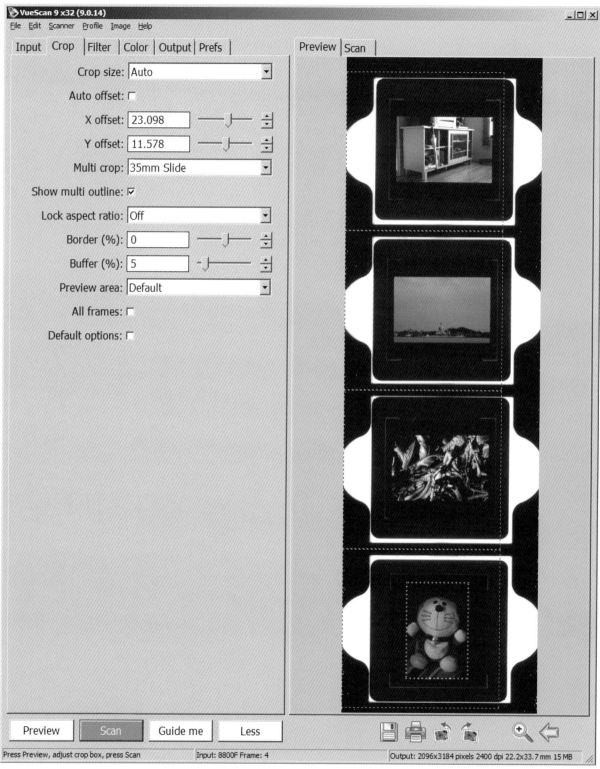

By default there is only one crop per scan. If you place more than one original on the scantray, use the **Multi crop** functionality of VueScan instead. Then you can have separate crops for each original.

Reference – Filter Tab

A good scanner will reproduce your reflective or transparent original exactly, but the resulting unprocessed scan is usually far from desirable. Depending on the condition and the age of your original, there can be undesirable side effects. Faded colors, dust and scratches, and a generally fuzzy appearance are frequently visible in an unprocessed scan. This is usually not a malfunction of the scanner, but rather simply what happens when you reproduce an analog original 1:1 with a state-of-the-art device. To convert an unprocessed scan into a decent picture, you will have to filter it! This is the point where the **Filter** tab of VueScan deserves your attention.

Contents

10.1 Reference – Filter tab

Filtering is an important step in image refinement, but you can wreck your scan completely with a wrong filter setting. Fortunately, a big advantage of VueScan over other scanning software is that its filter settings do not manipulate the raw file. Just choose an output file type that can store all of the information of the raw scan. You can perform any filtering option in VueScan conveniently after the raw scan—e.g., you can try as many filter settings as you like without having to rescan once. This alone is a good reason to dump your manufacturer's software and buy a VueScan license.

Filter ▸ Infrared clean

Modern scanners can read the tiniest bit of information on an image. Unfortunately, they also record details we could do without: specks of dust and scratches. A tiny scratch in a 35mm slide may seem insignificant when you examine the original on a lightbox, but the scanned image will tell a different story. A tiny scratch in the original will appear as a major ditch on the computer screen due to the strong magnification of the scanner. There are four configuration options for Infrared Clean : *None*, *Light*, *Medium* and *Heavy*. They control the filtering intensity. If you choose a setting that is too weak, VueScan will not remove all scratches and dust particles. If the filter setting is too strong, this may lead to artifacts. You can control the display of filtering intensity by enabling Color ▸ Pixel colors .

Manual vs. automated correction
After scanning, you can always touch up dust and scratches image by image in Photoshop. Most image editors can handle these functions, and Photoshop also has convenient plug-ins. However, software cannot easily distinguish dust and scratches from other image details. Therefore, the process cannot be automated. In some cases, manual retouching makes sense; it gives full control over the corrections required to improve image quality. For large numbers of images, however, it is too time-consuming and therefore not practical.

To sum up: manual dust and scratch removal in software is used mainly as a makeshift when hardware-based methods fail. The dust and scratch removal option in VueScan is Infrared Clean . Like all of the other filtering options discussed in this chapter, you will find it in the Filter tab. It is hardware-based and costs you no effort. Simply activate Infrared Clean , choose an intensity level, and let VueScan do the rest automatically.

How it works: Infrared channel
Before a filter can effectively remove dust and scratches, the program needs to know the location of those interferences in the image. This is a crucial issue, as software-based algorithms are far from precise. A classic scanner with only three color channels for RGB reproduction is not sufficient for this task. A good scanner nowadays has an additional channel, the dedicated infrared channel, which contains the information that an infrared beam gets by sweeping the image. VueScan not only uses the infrared channel for Infrared Clean, but also allows you to store it separately or together with the RGB information in the image file.

Infrared Clean works perfectly with transparent media like color negatives (C41 process) and color slides (E6 process). Switch on Infrared Clean when scanning these types of originals. Dust and scratches will be visibly reduced, and negative side effects of the filter are minimal. You can use it with reflective originals as well, but usually it will not lead to a visible improvement. In some cases, e.g., with matte finish reflective originals, using Infrared Clean can even result in a completely blurry image. So, in general, Infrared Clean should be disabled for reflective media.

Scanner light source and scratches
The scanner's light source plays a major role in highlighting scratches in transparent originals. The comparatively harsh LED light of Nikon film scanners (e.g., Coolscan V/5000) tends to emphasize scratches.

This effect is less pronounced in scanners with softer, more diffuse light sources like the fluorescent lamps in older flatbed scanners (e.g., Canon 9950F). There is little you can do about this effect once you have bought the scanner, but infrared-based dust and scratch removal makes it a nonissue for color slides/negatives. However, for black-and-white scanning where infrared beams are misrouted, it may be worthwhile to change your scanner model.

Infrared Clean with black-and-white film

Conventional black-and-white film contains silver crystals that prevent dust detection via the infrared beam. These films are explicitly not supported by `Infrared Clean`! This is a general technical limitation, as there is no scanner or scanning software that offers effective automated scratch removal for black-and-white originals. This does not apply to chromogenic black-and-white films that can be developed with the C41 process for color negatives like Ilford XP2. But, in fact, those films cannot be regarded as true black-and-white films; they are more or less color films without any color.

Infrared Clean with Kodachrome

Kodachrome slides are also special; they are based on a different technology (K14) than normal slide film. Kodachrome slides very much resemble classic black-and-white films. Due to this, infrared-based dust and scratch removal with Kodachrome is tricky. VueScan includes a sophisticated algorithm for determining the relationship between visible light and infrared light with Kodachrome, since Kodachrome dyes can be seen strongly in infrared light. Even different batches of Kodachrome will have different relationships between visible and infrared light, but VueScan determines this relationship for each slide scanned and compensates for it. The only time VueScan has a problem with Kodachrome is when the slides weren't properly developed and there are residual silver particles in the dark areas of the slide. In this case, you can determine this by enabling `Color ▸ Pixel colors`. By default this option is set to *Red* for `Infrared defect color`. There you can follow up which pixels VueScan regards as dust spots, they will be displayed in Red. If too many pixels in the dark areas are red, pay careful attention to whether the cleaning worked in these areas. Only some types of improperly developed Kodachrome will have this problem though.

Configuring Infrared Clean

The configuration of the filter is quite simple. There are four options: *Light*, *Medium*, *Heavy*, or *None* (which disables the filter). In general, every filter has some unwanted side effects, so it is best to use a filter only when absolutely necessary. It follows that `Infrared Clean` should be switched on only when needed and then only at the lowest intensity level that produces the desired result. Infrared-based dust and scratch removal can reduce the sharpness of an image, although this effect is less pronounced in VueScan than in other programs that use such methods as Digital ICE.

Like its competitors, `Infrared Clean` uses interpolation to fill in the pixels where the the infrared beam detects scratches. Although this interpolation is on a high level, it is still just a guess. The stronger the filter is, the more image space will be detected as faulty, and the more likely it is that your correction will produce some unwanted artifacts. That's why you should only use a filter when it's actually needed.

When you're doing batch scans and have no time for individual fine tuning, simply switch on `Infrared Clean` and let the scanner automatically processes the scans. Usually the *Light* setting is sufficient; if that's not enough, switch to *Medium*. *Heavy* should only be used when the originals are in very poor condition. By the way, properly cleaning the originals before scanning is far better than using a strong filter on scans from dirty slides.

Speaking from experience, it is next to impossible to find any slide or negative that has no scratches and is completely dust-free. Scanning services that process thousands of pictures every day usually use `Infrared Clean` or comparable filters. These filters definitely improve the overall image output with little effort. Manual correction will lead to even better pictures, but you have to invest a lot of time for it.

Filter tab

Filter tab

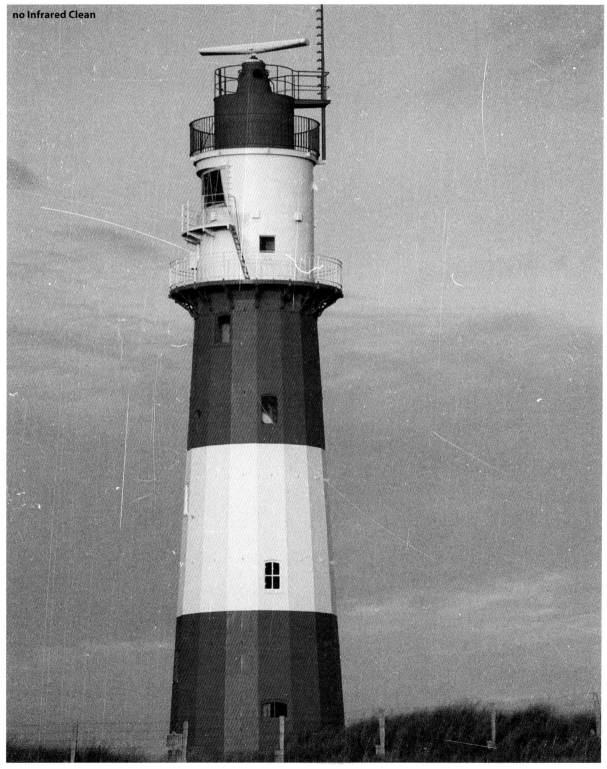

no Infrared Clean

This piece of color negative film (Agfa Optima) from the early 1990s has a scratched surface. It needs either manual retouching after scanning or appropriate filtering during scanning.

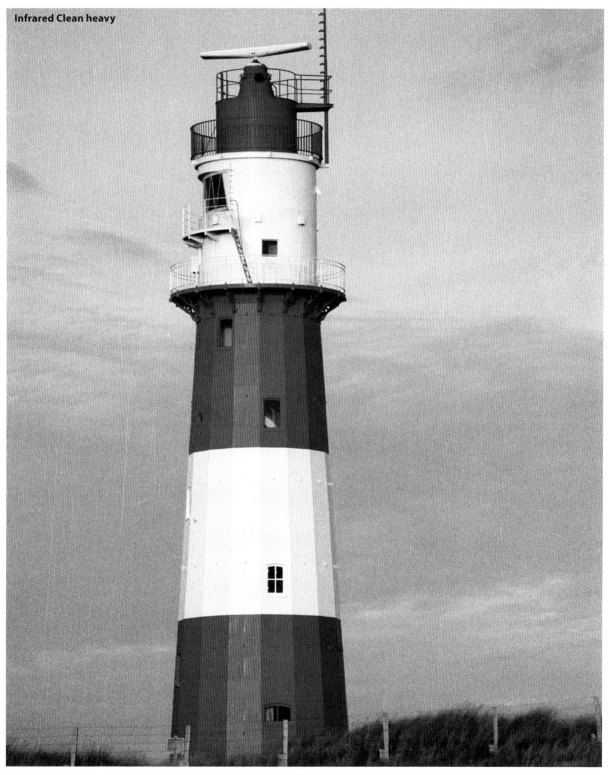

Infrared Clean heavy

Infrared Clean can detect and remove scratches and dust automatically. This will improve the quality of the scan visibly. There is only little if any need for manual retouching if the user enables this filter.

Enable Color ▶ Pixel colors and VueScan's Infrared clean will mark everything it regards as scratches or dust in red colors. This is great to estimate the effect of the filter before scanning, it helps to find the right setting.

VueScan is able to display and save the infrared channel where you can see the amount of surface damages. This filmstrip is extremely scratched and a good test for the efficiency of Infrared clean.

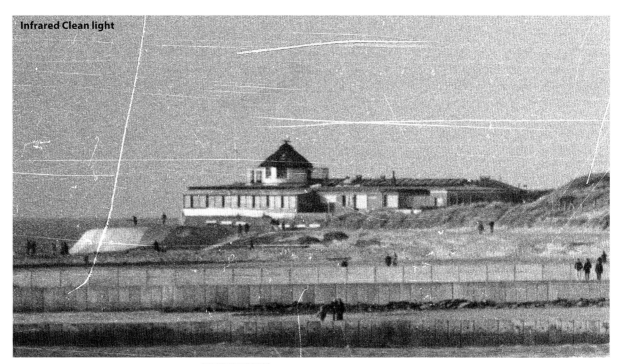

Infrared Clean light

The filtering intensity in the *Light* setting of **Infrared clean** is low. This is enough for originals that are in very good condition, but this negative needs a stronger setting.

Infrared Clean heavy

The *Heavy* setting filters out many more scratches than the *Light* setting, but of course there are limits. You can remove these remaining long and deep scratches only by manual retouching in Photoshop.

Efficient workflow with RAW scanning

If you are quality conscious, there is no other option that equals filtering each picture individually. The preview window in VueScan will show the different filtering results as you switch through the options. Since VueScan works with raw data internally, you don't need to rescan when you change the filtering intensity. VueScan will take a few seconds to apply the new filter setting, and that's it.

Still, it is time-consuming to do this procedure before every scan. It is far more convenient to scan a whole batch in raw first. As a second step, you can read the whole batch by changing Input ▶ Source to *File*. Then you can do all of the filtering very efficiently, as you no longer have to wait for the scanner. It is much faster to access a RAW file from the hard disk than from even the best scanner. The RAW workflow is possible with any filter in VueScan, not only with Infrared Clean.

Filter ▶ Restore Colors/Fading

A digital picture is immune to aging. If it is stored properly, a digital image will not show any signs of wear, even if you store it for decades. This attribute makes digital images the perfect solution for archiving analog originals. With scanning, you can preserve the given state of an analog original for eternity.

Unfortunately, many analog originals may already be in a condition where the ravages of time are highly visible. If you scan slides from the 1980s, at least some of them will show age-related damage. Fading is the most common occurrence. All color pigments fade over time; there is no way to stop this. With time, slides that were once luminous and colorful will lose some of those qualities. That is one reason—apart from hairstyles, automobiles, and fashions—you can easily distinguish vintage slides from new slides.

In addition to fading, you will most likely see age-related color casts. Color casts can happen even with brand-new film. A good example is Fuju Velvia 50, a very popular slide film in the 1990s. This Velvia produces a light magenta color cast by default. This color cast is a wanted effect, and you should preserve it. But more often you will see age-related color casts that are less pleasant, e.g., strong green or red. They simply ruin the whole picture.

The reason for age-related color casts is simple. Take color slides as an example. Slide film has several layers, each of which represents a different color. Over time, as slide film ages, each of these layers ages—but sometimes at different speeds. Over time, this will misalign the color balance of the slide and result in color casts. In the Filter tab, VueScan has two options for color restoration.

Projecting E6 and Kodachrome slides

Kodachrome slides have a reputation for keeping their original colors stable even over long periods. In general, this is true, and many archives have old Kodachrome slides that are in very good shape despite their age. On the other hand, Kodachrome is notorious for dying out extremely fast, which can result in dull colors compared to newer slides.

This may sound like a paradox, but there is truth in both statements. The long-term stability of Kodachrome depends on its storage conditions. Like any other film, Kodachrome should be stored in a cool, dry, dark place. If exposed to sunlight or the harsh beam of a slide projector, slides fade quickly. With Kodachrome, this effect is even more pronounced than with average E6 slides.

So, if you want to keep your slide collection in good shape, store your slides properly and avoid projecting them. A slide show with scanned images on your computer screen may seem tiny compared to a traditional slide show of analog originals on the silver screen—but from a conservation point of view, it is clearly the better choice.

The first filter, Restore Colors , will restore each color channel—i.e., the program itself tries to restore the red, green, and blue color channels separately. The second filter, Restore fading , will restore the effects of film fading and thus remove color casts. Both options are quite limited with no fine tuning possible—you can only enable or disable them. In practical use, the results of these color restoration options vary. Sometimes they improve an image, sometimes not. In any case, the results will not match what you can achieve with post-processing in Photoshop or any other good image editor where you can control the level of correction yourself. If you are not a Photoshop guru, you can use plug-ins like ASF Digital ROC. Digital ROC is a good plug-in for color restoration, but unfortunately you have to buy it separately. To sum up: color restoration is an important issue in scanning, especially for old slides. You can try the VueScan onboard solutions, but for outstanding results you would be better off shifting this work step to image post-processing in Photoshop.

Filter ▸ Grain reduction

Film grain is the analog counterpart of digital image noise. From a technician's point of view, both effects are nothing more than interferences. If you look at real-life scenery, you will see neither grain nor image noise. If you take a picture on film, you will most likely see film grain; if you take a picture with a digital camera, some image noise may be visible, especially in low-light conditions. The perception of these effects is unequal. While digital image noise is widely regarded as undesirable, analog film grain is nothing less than an object of worship. Film grain is reputed to give each type of film an individual fingerprint, and it actually does. While a good digital photo usually has no visible image noise, a good analog shot will most likely show prominent film grain. So, in general, nobody should be unhappy about some film grain in a scan, right? Well, that depends on exactly what happens to the analog original when you scan it.

Most analog pictures were taken when nobody had a computer at home, not to mention a scanner. In the past, the wet chemical process of the photo lab optimized film grain to give the best results. Nowadays some films on the market have improved scanning abilities. But for most analog films in the archives, this is not the case. The appearance of film grain in a scanned image can range from acceptable to annoying. At least in some cases, there is a need to minimize or even remove the grain completely.

Grain is not a fixed parameter, either on film or during scanning. First of all, the appearance of grain depends on the film and its speed. Slow films like Kodak T-Max ISO 100 tend to have extremely fine grain. The faster the film, the bigger the grain, as you can easily see by looking at the prominent grain of Kodak T-Max ISO 3200. But choosing the film type is only one factor. The amount and appearance of the grain is heavily influenced by the film's exposure and development. The grain can differ not only among different film rolls of the same type, but also among different pictures on the same roll!

Once you start scanning, things get even more complex. The scanner light, the chosen resolution, and the overall sharpness of the optical system all play important roles in reproducing grain. First-class film scanners like the Nikon Coolscan 5000 with its harsh LED lighting relentlessly chisel every bit of grain out of the analog original—especially when scanning at maximum resolution. In regard to grain reproduction, the much cheaper flatbed scanners are usually more docile, especially those that use old-style fluorescent lamps.

Grain reduction vs. dedicated noise specialists

If you are looking for alternative noise filtering options, you will find a wide variety of programs. Almost any image editing program (e.g., Photoshop) and any RAW converter (e.g., Adobe Lightroom or Apple Aperture) come with integrated noise filtering options. However, these programs are usually designed for digital noise and not for film grain. Programs like Neat Image, Noise Ninja, AKVIS Noise Buster, Noiseware, Kodak Digital GEM, and Nik Dfine are dedicated noise specialists that allow more fine tuning in noise/grain removal.

Filter tab

Filter Tab (sidebar)

Filter ▶ Sharpen

Sharpening is an indispensable part of the workflow when processing digital images. Both digital cameras and scanners use anti-aliasing filters to improve overall image quality, but these filters have an unwanted side effect: they reduce sharpness. So no matter how good your scanner or your lens is, the unprocessed raw image will appear unsharp!

If you want to convert a raw image into a crisp, clear picture, you will need to sharpen it. Some cameras and cheap scanners presharpen their images automatically to leave a better impression, but from a quality point of view this is far from optimal.

VueScan offers the option **Sharpen** in the **Filter** tab for this purpose, but you should use it with care. This built-in sharpening option is fully automatic. You can enable or disable it, but no fine tuning is possible at all. This is far from desirable, as unsharp masking can be a sophisticated process—especially if you are a quality-conscious pixel peeper who wants to enjoy pictures even in 100% view. A full range of configuration options would be better, but unfortunately VueScan has nothing to offer here.

In a quality-conscious workflow, VueScan is only the first step. For appealing results, the scan should be post-processed via an image editor. This is the point where a previously applied unsharp mask would be troublesome. Unsharp masking should be the very last step in any workflow. If you adjust contrast levels or correct the tonal range, both standard corrections in any workflow, these settings would interfere with an existing unsharp mask.

All in all, the sharpening option of VueScan should only be enabled if you are definitely sure that the scan will not be post-processed, e.g., during PDF creation. Then it is a convenient option to improve the overall sharpness of the picture. If you plan to post-process your images, it should be disabled. You can produce better results if you do sharpening with a good image editor after scanning. Of course, this requires some extra time and may not be necessary for some purposes.

Filter ▶ Default options

Here you can reset the default configuration of this tab with a single click. This option is only displayed if you actually changed the default configuration previously.

Reference – Color Tab

Vibrant colors make the difference between an ordinary and a superior scan. Since finding the correct color is a crucial part of every scanning activity, VueScan offers a wide variety of options to serve this purpose. You can control the color balance of the scan itself, apply a film profile, manipulate the brightness, or set up full-fledged color management, just to name a few options.

Contents

A complete reference for the **Color** tab

11.1 Reference – Color tab

Color is a vital part of photographic images, and since the 1950s most photographers have preferred color film to black-and-white. In scanning color originals, you will face two major challenges. The first challenge is reproducing the analog original as closely as possible. For positive targets, you can calibrate your scanner to enhance its accuracy; for negative film, there is no comparable technique. The second challenge is accurately reproducing the colors of the original scenery. This is a task where film profiles can potentially help improve your scanning results. Keep in mind that the settings in the **Color** tab do not affect the RAW file itself, so you can conveniently apply color settings after the scan if you are scanning RAW.

Last, but not least, the accurate reproduction of colors depends on your scanning hardware. A good scanner can reproduce vibrant and brilliant slide colors, but a cheap scanner can look quite dull in comparison and not even calibration can help. Neither VueScan nor Photoshop has any way to compensate for this. To obtain the best colors in your scans, buy the best scanner you can afford.

Color ▶ Color balance

Every cheap digital camera has built-in functionality for **White balance**. This nomenclature is not precise; in fact, it does not refer to white balance at all, but rather to color balance that aims to achieve natural colors—one of which is white. The appropriate function in VueScan is **Color** ▶ **Color balance**. This option will balance out all three color channels individually, and usually there are some predefined settings for ease of use. None of these settings affect the RAW file. Check it yourself by displaying the raw histogram with the shortcut Ctrl-1. You can fiddle around with these settings as much as you like, but the histogram of the RAW file will not be affected—only the histogram of the image itself Ctrl-4. **Color** ▶ **Color balance** is only accessible if **Input** ▶ **Lock image color** is disabled. In all cases, the RAW file will be gamma corrected for proper display.

▶ None
None is the most basic color correction that VueScan has to offer. This is a gamma correction applied to convert a dark raw scan into an acceptable image and to correct the color response of the scanner's CCD.

▶ Manual
Here you can control the color balance manually—the expert's choice. There are sliders for black point and white point, plus appropriate options for the red, green, and blue color channels. With black point and white point, you can stretch the intensity range of the image. In both cases, you try to shift the curves (all three RGB channels together) to the ends of the scale. For black point, it's the left side of the histogram, and for white point it's the right side of the histogram. A perfect setting is achieved when the outer curve adjoins the end of the scale, there is no empty space, and none of the curves is cut off.

In the next step, you can adjust the different color channels separately. If you adjust each of them as described above, you will usually remove color casts that result from shifted color balance. But since each histogram and each analog original is unique, there is no universal cure. With **Color balance** ▶ *Manual*, however, you can comprehensively control the color balance of your scan. The controls are a bit unwieldy compared to the tools in Photoshop. In VueScan, you have to fiddle around with the sliders until you find the best setting. The displayed image histogram Ctrl+4 is a big help.

▶ Neutral
With this option, the black and white points are stretched automatically and the color channels remain untouched. It's a minimalistic and convenient correction. If you still have color casts, you might want to try another option or switch over to *Manual*. There is no way to control the balance of the color channels here. If you want to do post-processing and color correction in Photoshop, the setting *Neutral* is a good choice.

▶ **Tungsten**

Tungsten light is produced by standard incandescent light bulbs—i.e., old-fashioned bulbs, not energy-saving fluorescents. This setting will adjust the black and white points and remove the distinctive reddish color cast that most indoor images get from tungsten light. For indoor pictures taken with flash, this setting is not appropriate, as the flash will outshine the bulbs.

▶ **Fluorescent**

Fluorescent light usually produces a cold green color cast, but the exact color varies depending on the exact type of light. This option corrects the black and white points plus the color balance of fluorescent light. You can try it for any green color cast—sometimes flash can produce a similar cast.

▶ **Night**

The average correction of black and white points is useful for any picture taken under normal daylight conditions. For night shots, it is not recommended and can even completely ruin your image. *Night* is a special setting for night pictures. The darkest 10% of the image is used for calculating the white point. This option is designed to produce the best results in images that contain a good portion of black along with fluorescent lights (green color cast) or average light bulbs (yellow color cast).

▶ **Auto levels**

This simple automatic setting assigns an intensity of 0.00 to dark colors and 0.95 to highlights. In one setting, you can achieve a good color correction and more brilliant colors for most images. It's ideal for beginners or people who are short on time. Experienced users can achieve better results with manual tweaking and a bigger investment of time.

▶ **White balance**

This setting is designed to produce neutral colors. It sets the black and white points and corrects each color channel separately. The way VueScan's *White balance* works is it searches for the colors that are closest to neutral (i.e. shades of gray) and adjusts the overall color balance so that these colors are shades of gray. Most images have significant areas of neutral (i.e. gray) colors, so this works well with most colors. However, images that should have a strong color cast, like photos taken at sunset, don't always work well with the automatic white balance in VueScan. VueScan detects when an image doesn't have a significant amount of neutral color, and in this case falls back to the *Neutral* color balance setting. The results of *White balance* may look boring when compared to the vibrant colors of *Auto levels*, but *White balance* will definitely be closer to the original shot. As with all color corrections, beauty lies in the eye of the beholder.

▶ **Landscape**

Here is another setting that corrects the black and white points plus all the color channels separately. The aim is to produce neutral colors and to achieve an accurate reproduction of blue sky and green foliage. That means, the *Landscape* setting is perfect for the average usual landscape photography. But of course there are different types of landscape that demand another type of color reproduction. These are any landscape photos with vibrant colors, e.g., active volcanos. Then the *Landscape* setting may not be your first choice.

▶ **Portrait**

Color correction of portrait photos is a difficult issue, as skin tones can be critical. This option is worth a try if you need neutral colors and lifelike skin tones. The *Portrait* option leaves the color balance between the different channels largely untouched. That means it will preserve the original tone of the skin as closely as possible. Please consider that different types of films have a very different color reproduction. You will get neutral skin colors with this setting only if you used an appropriate type of film for the original.

Color ▶ Neutral red/green/blue

You can use this option if `Color` ▶ `Color balance` is set to *Manual* and `Input` ▶ `Lock image color` is disabled. Here you can configure each color channel separately. Don't forget to display the histogram of the image during the process `Ctrl`-`4`. If you move a slider, e.g., for neutral red, you will notice that the red curve of the histogram hardly moves but that blue and green curves change. The same effect (with different color curves, of course) happens when you move the blue or green sliders. Configuration via sliders is cumbersome; it's much more convenient to use the gray point that can be set with a mouse click.

Setting a gray point with the mouse

The gray point is a well-known feature in Photoshop. If an image has a color cast, you can set a gray point to balance out the three color channels automatically and hopefully remove the color cast. This works only if the gray point is set to a neutral-colored spot on the image—preferably a neutral grey spot, but any neutral-colored spot will do (i.e., where red, green, and blue values are equal, like 188/188/188).

VueScan offers grey point functionality as well. Just right click with the right mouse on any neutral-colored spot. This will work unless you enable `Input` ▶ `Lock image color`. You will see that `Color` ▶ `Color balance` switches to *Manual* mode. If you have problems finding a neutral-colored spot (not many people take photos of calibration targets!), there is an alternative if you're scanning slides. Just click on the black border of the film. This is, or at least should be, neutral black. Please be aware that although the border may look pitch black, it may be unevenly colored. Try out different positions on the border, and you will most likely find a neutral spot.

Color ▶ Black point (%)

The black point marks the darkest spot of an image. A properly set black point will improve an image's brilliance and contrast, while a careless setting will result in a loss of tonal values (since dark tonal values will be clipped). This functionality is well known from Photoshop, but VueScan has no way to set a black point via a mouse click. You must use cumbersome sliders instead.

`Color` ▶ `Black point (%)` will set the black point for all RGB channels combined. By default, it is set to 0; sometimes setting it to a higher value can improve an image, but this depends on the image's tonal value. Check the histogram. The curves (at least, the outer curves) should ideally start at the histogram's left corner. In most cases, there will be a gap between the left corner of the histogram and the beginning of the curves. Change the black point settings until the curves start directly at the corner. Avoid cutting off a curve, as you will lose tonal values.

Color ▶ Black point red/green/blue

Here you can set the black point for each color channel separately. As these values are applied directly to linear color space (not gamma corrected space), they are only available when `Input` ▶ `Lock image color` is set. If you want to survey your changes, you have to display the histogram for the image.

Image graph for black and white points

With Image ▶ Graph b/w, you can display the curves and control `Color` ▶ `Black point` and `Color` ▶ `White point` via triangled sliders. Reset any changes with a double click on the appropriate curve.

You can do this with $\boxed{\text{Ctrl}}$-$\boxed{4}$; the graph for the raw scan $\boxed{\text{Ctrl}}$-$\boxed{1}$ is not helpful for this task. The changes will be applied at the raw level, but they will not change the RAW file itself. You basically apply the same settings here as in **Color** ▸ **Black point (%)**; the only difference is that you can control every channel separately. This option's controls are difficult to handle; in most cases, you are better off not touching them and sticking to the default value of *0*.

Color ▸ White point (%)

The white point, like the black point, is generated automatically, and the default value is 1. That means 1% of the brightest pixels in the image are converted to pure white by default. In general, the effect and the handling of the white point equals **Color** ▸ **Black point (%)**, but of course the white point affects the highlights. A properly set white point increases the contrast and brilliance of an image. An inaccurately set white point can result in clipped highlights and an overall flat look. In VueScan, there is no way to set the white point via a mouse click; you have to use the slider instead. For better control, display the image histogram. The white point is set correctly when all curves (or at least the outer curve) end at the right corner of the histogram. An empty gap is not ideal, and a curve that is clipped is worse. But there are some cases when you cannot avoid clipping completely, because you cannot move the sliders far enough.

For average daylight photos, the ideal histogram is shaped like a bell. The curves start in the left corner of the bottom line, go up, then down, and end at the right corner of the bottom line. In most cases, this type of histogram produces the best results, and it can be remembered as a rule of thumb. For exotic cases, like high-key or low-key photos, different rules may apply.

Color ▸ White point red/green/blue

Here you can set the white point for each color channel separately. As these values are applied directly to linear color space (not gamma corrected space), they are only available when **Input** ▸ **Lock image color** is set. If you want to survey your changes, you have to display the histogram for the image and not for the raw scan. The changes will be applied at the raw level, but they will not change the RAW file itself. You basically apply the same settings here as in **Color** ▸ **White point (%)**; the only difference is that you can control every channel separately.

Color ▸ Threshold

This option shows up when you set **Input** ▸ **Media** to *Text* or *Line art* or scan in 1-bit mode. Here you have only two colors while scanning: the black text and the white paper. With the option **Color** ▸ **Threshold**, you configure the threshold, i.e., the border between black and white. The default value is 0.5. If you decrease it, the text will be thicker and more of the image will be black—even light impurities will appear black on the scan. Thus, the higher sensitivity for text recognition brings the risk of unwanted image noise.

If you increase the default value, the sensitivity for text recognition will drop. That means less image noise and a cleaner-looking scan—but parts of the text may be hard to see as an unwanted side effect in some cases. The best individual setting depends on the paper and ink of your original; it is always a compromise. But this sounds worse than it is. In general the readability of the scans really improves by using *Text* or *Line art* mode.

Color ▸ Invert

This option is a simple inversion of black and white. It comes with **Color** ▸ **Threshold** and is useful in the rare case when you are scanning white letters on a black background. Usually, it's the other way around, but exceptions are possible of course.

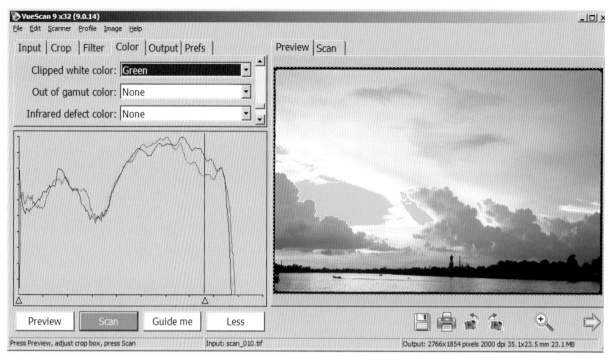

Blown highlights may occur if the slider for the white point clips the highlights. In most cases you can easily fix this by moving the slider to the outer part of the curve.

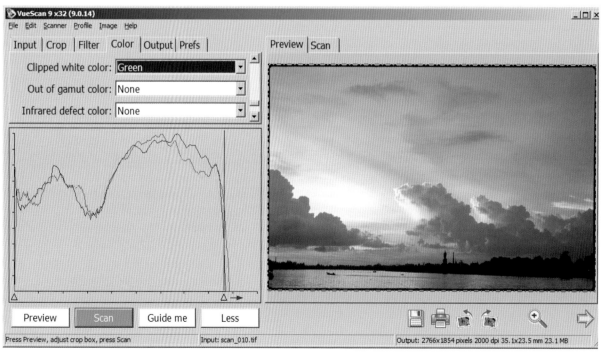

By moving the slider to the outer part of the curves, you can usually fix the problem with the blown highlights easily. The slider allows you stronger settings than Color ▶ White point.

Clipped shadows may occur if the slider for the black point clips the shadows. In some but not all cases you correct it by moving the slider to the outer part of the curve. This image suffers from clipped shadows at the tip of the polar bear's nose.

In most cases it is possible to remove clipped shadows by moving the slider to the outer part of the curve. Not all histograms have a bell shaped curve like this; sometimes they are somewhat clipped in the shadows already, which limits the amount of correction you can apply.

Color ▸ Curve low/high

These options can be used after the black and white points are set. They work similarly to the Highlights/ Shadows filter in Photoshop. Color ▸ Curve low can be used to show more details in the black parts of the image. Color ▸ Curve high can be used to show more details in the highlights. Another way to configure these options is via Image ▸ *Graph curve* Ctrl - 3 using the triangled sliders directly below the graph. While this seems to be more convenient, you can't see the histogram when the graph curve is displayed! This is like flying blind—it's better to display the image histogram with Image ▸ Graph image and use the configuration options of the Color tab.

Resetting Curve low and Curve high to default

If you display Image ▸ *Graph curve* and double click on the curve, you can reset it to the default values. This is the only dedicated reset option for Curve low and Curve high, as Color ▸ Default options resets the whole Color tab.

Color ▸ Brightness

This option controls image brightness by changing the gamma of all three RGB channels at once. Like its Photoshop equivalent, this correction method should be used with care, as it can lead to loss of tonal values.

Color ▸ Brightness red/green/blue

This is basically the same option as Color ▸ Brightness; the only difference is that you can control each color channel separately.

Color ▸ Film base color red/green/blue

This option is displayed when Input ▸ Lock film base color is selected. By default, VueScan detects the base color of the film automatically, but here you can configure it. This is helpful when you are scanning a complete roll of film at one go. It is less helpful when your originals are from different film rolls. Even if you have different films of the same type, they can have different base colors. For example, factors like development, aging, and storage can change base color.

Color ▸ Slide/Negative/B/W vendor/brand/type

Here you can choose film profiles for different types of film. Depending on the setting in Input ▸ Media, either negative or positive films will be displayed. If you have problems identifying your film, look closely at its edges. Usually there is a number that you can Google to find its name. If you don't find your specific film, you can choose a generic film profile. Even a compatible film profile will not guarantee perfect colors. Aging, development, and storage conditions can change film color over time, and manual correction may be needed.

Color ▸ Scanner color space

This is the color space used internally by the scanner. You can either use the *Built-in* profile or embed an ICC profile of your choice. If you profile your scanner with VueScan (Profile ▸ Profile scanner), the created profile is embedded automatically.

Color ▶ Printer color space

You can print out of VueScan directly and configure a special color space for the print data. If you use Windows or any other application for printing an image created in VueScan, this color space has no (!) effect. It is only useful when you print in VueScan directly via File ▶ Print image. You can choose predefined color spaces here, or your own ICC profile for the printer.

Color ▶ Film color space

With VueScan, you can create your own film profile and embed the resulting ICC profile here.

Color ▶ Show IT8 outline

This option displays a grid with the outline of an IT8 target in the `Preview` window. This is useful you when you are creating a scanner profile. You must position the crop directly over the appropriate parts of the target.

Color ▶ Output color space

This is the color space written into the output files in JPEG, TIFF, PDF, and BMP index files. If you open the output file in Photoshop, the image editor recognizes the output color space and uses it. If the color space of the image file differs from the default color space configured in Photoshop, Photoshop will ask you which of the color spaces you want to use.

Color ▶ Monitor color space

This is the color space for your screen. It ensures that preview and scan images are displayed correctly. By default, it is sRGB—an outdated value that should be changed. Most monitors can display more colors than sRGB. The best practice is to embed an ICC profile that is dedicated to your specific screen. You can either download it from the manufacturer's website or create your own profile with a colorimeter.

Color ▶ Scanner/Printer/Film/Monitor ICC profile

This option pops up if you choose the option ICC profile for scanner, printer, film, or monitor space. Here you can specify the location of the desired profile. By default, VueScan only reads existing ICC profiles. If you use the profiling functions of VueScan, however, the program will write ICC profiles as well.

Color ▶ Scanner/Printer/Film ICC description

If you use several ICC profiles, it is easy to lose track of them as they all have the same *.icc* file extension. You can solve this either by a consistent filenaming convention or by a description. This option allows you to add a descripton when you create an ICC profile. A consistent file naming convention, however, is the better option, as you don't have to open the profile to identify it.

Color ▶ Scanner/Printer/Film IT8 data

For calibrating your scanner/printer/film, you need an IT8 target. There are different IT8 targets on the market; they are not fully standardized. So, for proper calibration, you will need the matching IT8 description file that was shipped with the target. Choose it with care—a wrong IT8 description will wreck the calibration.

Color ▶ View color

This option allows you to pick the color channel you want to see in the preview. Internally, scanners work with red, green, and blue color channels, and newer scanners also have an infrared channel. The default setting is RGB, which shows the resulting color picture. But if you use this option to pick each color and the infrared channel seperately, the image shows in black-and-white! This option is useful if you want to choose the color channel for black-and-white scanning that best suits your personal taste.

Color ▶ Pixel colors

This enables all colored markers in VueScan that visualize clipped colors, out-of-gamut, and infrared detection. It can be a big help in finding the best configuration. Once it is enabled, the entire list of options will roll out, and by default there are markings for every option. You can reconfigure the color for each option separately; if you don't need a specific option, simply set it to *None*. A perfect image will show no markings at all, but perfection is always difficult to reach.

Color ▶ Clipped black color

This option shows all of the dark parts of the image that are clipped to black. In this case, color information that is part of the RAW file will get lost during output. You can fix it in most cases by setting the black point.

Color ▶ Clipped white color

With this all of the light parts of the scan that are clipped to white will show up as green. In this case, color information that is part of the RAW file will get lost during output. You can fix it in most cases by setting the white point.

Color ▶ Out-of-gamut color

This shows all parts of the image that are out-of-gamut in a cyan. In this case, color information that is part of the RAW file will get lost during output, because the output color space has a small gamut and cannot properly display a scanned color. You can avoid this by changing to another output color space with a bigger gamut. In some cases filtering options can lead to Out-of-gamut, like `Filter` ▶ `Sharpen`.

Color ▶ Infrared defect color

This displays the results of the infrared detection process. If you enable `Filter` ▶ `Infrared clean`, it will show all defects in a striking red color. If you switch through the different filter settings—*Light*, *Medium*, *Heavy*—you will see how the detection rate changes.

Color ▶ All frames

If you work with multi crop, you may want to apply color settings to all frames in equal measure. You can do this with a single click by selecting `Color` ▶ `All frames`. This option affects all settings of the `Color` tab in equal measure.

Color ▶ Default options

Here you can reset the default configuration of this tab with a single click.

Reference – Output Tab

12

There is no other current scanning program that offers as many sophisticated output options as VueScan. The variety of choices is nothing less than impressive. This chapter will help you choose the best output format for your individual scanning task.

Contents

A complete reference of the **Output** tab

12.1 Reference – Output tab

The **Output** tab is the command center that allows you to specify the output format of your scan. Here you can choose between different file formats and configure filenames, storage folders, and subsequent options like file compression or output size compression. The text below gives a brief overview of general options that apply to different file formats.

By default, all files are stored in the folder specified in **Output** ▸ **Default folder**. The naming is automated as well; every naming option (e.g., **Output** ▸ **TIFF file name**) has a code (here, @.tif) that assigns filenames automatically. Of course, you can configure everything individually as well.

Please keep in mind that VueScan is able to execute multiple file formats in parallel. With your scanner manufacturer's software, you may be used to choosing between TIFF and JPEG; with VueScan, that is possible but not mandatory. Instead, you can have TIFF and JPEG output at the same time.

The VueScan filenaming options

Every naming option (e.g., **Output** ▸ **TIFF file name**) has an @ button. If you click it, a file and the folder navigation window of your operating system will open, and you can specify filenames and storage locations individually. But you only have to do this if you want individual filenames.

Default filenaming
By default, filenames and numbers are generated automatically. A simple @sign + file extension (e.g., @.tif) is the default setting. This results in an output filename like *Scan-YYMMDD-0001+*. YY is the year (e.g., 10 for 2010), *MM* is the month (e.g., 11 for November) and *DD* is the day (e.g., 22 for the 22nd of the month). The plus sign (+) indicates that VueScan will count automatically. The first filename in the row will be *Scan-101122-0001.tif*, the second *Scan-101122-0002.tif*, and so on.

Serial numbering with +
You can place the plus sign (+) anywhere in the filename. If you place it behind digits, VueScan will start counting from the given number. You can add as many plus signs as you like, but VueScan will ignore all but the last. For example, if your filename is 0000+.tif, the output files will be 0000.tif, 0001. tif, 0002.tif, and so on.

Leading zeros are useful, since they guarantee filenames of the same length. For example, +.tif produces filenames like *1.tif, 10.tif, 100.tif*, and so on. A naming convention like *0000+.tif* avoids this and produces filenames like *0001.tif, 0010.tif*, and *0100.tif* instead. File administration is much easier when filename lengths are identical. You can start at any number. Numbering is always relative to the contents of the folder, not absolute. VueScan will check first to see if there are existing files with the same naming convention. If so, it will start numbering at the lowest free slot. This can lead to some confusion if you deleted some files in a batch.

For example, say your filename is *0000+.tif* and you scan five images in a batch. The resulting files are *0001.tif, 0002.tif, 0003.tif, 0004.tif*, and *0005.tif*. Now you delete *0002.tif*. If you perform two more scans, they will be named *0002.tif* and *0006.tif*. The first file will fill the gap in the existing row, and the second file will continue the naming convention of the batch.

Inheriting RAW file names with *
If you are processing RAW files (**Input** ▸ **Source** set to *File*), you can assign the output files identical names as the RAW files. Just replace the default @ sign in the filename with an asterisk *.

Frame numbering with =

The frame number assigned by VueScan can be written into the filename of the output file. Just insert an equal sign (=) in the filename. If you save the scan more than once, VueScan will try to overwrite the existing file. By default, the application will warn you before actually replacing the file.

Specifying a starting number is a little different from serial numbering with the plus sign. The starting number will be the specified number + the frame number -1. This may sound complicated, but it actually is very useful in batch scanning filmstrips when you want the filenames to match the numbers on the negatives. Simply configure the first number of the original, and VueScan will do the rest.

For example: your filename is *Scan_33=.tif* because the number of the first negative on the strip is 33. There are four images on the filmstrip, from 33-36. Now perform a batch scan of the four frames. The resulting filenames will be *Scan_33.tif* (frame 1, 33+1-1), *Scan_34.tif* (frame 2, 33+2-1), *Scan_35.tif* (frame 3, 33+3-1) and *Scan_36.tif* (frame 4, 33+4-1). Since the frame numbering is relative and not absolute, you should assign a new name for each filmstrip you scan. This is necessary anyway, as each filmstrip has a different starting number.

Output ▸ Default folder

This is the default folder for all output files generated by VueScan. All file types relegate in standard configuration to this folder. That's why simple filenames like @.tif are a sufficient description in the default settings; the file path is the default path. Of course, you can reconfigure this. If you specify different paths for individual file types (e.g., Output ▸ Tiff file name, Output ▸ JPEG file name, Output ▸ PDF file name, and so on), they will override the default settings.

Output ▸ Printed size

This setting has no practical influence on file size or on the scan itself. It is simply a descriptive function that can be useful for printing. Output ▸ Printed size does not (!) resample the image, it will not (!) change the absolute numbers of pixels, and it will not necessarily be used for output purposes. The important value is always the scan size itself, i.e., the absolute number of pixels.

For example: you scan a 35mm slide (25.025 x 36.678 mm) with an Input ▸ Scan resolution of 2000 spi. Set Output ▸ Printed size to *8″ x 12″*. The resulting file will be 2888 x 1971 pixels. If you open it in Photoshop, it will display a document size of 11.692″ x 7.98″—approximately the configured output size of 8″ x 12″. The relative resolution for this document size is 247 pixels/inch. This is not sufficient for a high-quality printout; in that case, you would need a relative resolution 300-400 dpi instead. But changing Output ▸ Printed size will have no effect at all, as it does not affect the file size; you will have to increase Input ▸ Scan resolution. You can configure Output ▸ Printed size in four ways. The first option is to choose *Scan size*, in which case the relative scan resolution (e.g., 2000 spi) equals the printed resolution (here, 2000 dpi). The second option is to choose a predefined value like 8″ x 12″ as described above. This and the following option are handy to estimate whether your scan resolution is sufficient for the desired output. Check the bottom line of VueScan where absolute and relative pixels for a given output size are displayed (e.g., *Output: 2480 x 3580 pixels 213 dpi 297 x 420 mm*). In this case, the scan resolution is too low for the given output size; 213 dpi is not sufficient for printing. You will need a higher resolution for scanning. If you don't find the the desired output size in the list, you can define it yourself with *Manual*, the third option. The fourth and last option is *Fixed dpi*. This option is useful if you just want to show the maximum enlargement for your scan. If you set it to 300 dpi per our example, it will show *Output: 2480 x 3580 pixels 300 dpi 210 x 297 mm*, the exact print size for a relative resolution of 300 dpi.

Output ▸ Printed width/height

These options show up only when you choose to configure the printed size as *Manual*. You can configure Output ▸ Printed width and Output ▸ Printed height manually via sliders. Units (pixels, mm, cm, inches, etc.) can be defined in Prefs ▸ Printed units.

Output ▸ Printed dpi

In the author's personal opinion, *Fixed dpi* is the best option in Output ▸ Printed size. Here you can configure a fixed relative resolution, e.g., 300 dpi, which will be applied to all scans and will help you estimate the printable size of your scans.

For example: you scan a 35mm slide (25.025 x 36.678 mm) with an Input ▸ Scan resolution of 2000 spi. Set the Output ▸ Printed size to *Fixed dpi* and choose *300 dpi* for Output ▸ Printed dpi. As in the example above, the resulting file will be 2888 x 1971 pixels. If you open it in Photoshop, it will display the document size as 9.627″ x 6.57″ at 300 dpi. This is the maximum print size for 300 dpi; if you need bigger prints, you will have to increase the Input ▸ Scan resolution.

Output ▸ Magnification (%)

This option is available when Output ▸ Printed size is set to *Scan size*. It allows you to set a magnification factor. Output ▸ Magnification (%) does not (!) resample the image and will not (!) change the absolute number of pixels.

For example: you scan a 35mm slide (25.025 x 36.678 mm) with an Input ▸ Scan resolution of 2000 spi. Set the Output ▸ Printed size to *Scan size*. Configure a magnification of *100%* (the default value). As in the example above, the resulting file will be 2888 x 1971 pixels. If you open it in Photoshop, it will display the document size as 3.67 x 2.5 cm (the size of the original) at 2000 dpi (the scan resolution). Now scan again with a magnification of *400%*. The resulting file will still be 2888 x 1971 pixels. If you open it in Photoshop, it will display the document size as 14.67 x 10.01 cm (400% of the size of the original) at 500 dpi (the scan resolution divided by four).

Output ▸ Auto file name

This option is enabled by default and ensures that the filenames specified for various file types (Output ▸ TIFF file name, Output ▸ JPEG file name, etc.) are generated automatically. Disable it if you want to assign filenames for each scan individually. In that case, a window will pop up for every scan asking for the filename.

Output ▸ TIFF file

This option enables you to output TIFF files. Subsequently, all dependent TIFF options will show up when Output ▸ TIFF file is selected. TIFF is a lossless format, but a TIFF file it is not a RAW file anymore.

▸ Output ▸ TIFF file name
Here you can specify filename and storage location for TIFF files.

▸ Output ▸ TIFF size reduction
Here you can effectively reduce the pixel count of a scan by reducing its output size. By default, the output size is set to *1*, which means no size reduction. Please see the table below for the effects of size reduction.

TIFF size reduction	Width x Height	File size	Resolution
1 (=no size reduction)	2888 x 1971 pixels	13.2 MB	5.6 megapixels
2 (by factor of 2)	1444 x 985 pixels	3.0 MB	1.4 megapixels
3 (by factor of 3)	961 x 657 pixels	1.3 MB	0.6 megapixels

The TIFF size reduction merges blocks of several pixels into single pixels. A TIFF size reduction of *2* combines blocks of 2 x 2 pixels and merges them into a single pixel. A similar technique is used for rescaling in image editing programs. This effectively reduces file size, and it can help to lessen image noise. The effect is comparable to multiscanning.

For example: you want a 2000 spi scan of a 35mm slide. Set `Input` ▶ `Scan resolution` to 4000 spi and `Output` ▶ `TIFF size reduction` to factor *2*. The scanner will read the 4000 spi scan and resample it into a 2000 spi file. Depending on your scanner, this can reduce the amount of visible image noise compared to a 2000 spi scan with no size reduction.

▶ Output ▶ TIFF multi page

This option will create TIFF files of several pages comparable to PDFs with every scan (or frame) as a separate page. Please keep in mind that few applications support TIFFs with multiple pages, compatibility is definitely an issue here. Especially for scanning documents, PDFs may be the better alternative when you don't need the superior picture quality of TIFFs.

▶ Output ▶ TIFF file type

This option describes the pixel depth of the TIFF file. Due to the versatile definition of the TIFF format, you can choose all steps between 1-bit B/W and 64-bit RGBI—you can even process the infrared channel separately. TIFF files may be bigger than JPEGs, but they are the best choice when you plan to do post-processing in Photoshop.

▶ Output ▶ TIFF compression

Here you can enable TIFF compression, which in most but not in all cases will reduce the effective file size. TIFF compression is lossless and does not affect image quality. In some cases, the effect can be counterproductive and actually increase the file size. That's why VueScan has an *Auto* setting that activates TIFF compression only if its use is justified. Alternatively, you can switch it *Off* or *On*. (By default, it is switched off.) On rare occasions, TIFF compression can lead to incompatibilities with other applications, as not all programs or specifications support it. But in general this is really a good way to save storage space without any loss of image details.

▶ Output ▶ TIFF DNG format

If you select this option, VueScan will export the file in DNG format (**.dng*) instead of standard TIFF format (**.tif*). Regardless of the file type, it is still a processed TIFF and not a true RAW file. This can lead to some confusion; either you avoid this, or you choose an appropriate naming convention for these TIFF-DNGs. You should avoid mixing them with true RAW-DNG files.

▶ Output ▶ TIFF profile

VueScan can embed the ICC color profile specified in `Color` ▶ `Output color space` into the TIFF file during output automatically. When disabled, the output file will have no embedded profile. The embedded profile can be identified and used automatically by image editing programs like Photoshop. Image editing applications can, but don't nescessarily have to use the embedded color profile.

Output tab

Output ▸ JPEG file

This option enables JPEG output. JPEGs are processed scans like TIFFs, but they use lossy compression while TIFF is a lossless format even when compression is activated. The smaller JPEG file size comes at a price, as JPEGs are not well designed for post-processing. However, if you don't have big plans for post-processing, JPEGs are a good choice due to their small file size and the reasonably good image quality.

▸ Output ▸ JPEG filename
Here you can specify filename and storage location for a JPEG file. VueScan will use this configuration whenever you are scanning JPEGs.

▸ Output ▸ JPEG size reduction
This option is identical to `Output` ▸ `TIFF size reduction`; please refer to that reference for details. The benefits and side effects of the output size reduction are basically the same, whether TIFF or JPEG is the output format.

▸ Output ▸ JPEG quality
This option deals with genuine JPEG functionality. JPEG is by design a lossy file format. It uses strong compression algorithms to achieve small file sizes. That's why JPEGs are smaller than comparable TIFFs. In some cases, this lossy compression can lead to visible JPEG artifacts. The use of `Output` ▸ `JPEG quality` can improve image quality. At the default value, which is *90*, the images will be already quite small but show few artifacts. Lesser values, like *50*, will produce even smaller files but more visible artifacts. Higher values, like *100*, will produce considerably larger files and fewer artifacts than the default value. JPEG is a good choice if you don't want to post-process your images. If you do post-processing with an image editor, your JPEGs will most likely be compressed again, which leads to even more artifacts. High compression ratio during scanning is only useful if you are not going to post-process your images.

▸ Output ▸ JPEG black/white
By default, JPEGs store image information for all three color channels (RGB). If you are scanning black-and-white images, you can use this option for monochrome JPEG files. They are even smaller than standard JPEGs.

▸ Output ▸ JPEG profile
You can embed the ICC color profile specified in `Color` ▸ `Output color space` into the JPEG file during output. When disabled, the output file will have no embedded profile. The embedded profile can be identified and used automatically by image editing programs like Photoshop.

Output ▸ PDF file

This option enables PDF output. PDF is not an image format but rather a document format that can contain text, images, and graphics. PDF is vector-based, meaning that the text it contains can be enlarged indefinitely without any pixelization. Of course, this is not possible for embedded graphics and images, which are not vectorized. PDF is the perfect output format if you want to generate electronic documents from your scans. It is not well suited for post-processing scans or for producing facsimiles of analog originals.

▸ Output ▸ PDF file name
Here you can specify a filename and storage location for a PDF file.

▶ Output ▶ PDF size reduction

This option is identical to `Output` ▶ `TIFF size reduction`; please refer to that reference for details. The benefits and side effects are the same, whether TIFF or PDF is the output format. PDF only embeds images, but its file size will shrink subsequently when the scan size is reduced with this size reduction option.

▶ Output ▶ PDF multipage

This option enables you to create PDFs with multiple pages. For example, if you want to scan a four-page document into a single PDF with four separate pages, this is your option of choice. Every scan will be added to the PDF until you press the `Last scan` button.

▶ Output ▶ PDF file type

Here you can configure the pixel depth of the PDF, respective of the pixel depth of the scans that VueScan embeds into the PDF. Although VueScan displays the full range of options, only these are usable in practice: 1-bit B/W, 8-bit Gray, and 24-bit RGB. 24-bit (i.e., 8 bits per color channel) is the maximum pixel depth that can be embedded into PDFs.

If you want, you can even choose the 16-bit Infrared channel, but there is hardly any reason to use it for PDF generation.

▶ Output ▶ PDF compression

By default, PDF compression is *Off*. High-resolution scans lead to very large PDF files. You can reduce the file size by switching compression to *On*. This will instantly shrink even the largest PDF files, as the internal image format is switched over to JPEG (compression level 90). You can further reduce the PDF size by setting compression to *Maximum* (JPEG compression level *75*).

▶ Output ▶ PDF paper size

Here you can choose the paper size of the PDF document. If the scanned image is smaller than the chosen PDF paper size, it will be centered. If the scanned image is larger than the chosen PDF paper size, VueScan will automatically switch to a larger paper size. This option will not shrink the scanned image to fit the chosen paper size.

▶ Output ▶ PDF profile

You can embed the ICC color profile specified in `Color` ▶ `Output color space` into the PDF file during output. When this option is disabled, the output file will have no embedded profile. The embedded profile can be identified and used automatically by programs in the subsequent workflow. Like with any other embedded profile, the application will decide whether to use the embedded profile or not. Embedding a profile is just an offer, but it simplifies post processing.

▶ Output ▶ PDF OCR text

VueScan's Optical Character Recognition (OCR) option detects text in the image and marks its location automatically. The resulting PDFs are searchable, and you can mark and copy text in them. The documents can be searched by search engines as well. All in all, OCR is a very useful feature; a standard scan without OCR only displays the image without offering any of the described options.

While VueScan's OCR feature is convenient and useful, you can only use it as it is—i.e., it is not self-learning like dedicated OCR software. For more sophisticated tasks, OCR software like ABBYY FineReader is the better (although quite pricey) choice. Professional OCR software can cost much more than a VueScan license; but for standard tasks, the integrated functionality of VueScan delivers sufficient results. There is an easy way to improve the hit rate of VueScan's OCR. You can and should choose the text language, see text below.

Output tab

Output ▸ OCR text file

Another output option, aside from the PDF, is a simple text file—more precisely, a Rich Text (*.rtf*) file which, by default, can be edited with many text editors. This is a good option if you want to overhaul and process automatically detected text easily.

▸ Output ▸ OCR text filename
Here you can specify filename and storage location for an OCR text file.

▸ Output ▸ OCR text language
Here you can choose the language of the text you are scanning. By default, VueScan is shipped with English only. The option *More* directs you to the VueScan homepage where you can download many more languages, ranging from Bulgarian to Vietnamese. Common languages like Chinese, French, German, Spanish, and Portuguese are supported as well; VueScan supports 32 languages at the time of writing this book. Please be aware that only characters in the Windows 1252 character set can be written into a PDF. This narrows the OCR application area mainly to Western European languages.

▸ Output ▸ OCR text multi page
This option creates OCR text files with multiple pages. For every scan, a new page is created within the same text file. The purpose is the same as `Output ▸ PDF multipage`; select both options if you want both PDF and OCR text files as multipage documents.

▸ Output ▸ OCR text RTF format
This option is enabled by default. OCR text files are in Rich Text format (*.rtf*). Rich Text supports pages and some formatting options; it is easier to use than plain text and is supported by most text editors. If you disable this option, the output will be plain text (*.txt*) instead. Plain text has an even broader compatibility but hardly any formatting options. Plain text does not even support pages, and it does not store the location of the text on the original like RTF does. For everyday use Rich Text format is definitely easier to handle and its compatibility should be sufficient as well.

Output ▸ Index file

In the analog world, the index print used to be common. For every roll of film, the photographic laboratory would give you an index print—a print with thumbnails of all the pictures on the roll. When you enable `Index file`, every scan will be added to the index print until you disable this feature or create a new index file. This option is especially useful when combined with batch scanning. The index file is saved after each scan, but you can add more pictures to it with every additional scan.

▸ Output ▸ Index filename
Here you can specify a filename and location of an index file, which is saved as a Bitmap (*.bmp) file.

▸ Output ▸ Index frame
This option controls the placement of index files. The default setting is zero, which means images are added in the same way you write: from left to right and from top to bottom. The number of images in a row is defined in `Output ▸ Index across`. After each scan, the index setting increases automatically. An index setting of 6 in an index with 5 images across indicates the first image in the second row. Configure `Output ▸ Index frame` only when you want to replace a specific single image in an index print.

▶ **Output ▶ Index width**
This is the pixel-width of every single image frame in the index.

▶ **Output ▶ Index height**
This is the pixel-height of every single image frame in the index.

▶ **Output ▶ Index margin**
This is the pixel-width margin around every single image frame in the index.

▶ **Output ▶ Index across**
This is the number of single image frames in one row of the index file. For example, when set to 5, the first five pictures of the batch scan will be in the first row and the subsequent scan will be the first image in the second row.

Output ▶ Raw file

This is an exclusive option in VueScan Professional; the Standard Edition does not support RAW output. It shows up when your input device is a physical scanner but not when your input device is a file. Unless of couse, you select `Prefs` ▶ `Enable Raw from disk`. But genuine raw data comes from the scanner directly. The RAW file is the unprocessed scan data. By storing the scan data, you can perform crucial processing steps, like infrared cleaning, at a later stage.

RAW files can be opened with most image editing programs (e.g., Adobe Photoshop) or converters (e.g., Adobe Lightroom). However, the full range of scan-specific processing options is only available within the scanning program VueScan. Depending on your settings or the application you use, Raw scans may look dull. For 16-bit scanning (16-bit Gray, 48-bit RGB, 64-bit RGBI), no gamma correction is applied, and uncorrected images with gamma 1.0 will look gloomy. All 8-bit scans (8-bit Gray, 24-bit RGB) are gamma corrected (gamma 2.2) even as RAW files. At this stage, the scans are rough diamonds waiting for fine tuning. To sum up: RAW files are the best way to archive analog originals in digital mode.

▶ **Output ▶ Raw filename**
Here you can specify a filename and location of a RAW file. By default, the file type is TIFF; if you enable `Output` ▶ `Raw DNG format`, it changes to DNG.

▶ **Output ▶ Raw size reduction**
This option is identical to `Output` ▶ `TIFF size reduction`; please refer to that reference for details. If you enable the size reduction, the resulting file is not a RAW file in a strict sense any more because it has been rescaled. For true RAW output, choose a lower scan resolution instead.

If you have used size reduction at the raw level already, a size reduction of the JPEG and TIFF output can be critical in some cases. The benefit of the RAW size reduction is that it reduces the scan size to the size you actually need. The rescaling usually improves overall image quality of the scan as it will effectively reduce image noise.

▶ **Output ▶ Raw file type**
Here you can choose all pixel depths ranging from 1-bit B/W to 64-bit RGBI. If you want real RAW data output to preserve the full quality of the scan, you should choose 48-bit RGB for black-and-white negatives and all reflectives and 64-bit RGBI for color slides and negatives. This is the full color information of the scanner, and you will have maximum range for post-processing.

Output tab

▶ **Output ▶ Raw output with**

Here you can choose what operations in VueScan trigger RAW output. You have the options *Save*, *Preview*, and *Scan*. *Save* should be avoided for true raw data scanning, as it saves the processed data—even infrared cleaning and grain are applied to the RAW file and cannot be reverted. *Preview* saves the raw data of the preview. For most purposes, the best choice is *Scan*. Both *Preview* and *Scan* save unprocessed RAW.

▶ **Output ▶ Raw save film**

If you choose this option, film corrections in the `Color` tab are written into the RAW file. Furthermore, rotation and infrared cleaning are written into the RAW file as well. The resulting file is not exactly RAW data anymore, but it is well suited for post-processing with programs like Adobe Lightroom.

▶ **Output ▶ Raw compression**

This is more a TIFF compression than a RAW compression as the name may suggest. It is only available for TIFF and not for DNG. For details, refer to `Output` ▶ `TIFF compression`; the function behind it is the same.

▶ **Output ▶ Raw DNG format**

Here you can set the RAW format to DNG instead of TIFF. With DNG, the files are better adapted for post-processing in Adobe Camera Raw or Lightroom than TIFF RAW. Please keep in mind that scan-specific corrections like `Infrared clean` can be performed only in VueScan itself.

Output ▶ Description

Here you can add a description of the scan. For image files, it will be part of the EXIF fields; for OCR text files, it will show up at the top of the page.

Output ▶ Copyright

This is another EXIF field for copyright information.

Output ▶ Date

This EXIF field is used to record the creation date of the analog original. According to ISO standards, the syntax is *YYYY:MM:DD HH:MM:SS*. *YYYY* is the year, *MM* is the month, *DD* is the day, *HH* is the hour, *MM* is the minute, and *SS* is the seconds. You can use different syntax options for the input (e.g., *1989*, *April 1989*, *19980401*, *01/04/1989*, *1989:04:23*), and VueScan will try to convert them to ISO automatically.

Output ▶ Log file

The log file records all operations of the scanner. This file is named *vuescan.log*. You will find this file in the VueScan folder. In case of a problem, you can send the log together with a bug report to Ed Hamrick.

Output ▶ Log file max size (MB)

The standard size of the log file is 2 megabytes. You can enlarge it up to 100 megabytes if needed.

Output ▶ Default options

Here you can reset the default settings of the `Output` tab with a single click.

Reference – Prefs Tab

13

The **Prefs** tab—an abbreviation for preferences—is the central control box for configuring VueScan. Here you can configure all of the general settings that will help you adjust the program to your individual needs. A few clicks in the **Prefs** tab can save a lot of effort in your daily routine.

Contents

A complete reference of the **Prefs** tab

13.1 Reference – Prefs tab

The **Prefs** tab is the central control box for configuring VueScan. Here you can configure general settings for the program and you can tweak VueScan according to your individual needs. Please keep in mind that the color management settings in VueScan are not part of the **Prefs** but rather of the **Color** tab.

Prefs ▶ Language

The original language of VueScan is English, but now it supports all of the popular western languages—German, French, Spanish, and Portuguese—and a good portion of the rest, including Vietnamese. In the default setting, Standard, VueScan will switch automatically to the same language as your operating system. Alternatively, you can select one of the languages from the dropdown list. If you cannot find your language in the list, choose *More*, which will redirect you to Ed Hamrick's website where you can check the current status of the localization. By the way: Ed Hamrick is always happy if somebody supports him with translations.

Prefs ▶ Font size (pt)

Here you can configure the font size in VueScan according to the acuteness of your vision or the size of your screen. The unit of measurement for font size is *point*. When you choose a different font size, the display will change immediately. The recommended minimum font size by Ed Hamrick is 6 points, but for daily use it should be 8 points or larger. Larger fonts improve readability but consume more monitor space.

Prefs ▶ Crop units

This option allows you to select how crop units are measured. The default is *mm*, but you can also choose *pixel*, *cm*, *inch*, *pica*, or *point* instead. Picas and points are typographic units; if you want to select them, you should know what they represent. Lesser mortals will be happier with metric (mm, cm) or inch units. **Prefs ▶ Crop units** only affects the display units in the **Crop** tab. It will not change the output sizes of the scan.

Prefs ▶ Printed units

Compare **Prefs ▶ Crop units**. The only difference is that this option is for print sizes. **Prefs ▶ Printed units** is displayed in the status area (lower right line below the **Preview** / **Scan** window).

Prefs ▶ External viewer

Here you can enable an external image viewer that opens the images after scanning automatically (see next option).

Prefs ▶ Viewer

In this option you can set the file path to an external viewer for your scanned images. The standard setting is default, i.e., the system default of your operating system, but you can of course choose any other viewer you like. The system default handling depends on your operating system. In Windows 7, you have Default Programs in the control panel where you can assign a default program for each file extension individually. In Mac OS X, you have to click on an image, choose File ▶ Show info, select an application, and choose Change all to make it a general system setting. Tip: You can even choose an image editor like Photoshop. That's very convenient when you want to do post processing immediately after scanning.

Prefs ▸ External editor

Here you can enable an editor for OCR text files.

Prefs ▸ Editor

Here you can set the file path to an external editor for OCR text files. See `Prefs` ▸ `Viewer` for details; the process is the same.

Prefs ▸ Browser

This option is found exclusively on Linux systems. It allows you to choose a different web browser from the default browser. Most Linux systems use Mozilla by default.

Prefs ▸ Graph type

You can display a graph (i.e., histogram) in VueScan below the tabs via Image ▸ Graph. It is not visible in `Guide me` mode. Depending on your choices, it will show different graphs.

▸ Raw
This graph shows the uncorrected (gamma 1.0) curves of RGB color and the infrared channel. The histogram curves of the RAW file will not change when you configure settings in the `Color` tab.

▸ B/W
This graph shows the black-and-white points in the histogram. You can configure them here manually by pulling the triangular sliders below the curve. The curves of the histogram displayed in the background will not change when you configure settings in the `Color` tab.

▸ Curve
This option basically resembles the Curves option in Photoshop. In Photoshop, Curves is a popular and versatile option, e.g., to control the contrast of an image. In VueScan, it's a different story. First, there is no histogram display that allows you to supervise the effect of your changes in real time. Second, you can control the curve only by two rectangular sliders that are far from precise. Photoshop is by far the better tool.

▸ Image
This is where you can survey, in real time, the effect of your changes in the `Color` tab on the histogram of the final image. Enable it by default if you want to see what your configuration does to the scan's tonal values.

Prefs ▸ Button 1/2/3/4 action

Most flatbed scanners have this option; it is displayed when your scanner has buttons for rapid access. If you use the manufacturer's software, you can press a button and the scanner will perform the scan automatically. With VueScan, you can use them for general commands like *Scan*, *Print*, *Preview*, and *Save*. This is nice, but usually the customization in the manufacturer's software is even better. With the manufacturer's software, you can assign one button to $8^{1/2}$" x 11" PDFs, another to Photocopier, and so on. When you press the different buttons, the scan program will use the different configurations. To achieve a similar effect in VueScan, you must configure the application accordingly before you press a button.

Prefs tab

Prefs ▶ Auto refresh

This option, enabled by default, refreshes the image automatically to display changed settings in the preview in real time. You can switch it off and do the refresh manually via the menu Image ▶ Refresh if you want. Unless you have a very old and slow computer—which you should not use for scanning, anyway—there is no reason to disable the automatic refresh.

Prefs ▶ Display Raw scan

This option provides a display of the scanning process in real time. Like the option above, you can disable it to save some computing resources, but with a fast computer this is not necessary. Apart from that, it is interesting to see what happens in VueScan during scanning, especially if you display Image ▶ Graph image.

Prefs ▶ Display positive

This option is displayed only when Input ▶ Media is set to either *B/W negative* or *Color negative*. It shows the raw scan as a positive so you can evaluate the initial visual impact of the scan. The final conversion can look quite different, depending on what film profile you use.

Prefs ▶ Splash screen

Here you can disable the splash screen that pops up when you start VueScan. This accelerates the start of the application for a split second.

Prefs ▶ Histogram type

By default, the histogram is *Linear*, meaning that it displays the number of samples on the Y axis (the vertical axis). If you want to display the square root of the number of samples, use *Square root*. For the logarithm of the number of samples, use *Logarithmic*. For average use, *Linear* is recommended.

Prefs ▶ Animate crop box

The crop box is animated by default, which makes it easier to see—especially when you use skewing. But if you disable it, you can set the crop more precisely as there is no blinking line to confuse your eye.

Prefs ▶ Thick crop box

By default, a thick line marks the crop box. This is easier to see but less precise than the thin line you get by disabling this option.

Prefs ▶ Add extensions

VueScan's automatically generated filenames always have a file extension (like **.tif*). By default, this option is enabled. If you manually choose filenames (e.g., *Scan_001*), the system will add the extension (**.tif*) automatically, and the complete filename will be *Scan_001.tif*. Since you don't have to add a file extension manually, this saves you some typing. If you type in a filename with a period (e.g., *Scan_001.abc*), the period and everything following it will be cut off and the configured file extension will be added (e.g., *Scan_001.tif*). The official VueScan documentation states, that no file extension will be added if the file name has a period.

But at least on Windows computers, this is not the case. Even with disabled **Prefs** ▸ **Add extensions**, VueScan will still automatically add a file extension on a Windows computer but will not cut off periods.

Prefs ▸ Substitute date

This is a clever option that helps you assign the date of the scan to file names. It substitutes codes with date specifications. The date codes are *YYYY* (for the four-digit year, e.g., *2011*), *YY* (for the two-digit year, e.g., *11* for 2011), *MM* (the month, e.g., *03* for March) *DD* (the day of the month), *HH* (the hour) *II* (the minute), and *SS* (the second). VueScan uses the system time of your computer. The date substitution works only when at least three date/time codes are used in the file name. *YYYYMMDD.tif* will work, while *YYYYMM.tif* will not work. Hyphens, underscores, and other fillers are acceptable as well, e.g., *YYYY-MM-DD.tif* is fine. You can combine date substitution with auto numbering (*YYYY-MM-DD_0001+.tif*) to avoid double naming.

Prefs ▸ Warn on delete

This option displays a warning message when you scan multipage originals with **Input** ▸ **Multi page**. With **Page** ▸ **Delete**, you can delete single pages, and to avoid inadvertent deletions, VueScan will ask you if you are sure you want to delete.

Prefs ▸ Warn on overwrite

This option warns you when VueScan wants to write a filename that already exists. It is enabled by default, and you should not touch it. Instead of overwriting an existing file, it is better to delete it manually from the hard disk. If you disable the warning, mistakes like this can easily happen: you scan a full batch, and every new scan wipes out the preceding scan because of an inaccurate naming convention.

Prefs ▸ Warn on not ready

This option displays a warning message when the connected/chosen input device is not ready, e.g., a scanner that is not ready or a RAW file that does not exist.

Prefs ▸ Warn on no scanner

This option warns you when the scanner is not connected. After connecting the scanner, you may need to exit VueScan and start it again for proper functioning.

Prefs ▸ Exit when done

This option closes VueScan after the scan is finished. It can be useful if you do batch scanning unsupervised. Once the VueScan window disappears from the screen, the batch is completed.

Prefs ▸ Beep when done

Here's another VueScan option that is nothing less than ingenious, despite or even because of its simplicity! It makes the computer beep after the scan is completed. This may sound not too exciting, but it is a rare feature among scanning programs. It can be very handy when you stay in the room while the scanner is busy with a batch and you just need acoustic feedback when it's done. VueScan uses the default sound in Windows (Control Panel ▸ Sounds in Windows 7) and a simple beep in Linux and Mac OS X.

Prefs tab

Prefs ▶ Beep when auto eject

Once again, the computer will play a sound, this time when the scanned original is auto ejected. This is useful when you are scanning film strips with a slide feeder and the auto ejection is configured after the scan. When you hear the beep, not only is the scan ready but also you can grab the ejected analog original.

Prefs ▶ Use temp file name

If this option is enabled, VueScan will use the *.tmp* file extension for TIFF, JPEG, or PDF files that are being written but are not closed yet. When the file is closed, it will be renamed with its appropriate file extension. This is useful for monitored directories; once the file has the proper extension, it can be processed automatically by another application.

Prefs ▶ Anti-alias text

Text and line art scans (i.e., 1-bit B/W) can be displayed with anti-aliasing in the `Preview` or `Scan` window for a smoother look. This option consumes some processing power and is enabled by default. You can disable it if you are using an older computer. But seriously, you should better get a new computer for scanning.

Prefs ▶ Anti-alias image

This option enables anti-aliasing in grayscale and color images. Please refer to `Prefs` ▶ `Anti-alias text` for details.

Prefs ▶ Enable density display

This option enables you to display density values in the footer. To activate it, position your mouse over the image in the `Preview` or `Scan` window, press the `Ctrl` key, and move the mouse. You will see density values (e.g., *Density: 1.84 1.76 1.84*) replace RGB values (e.g., *Color: 202 187 185*). Release the `Ctrl` key and move the mouse again to reactivate the RGB display. Ed Hamrick comments on this feature as follows:

"The density is computed as log10 (max intensity/(intensity+1)). For instance, if a scanner has 12 bits per sample, the maximum sample value is 4095 and the minimum sample value is 0. The maximum density of this scanner is log10(4095/1) or about 3.6. Basically, the darker the film, the bigger the density value. The scale is logarithmic."

Prefs ▶ Enable raw from disk

Raw data is the original unprocessed data of the scanner; that's why you usually can't produce raw file output from RAW files on your hard disk. As a general rule, you must use a scanner if you want to save raw file output.

Here is an exception to the rule: with `Prefs` ▶ `Enable raw from disk`, you can actually use a RAW file on your hard disk for raw output. This can be justified if you need RAW files with a lower resolution than the source files (e.g., 2000 spi instead of 4000 spi) or with a lower pixel depth (e.g., 48-bit RGB instead of 64-bit RGBI, or grayscale instead of RGB). This will free up some hard disk space if you delete the originals. In case you aren't sure about the best pixel depth/resolution, here is my advice: if possible, scan everything at the maximum settings, and you will always be able to shrink even the RAW files! This is another remarkable feature of VueScan that you will not find in standard scanning software.

Prefs ▶ Disable scanners

By default, VueScan lists all scanners plus the option *File* in `Input` ▶ `Source`. Here you can switch between scanners. However, in practice, this can lead to some confusion as the individual scanners may need some scanner-specific configurations. If you have a flatbed scanner and a film scanner, and if you are using raw data from disk, you should install three copies of VueScan. Then you can use each installation exclusively for each scanner and also work with them in parallel. A multicore CPU is advisable. With `Prefs` ▶ `Disable scanners`, you can disable some or all scanners. For example, you can use the setting *All scanners* to completely disable all scanners for an installation, then use it for raw data processing exclusively. Disabling individual scanners can be a bit more tricky, as they are not always listed. All in all, this functionality is interesting but could use some revision before it becomes really useful. The settings take effect after you restart VueScan.

Prefs ▶ Enable sliders/spin buttons

Use these options to enable or disable sliders and spin buttons. The spin button is the little up/down arrow to the right of the sliders. It lets you adjust values in small increments, while the sliders let you adjust the options more coarsely. Disabling sliders and spin buttons can save some space if you are working on a small screen, but usability will suffer.

Prefs ▶ Enable popup tips

Popup tips are displayed for many options and buttons by default. Just hover your mouse over the text of the option to see the effect. It will take a second or so for the popup to appear. You can disable the popups if you don't need that kind of help.

Prefs ▶ Calibration period

Scanner lamps, lamp color, and uniformity can be affected by the ravages of time. This effect is less pronounced in modern LED scanners, but it is definitely an issue in old-fashioned scanners with fluorescent lights. A calibration from time to time is recommended. This option allows you to set the maximum number of days before VueScan reminds you to calibrate the device again. It shows up only for certain scanners.

Prefs ▶ Image memory (MB)

Usually computer applications grab as much memory on your computer system as they want, and this can lead to a shortage of available memory. Since VueScan is a polite little program, it lets you decide how much memory it is allowed to use. On a computer with 2 GB RAM it will assign 1 GB by default to be used for all previews and scans. Depending on the size and resolution of your scans, you may want to increase this.

Prefs ▶ Window maximized

By default, VueScan remembers the size and position of its window. If you exit VueScan and restart it, the window will restore to the last position and size automatically. With `Prefs` ▶ `Window maximized`, VueScan windows will always pop up in full frame.

Prefs ▶ Windows iconized

Enable this if you want VueScan to start minimized, and it will only appear in the task bar as an icon.

Prefs tab

Prefs ▶ Window x/y offset/size

This option lets you configure the offset (i.e., position) of the VueScan window and its exact size. Use the sliders for configuration as it does not scale stepless. These options only take effect when you restart VueScan. Next time you open the program you will see the difference.

Prefs ▶ Default options

Here you can reset the configuration of this tab to its default value.

In the **Prefs** tab you can choose between different measurement units. It does not matter whether you prefer inch or millimeter, with VueScan you can pick any of these options. Even units like *centimeter*, *pica*, *pixel*, or *point* are supported.

Menus, Buttons, and Shortcuts

14

You will find most options of VueScan in the tabs, but if you use the tab section exclusively, you will probably miss the best part. The menu section hosts some of the most powerful options of VueScan, and these do deserve your attention. Many of the menus have keyboard shortcuts, and on Windows and Linux these shortcuts generally use the Control key. On Mac OS X most shortcuts use the Command (or Apple) key. The shortcut is displayed in the menu next to the option.

Contents

Function in menu path	Button-name	Icon	Shortcut Windows + Linux	Shortcut Mac	Definition
14.1 File menu					
File ▶ Save image	Save		Ctrl-S	Command-S	Saves the last image scanned, either Scan or Preview.
File ▶ Last page	Last page	Last page	Ctrl-G	Command-G	Option 1: When using Input ▶ Multi page, all pages in memory will be saved to the hard drive. Option 2: When using Output ▶ TIFF multi page or Output ▶ PDF multi page, VueScan will write all pages in memory to the hard drive.
File ▶ Page setup	--	--	--	--	Page setup for printing.
File ▶ Print image	Print image		Ctrl-P	Command-P	Prints the current image in the memory, either Preview or Scan.
File ▶ Load options	--	--	F10	F10	Loads an *.ini file with configuration options. The current setting of the program is stored in *vuescan.ini*.
customized entries depending on user settings	--	--	F1 to F9	F1 to F9	Any customized *.ini file in VueScan folder will appear in the dropdown list of the menu. Subsequently you can load them by the associated function key shortcut.
File ▶ Save options	--	--	--	--	Saves the current configuration options to an *.ini file.
File ▶ Default options	--	--	--	--	Resets all options for VueScan and all scanners to default values. Should only be used in emergencies, e.g., if you wreck the system completely. Better to use the Default options for each tab if needed—they are more selective.
File ▶ Quit	--	--	Ctrl-Q	--	This exits VueScan, it closes the program. In Mac OS, you can find this function in the VueScan menu instead.

Function in menu path	Button-name	Icon	Shortcut Windows + Linux	Shortcut Mac	Definition
14.2 Edit menu					
Edit ▶ Copy image	--	--	Ctrl-C	Command-C	Copies the current image to the clipboard of your computer. You can insert it from there into any image editor.
Edit ▶ Copy OCR text	--	--	Ctrl-T	Command-T	Copies the OCR text of the current Preview or Scan into the clipboard of your computer. You can insert it from there into any text editor. It is available only if **Input** ▶ **Media** is either *Text* or *Microfilm*. For a good text detection rate, the scan resolution should be at least 300 spi.
14.3 Scanner menu					
Scanner ▶ Preview	Preview	Preview	Ctrl-I	Command-I	Triggers a preview.
Scanner ▶ Scan	Scan	Scan	Ctrl-N	Command-N	Triggers a scan.
Scanner ▶ Eject	--	--	Ctrl-J	Command-J	Ejects the analog original from a feeding unit.

Function in menu path	Button-name	Icon	Shortcut Windows + Linux	Shortcut Mac	Definition
Scanner ▸ Calibrate	--	--	--	--	Triggers a calibration. This is a kind of pre-glow process that will help to fix three things: - Uneven lighting of the scan - Different light sensitivity of the CCD elements - Different dark voltage level of the CCD elements Don't confuse scanner calibration with scanner profiling! The goal of calibration is for the scanner to produce consistent scans on the whole tray. The goal is not to achieve true colors. Scanners have to support calibration on the hardware level. In contrast, profiling needs no hardware support; instead, it needs software support and an IT8 target. The goal of profiling is to produce true colors. If you are profiling your scanner, in general you should execute a calibration beforehand.
Scanner ▸ Focus	--	--	Ctrl-F	Command-F	Focuses the scanner if the scanner supports it. Film scanners usually do; flatbed scanners usually don't.
Scanner ▸ Exposure	--	--	--	--	Calculates the exposure, i.e., the values for **Input** ▸ **RGB exposure** and **Input** ▸ **Infrared exposure**. By default, the exposure is based only on the cropped part of the image; change that with **Crop** ▸ **Border %** and **Crop** ▸ **Buffer %**.
Scanner ▸ Previous	--	--	PgUp	PgUp	Switches to the previous frame if you are scanning multi page.
Scanner ▸ Next	--	--	PgDn	PgDn	Switches to the next frame if you are scanning multi page.

Function in menu path	Button-name	Icon	Shortcut Windows + Linux	Shortcut Mac	Definition
14.4 Profile menu					
Profile ▶ Profile scanner	--	--	--	--	Profiles the scanner. The process will generate an ICC profile for the scanner. You need a prefabricated IT8 target. For reflectives and transparencies, you need different targets and different profiles.
Profile ▶ Profile printer	--	--	--	--	Profiles the printer, i.e., the individual combination of printer, ink, and paper. You must print out a target on your printer before you can do the profiling.
Profile ▶ Profile film	--	--	--	--	Profiles film. You will need to take a photo of an IT8 target with the specific film before you can start profiling it.
14.5 Image menu					
Image ▶ Refresh	--	--	Ctrl-E	Command-E	Refreshes the displayed image and histogram automatically by default. If you disabled **Prefs** ▶ **Auto refresh**, you can refresh the image here manually.
Image\Zoom in	Zoom in		Ctrl-Z	Command-+	Zooms into the image.
Image ▶ Zoom out	Zoom out		Ctrl-U	Command--	Zooms out of the image.
Image ▶ Rotate right	Rotate right		Ctrl-R	Command-R	Rotates the image clockwise by 90 degrees.
Image ▶ Rotate left	Rotate left		Ctrl-L	Command-L	Rotates the image counterclockwise by 90 degrees.
Image ▶ Flip	--	--	--	--	Flips the image. Flipping equals a rotation of 180 degrees.
Image ▶ Mirror	--	--	--	--	Mirrors the image from left to right.

Function in menu path	Button-name	Icon	Shortcut Windows + Linux	Shortcut Mac	Definition
Image ▶ Release memory	--	--	Ctrl-Y	Command-Y	VueScan stores raw data of scans and previews in memory for faster processing. You can use this command to release this data from the memory. This will temporarily free up the memory for other programs. If you want to reduce the amount of memory that VueScan uses permanently, change the configuration in Prefs ▶ Image Memory instead.
Image ▶ Graph off	--	--	Ctrl-0	Command-0	Default setting, no graph is displayed.
Image ▶ Graph raw	--	--	Ctrl-1	Command-1	Shows the uncorrected (gamma 1.0) curves of the RGB color and infrared channels. The histogram curves of the RAW file will not change when you configure settings in the Color tab.
Image ▶ Graph black-and-white	--	--	Ctrl-2	Command-2	Shows the black and white points in the histogram. You can configure them manually by pulling the triangular sliders below the curve. The curves of the histogram displayed in the background will not change when you configure settings in the Color tab.

Function in menu path	Button-name	Icon	Shortcut Windows + Linux	Shortcut Mac	Definition
Image ▶ Graph curve	--	--	Ctrl-3	Command-3	Resembles the Curves option in Photoshop. In Photoshop, this option can control the contrast of the image. In VueScan, it's a different story. First, there is no histogram display that allows you to supervise your changes in real time. Second, you can control the curve only by two rectangular sliders, which is far from precise. Photoshop is the better tool for curve corrections.
Image ▶ Graph image	--	--	Ctrl-4	Command-4	Surveys in real time the effect of your changes in the Color tab on the histogram of the final image. Enable it by default if you want to see what your configuration does to the tonal values of a scan. This is "the" histogram of the processed image.

14.6 Page menu

VueScan displays the Page menu only for Input ▶ Multi page . Use the page menu to navigate within the pages (frames) and to organize the scans for the final output file.

Function in menu path	Button-name	Icon	Shortcut Windows + Linux	Shortcut Mac	Definition
Page ▶ Previous	--	--	PgUp	PgUp	Jumps to the previous frame.
Page ▶ Next	--	--	PgDn	PgDn	Jumps to the next frame.
Page ▶ First	--	--	Shift-Home	Shift-Home	Jumps to the first frame.
Page ▶ Last	--	--	Shift-End	Shift-End	Jumps to the last frame.
Page ▶ Move front	--	--	Shift-PgUp	Shift-PgUp	Moves the current page one position to the front, e.g., from frame 3 to frame 2.
Page ▶ Move back	--	--	Shift-PgDn	Shift-PgDn	Moves the current page one position to the back, e.g., from frame 3 to frame 4.

Function in menu path	Button-name	Icon	Shortcut Windows + Linux	Shortcut Mac	Definition
Page ▶ Reverse	--	--	--	--	Reverses the order of the pages. The original first page will become the last page and vice versa. Your batch is turned upside down.
Page ▶ Interleave	--	--	--	--	Most document feeders will not support double-paged/duplex scanning. For example: You have a batch of 3 paper documents, and all are double sided. One front page (F) and one back page (B) each. The whole stack is FBFBFB. You will have to scan the front pages first (FFF) and the back pages after (BBB). The resulting image file is FFFBBB. With the Interleave command, you can restore the order of the document to FBFBFB.
Page ▶ Separate	--	--	--	--	Converts a stack of FBFBFB into FFFBBB. This command is simply the opposite of Page ▶ Interleave.
Page ▶ Swap even/odd	--	--	--	--	Swaps front and back pages. If your scan is BFBFBF because you scanned the documents with the back side first by mistake, the command will convert the order back to FBFBFB.
Page ▶ Delete	--	--	Shift - Del	Shift - Del	Deletes the current page/frame of the batch; the other pages remain intact. It's quite handy if you need to rescan a page for whatever reason.
Page ▶ Delete all	--	--	--	--	Deletes all pages. Afterwards, you will have to start from zero.

Function in menu path	Button-name	Icon	Shortcut Windows + Linux	Shortcut Mac	Definition
14.7 Help menu					
Help ▶ User's Guide	--	--	--	--	Directs you to the User's Guide on Ed Hamrick's web page. The User's Guide contains a complete reference for all VueScan's options and buttons, plus some workflows.
Help ▶ Usage tips	--	--	--	--	Opens a popup window with usage tips in VueScan.
Help ▶ Release Notes	--	--	--	--	Directs you to the release notes on Ed Hamrick's web page. Here you will get detailed information about the version history of VueScan.
Help ▶ About	--	--	--	--	Directs you to information about your licensing status and the version number of your software.

14.8 Troubleshooting

VueScan will not detect my scanner in the Input tab; why?

VueScan will only display scanners if the driver for the scanner is installed properly on the operating system and the scanner is up and running before (!) you start the VueScan application. VueScan will not update its status when you power up a scanner after you started the application. Close VueScan and start it again.

The scans of my slides look dull; what is the reason?

Even if you use the configurations of the `Color` tab you will most probably experience that a brillant slide will result in a rather dull looking digital image. If you own a good scanner and have followed the instructions of this book, there is nothing to worry about. There is simply one step left in the work process that's missing: post processing! Post processing with a good image editor like Adobe Photoshop will convert the scan into a presentable digital image. This is an essential step in the workflow, you cannot fully automate this. You will likely have to process tonal corrections, remove color casts, and apply unsharp masking as the very last step of your workflow. The amount of processing needed will vary from image to image. But this has nothing to do with scanning, this is basic image editing. If you just want fast scans and don't want to spend time on post processing use `Color` ▶ `Color balance` ▶ *Auto levels* and the built-in unsharp mask of VueScan's filtering options instead. This will improve your scans to some degree without too much effort. But manual post-processing is surely the better, yet more time consuming, choice.

My scans are less sharp than the images of my DSLR; why?

Scanning is basically the conversion of an analog original into a digital image file. This conversion is far from being perfect. And you should be aware of the fact than all small imperfections in this long processing change will add up in the end to a visible loss of image quality. The analog image itself, especially small formats like 35mm, will usually have its issues as well. Film is never as flat as a digital image sensor and the lenses of ancient times left something to be desired as well. But in the old times nobody realized that, because you had no 100% view in Photoshop as nowadays. Even the best film scanners suffer from problems like shallow depth of field; even a curvature of less than 1 mm in the film can lead to additional unsharpness. That's why even a 20 megapixel scan will usually have a lower absolute quality than a shot with any 6 megapixel consumer DSLR of the first generation. Even when you take all this into consideration you can still achieve good quality with scanning by absolute standards. You just have to take it into proportion, technologies change and improve over time. And a scanned image will still look like an analog image. This is part of the fascination of analog originals and some people love it, some don't.

I have weird colors in the Preview/Scan. What happened?

Weird colors in VueScan are usually caused by wrong settings in the `Color` tab. In most cases they are due to a wrong ICC-profile. That can happen easily if you are using two scanners with the same VueScan installation. To avoid this, you can install VueScan two times, then you have a separate installation for each scanner and can not mix up ICC-profiles any more.

Preview/Scan is not working at all. What is the reason for this?

This happens frequently when you are using a flatbed scanner in transparency mode. In this case, just open the scanner and remove the blindfold that is covering the transparency unit. That should fix the problem.

My scans are too small/too big. What went wrong?

Usually this problem is caused by a wrong configuration in **Input** ▸ **Quality**. You can avoid this by choosing the scanning resolution manually in **Input** ▸ **Scan resolution**. If this does not help, check the output size reduction that you can find in **Output** tab for the different file types. If set to a value higher than *1*, VueScan will shrink the files during output process. Sometimes this effect is desired, sometimes not.

I have 40,000+ slides. How can I scan them fast and in good quality?

There are some technologies like batch scanning and automated document/slide feeding that will help you to scan large numbers of originals. But the key factor for efficient scanning is found on another level. You have to carefully sort out your analog originals and choose only the good ones for scanning. That's the fastest and most efficient way to tame even big archives.

My RAW scans look dark in Explorer View. What can I do about it?

You are probably using TIFF-RAW. For many applications this just looks like any average TIFF file and the application assumes, that the image gamma is 2.2 although it is just a gamma of 1.0 as a RAW file. The solution is easy. Use DNG for your RAW file output instead. DNG has a gamma of 1.0 as well, but most applications will recognize it as a RAW file and automatically apply a gamma correction for proper display.

My scans have artifacts. What is the reason?

First of all, you have to ensure you are using a lossless image format like TIFF or RAW. Lossy formats like JPEG can add artefacts to your scan due to their compression algorithm. If this does not solve the problem, have a closer look at the filtering options. A strong setting for dust and scratch removal via **Filter** ▸ **Infrared clean** can in some cases lead to unwanted artifacts. Like with any other filtering option, you should use **Infrared clean** with the weakest setting that leads to the desired correction result.

Infrared Clean wipes out the details. Why?

For classic black-and-white film you cannot use **Infrared clean** due to the silver particles it contains. **Infrared clean** will in general work fine with Kodachrome, but only if the development of the film had been done carefully. In some rare cases there are still silver particles from the development left in the Kodachromes and that will lead to loss of image details as well. With E6-slides and C41-negatives you should experience no problems. But even then, you have to ensure that the filter setting is not too strong.

Some of my slide scans are out of gamut. How can I avoid this?

Out of gamut always happens when the output color space cannot display all colors of the raw scan. This happens frequently when you are using small color spaces like sRGB. But even larger color spaces like Adobe RGB can not always display all colors of the scan. You can choose a larger color space to avoid this, like Ekta Space, Pro Photo or Device RGB, the color space of the scanner. This will save the full gamut for the moment, but you should be aware that you will have to convert these files again at a later stage for most output purposes. Usually it is not visible in the final image that parts of it were out of gamut. It is not as obvious as e.g. blown highlights. In VueScan, the RAW file will contain the full gamut of the scan, no matter what output color space is configured. Please be aware of the fact that some corrections like **Filter** ▸ **Sharpen** can lead to out of gamut as well.

Get in the Picture!

c't Digital Photography gives you exclusive access to the techniques of the pros.

Keep on top of the latest trends and get your own regular dose of inside knowledge from our specialist authors. Every issue includes tips and tricks from experienced pro photographers as well as independent hardware and software tests. There are also regular high-end image processing and image management workshops to help you create your own perfect portfolio.

Each issue includes a free DVD with full and c't special version software, practical photo tools, eBooks, and comprehensive video tutorials.

Don't miss out – place your order now!